READER'S DIGEST

COMPLETE DRAWING & SKETCHING COURSE

Mastering lead pencils, charcoal, pastels, pen and ink, and water-soluble pencils

Course developed by Stan Smith

Reader's Digest

THE READER'S DIGEST ASSOCIATION, INC.
PLEASANTVILLE, NEW YORK/MONTREAL

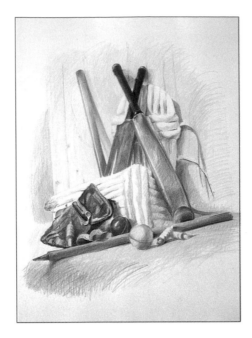

A READER'S DIGEST BOOK

Copyright © Eaglemoss Publications Ltd 2001

Picture credits: front cover(c) Humphrey Bangham, (r) Stan Smith;
spine: Joe Ferenczy; back cover: Stan Smith;
title page: Stan Smith; copyright page: Humphrey Bangham;
contents page: Albany Wiseman

READER'S DIGEST PROJECT STAFF
Senior Project Editor: Delilah Smittle
Editorial Manager: Christine R. Guido

Contributing Project Designer: Martha Grossman
Editorial Assistance: Ann Farr, Nancy Wallace Humes, Hilary A. Thomas

READER'S DIGEST ILLUSTRATED REFERENCE BOOKS
Editor-in-Chief: Christopher Cavanaugh
Art Director: Joan Mazzeo
Director, Trade Publishing: Christopher T. Reggio
Senior Design Director, Trade: Elizabeth L. Tunnicliffe
Editorial Director, Trade: Susan Randol

Library of Congress Cataloging in Publication Data

Smith, Stan.
 Reader's digest complete drawing & sketching course : mastering lead pencils,
charcoal, pastels, pen and ink, and water-soluble pencils / course developed by Stan Smith.
 p. cm.
 Includes index.
 ISBN 0-7621-0326-4
 1. Drawing–Technique. I. Title: Complete drawing & sketching course. II. Title:
Reader's digest complete drawing and sketching course. III. Reader's Digest Association.
IV. Title.

NC730 .S56 2001
741.2—dc21

 2001019435

Designed, edited and produced by Eaglemoss Publications Ltd,
based on the partwork *The Art of Drawing and Painting*

Printed in the Slovak Republic by Polygraf Print spol. s. r. o.

1 3 5 7 9 10 8 6 4 2

CONTENTS

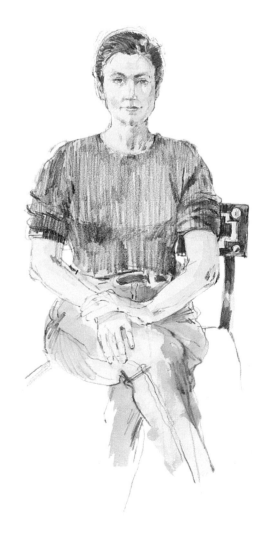

INTRODUCTION

Drawing is not only an important basis for most of the other visual arts. It is a major art form in its own right, its story stretching back to the days of the first cave paintings and the artistic achievements of the ancient Egyptians. There followed a long trek through classical Greece and Rome and on into the Italian Renaissance, which culminated in the modern drawing movements in France, Germany, the rest of Europe, and in North America. Throughout the centuries around the world, drawing has been employed in many ways—as a means of artistic investigation and discovery, and as a fundamental underpinning for painting, sculpture, and printmaking. Nor is drawing an exclusively Western preserve, for the East has produced its own unrivalled practitioners. The great Oriental masters, exemplified by Hokusai and Utamaro, possessed unparalleled skills in interpreting the "world as seen" and the use of line has never been better demonstrated than in their drawings.

What we are concerning ourselves with here is the type of drawing that defines and interprets what we see, with all the associated joys that come from beginning to understand how the world works in its visual form. Learning how to use and exploit the full potential of light, tone, and shade are the essentials in this, but the willingness to experiment and be adventurous are just as important, both in the seeing of what you intend to draw and in the materials that are used to capture it. As far as the latter are concerned, pencil, pen and ink, brush and ink, and ink wash with line are the traditional tools, but the use of color—in washes or via colored pencils—can be most effective.

Through the use of modern acrylic inks, a further fresh, spirited element can also be introduced. When it comes to the actual act of drawing, you will discover how everyone can develop a language of their own. A drawing is a visual autograph, in which the combination of line, tone, and invention come together. Some drawings are very tight—in other words, very well worked to describe things in detail—whereas others are vigorous and broad. Again, there is the drawing that simply involves putting a line around an idea. The process, after all, can be a diagnostic one, where risk and chances are pursued in the interest of new discoveries and realizations.

In this inspiring book, you will see examples using subjects and materials that I hope will trigger fresh thoughts and ideas to allow you to discover your personal drawing language. It contains everything you need to help you to develop and hone a full range of artistic skills. Above all, remember that, although there are many ways of looking at the world around you, to make drawings based on this seeing demands discipline—it does not happen without effort. Equally, as you will find, the great joy of creating a work of art with your own hands is one of the most gratifying pleasures around.

Read on and enjoy!

Stan Smith

CHAPTER ONE

Getting to know your medium

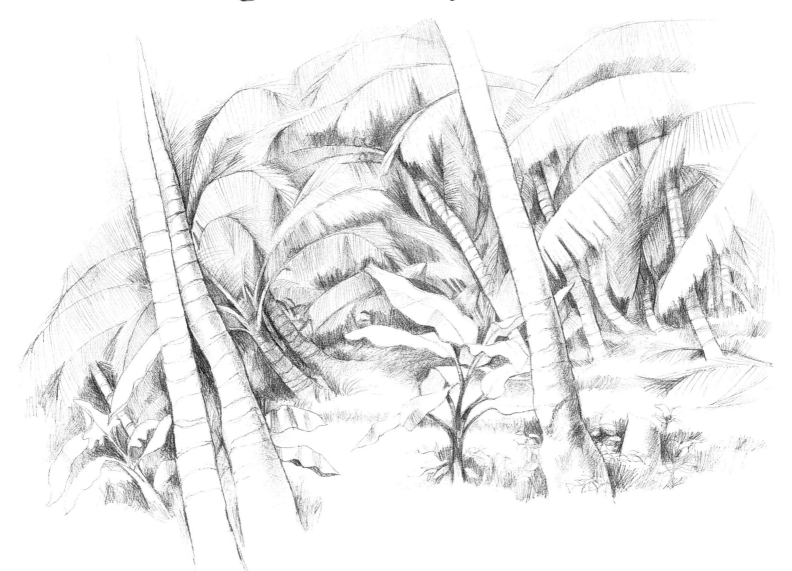

Charcoal sticks and pencils

By far the oldest drawing medium still available on the market today, charcoal is simple to use and lends itself to expressive, spontaneous work.

The perfect medium for beginners, charcoal is nearly always the starting point of any art course—students are encouraged to pick up a piece and start sketching big, bold images right away. This is because working with charcoal can teach a great deal about drawing textures and creating different tonal areas—essential steps before starting with color. And using charcoal encourages artists to think about the subject as a whole and not about fussy details.

Charcoal is made from burned vine and willow twigs and is available in natural or compressed sticks, pencils, or as a powder. Vine charcoal makes a brownish black color, while willow produces a bluish black mark.

There are varying degrees of hardness—soft, powdery charcoal blends easily and is useful for tonal areas, while the harder sticks are more suitable for linear work and details.

The sticks come in various thicknesses, so you can create a range of marks—from broad, sweeping strokes to fine details. In its pencil form—sticks of compressed charcoal encased in wood—charcoal is much cleaner to use, but you lose the feel of the traditional sticks because you can draw with only the pencil's point, not the sides.

Paper and accessories

Charcoal works well with any type of matte paper with a textured surface. Do not use it on smooth or glossy papers because it simply will not adhere to the surface. Canson and Strathmore are good-quality papers for drawing with charcoal, but for everyday practice, newsprint provides a suitable alternative.

willow charcoal sticks in various thicknesses

charcoal in pencil form

fine sandpaper

colored and white drawing paper

tortillon

kneaded-rubber eraser

GLASSPAPER BLOCK

WINSOR & NEWTON
for pointing pencils, charcoal, chalks etc.
Made in England, London HA3 5RH

LARGE KNEADED PUTTY RUBBER

utility knife

fixative

Aerosol
Fixative

Using charcoal

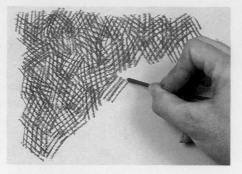

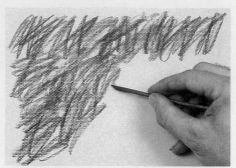

Smudging Charcoal smudges easily, allowing you to produce smooth, velvety effects. Use the sides of the stick to make a series of lines. Then, with the tip of your finger—or with a tortillon, a pencil-shaped roll of paper,—rub across the charcoal from one side to the other, creating light and dark tones by varying the pressure as you go.

Cross-hatching Another way to build up tone with charcoal is by using a series of loose strokes known as cross-hatching. To practice this technique, make a series of parallel lines, then cross them with a series of others at a different angle. Vary the size and closeness of the lines to each other to produce different tones.

Soft blending Instead of smudging the charcoal with your finger or a tortillon, use the wide tip of the charcoal stick to create lines and marks that blend into each other. Sharpen the tip slightly first on a piece of sandpaper, then hold the stick near the top end. Vary the pressure as you scribble to create a range of light and dark strokes.

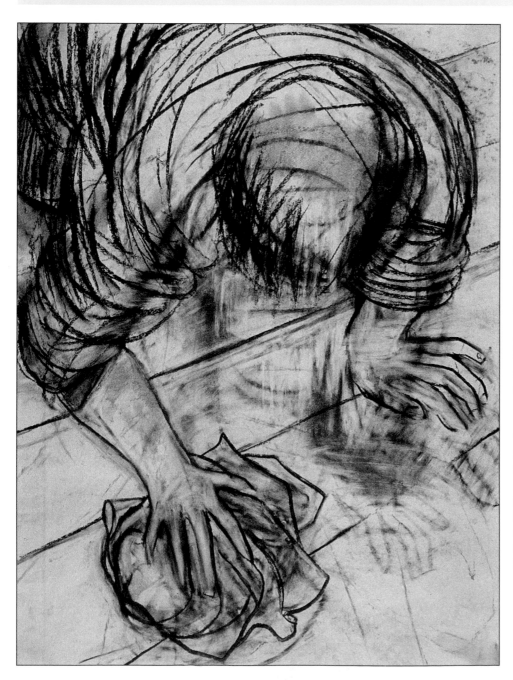

To begin, you need only the bare minimum of equipment—a few sticks of charcoal in different thicknesses, paper, and fixative (essential because charcoal smudges easily). Buy proper fixative from an art store or use ordinary hairspray to coat your finished drawing.

You will need fine sandpaper or a sharp utility knife to sharpen the point of a charcoal stick, and a kneaded-rubber eraser to create highlights and to correct errors. Fingers are ideal for the job of blending, but you can use a tortillon to avoid dirty hands. Paper tissues, cloth rags, and cotton swabs are inexpensive alternatives .

Wash your fingers after using them for blending—the dust can work into your skin and then you'll leave prints on the paper.

Experience will teach you the amount of pressure needed for the different grades of thick or thin sticks. Too much pressure on a thin stick causes it to break frequently, splattering charcoal crumbs across the paper.

◀ **Charcoal is ideal for life studies because it is so easy to erase and correct mistakes. You can also create a whole range of tones with it.**
This study was made with medium and thin sticks of willow (the artist finds thick sticks too bulky). Sweeping lines define the contours of the form, while smudges and blended tones give the figure bulk and create an entertaining picture surface.
Woman Cleaning by Sarah Cawkwell, 1987, 32 x 30 in. (81 x 76 cm.)

Alternative charcoals

Although willow and vine are the main types of charcoal available, there are several others that give you the chance to create many different tonal and linear values in your drawings.

Charcoal has been used as a drawing medium since Roman times, and probably before. It may be that the first artists discovered the potential of the medium by accident, when charred wood from a fire was used to sketch on stone in an idle after-dinner moment! But whatever the origins of the medium, it was not until many centuries later that the comparative virtues of different wood charcoals were recognized. One of the most commonly used and readily available is willow charcoal, but you can also purchase charcoal sticks and twigs in a variety of other wood types, sizes, grades, and shapes.

Square-cut sticks with pointed tips, for example, produce a relatively light tone and are excellent for drawing fine, sharp lines and detail. Beech twigs, however, make a darker, more velvety mark; and since each twig is unique in size and shape, the lines they produce are very varied. Chunky sticks of natural vine charcoal are often used for large-scale work. With their deep, rich tone, they are ideal for creating strong light-and-

shadow (chiaroscuro) effects; they can also be used to create black "grounds" out of which images can be erased, or "lifted out." Finally, charcoal powder provides you with perhaps the most direct form of drawing possible. Simply scatter some powder on paper and draw with your fingers, a cloth, an eraser, or some other blunt instrument. (Excess powder should be gently shaken or blown from the paper as the drawing progresses.)

You may not find some of these charcoals at general art suppliers. However, most stores should be able to order them for you or provide the names and addresses of specialist suppliers. Beech twig charcoals are available by mail order (see page 10).

Here is a representative range of non-willow charcoals that are available: (A) beech twigs; (B), (C) and (D) beech and poplar, square cut, with a pointed drawing end, in three grades: hard H, medium HB and soft B; (E) charcoal powder; (F) natural vine (thick and thin).

A

B

C

D

E

F

thick beech twig

thin beech twig

soft beech/poplar

medium beech/poplar

hard beech/poplar

natural vine

natural vine

▲ This drawing has the force, clarity, and directness of a woodcut print. Its power derives from the fact that a number of different charcoal methods have been used together. The blocklike background was drawn in with the side of a vine stick, while the swan was "carved" out of it with a kneaded-rubber eraser. Lines and details were stroked in with thick and thin beech twigs.

◄ The variety of charcoal marks is easily discernible here. To some extent, of course, the depth of charcoal tone will always depend upon the pressure applied to the stick and the number of coats applied, and on the surface of the paper itself. Nevertheless, this is a good guide to the tones that are possible from applying average pressure and one coat.

Beech twig charcoals

This type of charcoal is available from Luxor, an art material specialist, at this address:
Hameau de Coquin,
89140 Villethierry, France
(tel: 0033 3 86 66 53 87 or fax: 0033 3 86 66 12 25).

Blending with charcoal

The soft, powdery nature of charcoal is ideal for working with your finger or a tortillon to create a vast range of rich, velvety tones.

More than anything else, be it light, patterns, colors, or shadows, it is tone that gives your work the depth it needs to be convincing.

Charcoal is ideal for this. Drawn straight from the stick, the marks are grainy and highly textured. But rub them with your finger and you will find that they blend into a smooth layer that is perfect for subtle tones. Depending on the strength of your initial marks, you can create a variety of tones ranging from light to dark. You can reduce intensity by gently rubbing with a kneaded-rubber eraser, or increase it by simply repeating the blending process.

And that is not all. The bonus with using charcoal is that it is infinitely adjustable. If you do not want a mark you have made, dust it away. This leaves an appealing "ghost" image that also functions as a guide for laying down new marks.

If this technique is new to you, practice blending with your fingers and a tortillon before you begin to draw. You will need paper with a rough texture, or slight tooth, or the dry charcoal powder will not lie on the surface. Charcoal smudges easily, so spray your drawing with one or two light coats of fixative at the end to protect it.

▼ Rich, crumbly charcoal lends itself well to blending, giving you subtle, smooth tones that suggest solid, rounded forms.

Notice here the play of lights and darks that create depth inside and around the basket. Our artist has also used a range of tones to suggest various textures—the metal trowel and fork, the terra-cotta pots, the thick cloth gloves, and the wooden handles.

Blending techniques

Lightly build up an even area of scribbled marks with a charcoal stick. Use a tortillon (top) or your fingertip (above) and lightly rub the scribbled marks so that they blend together. The fine point of a tortillon gives you more control in intricate areas.

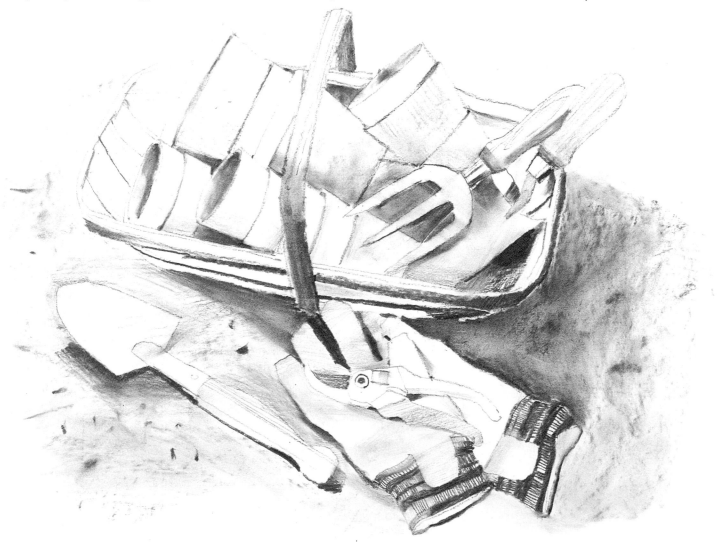

Overcoat on a hook

▶ **The setup** The flowing lines, soft textures, and range of deep tones on this overcoat contrast dramatically with the pale, solid, angular door—an excellent combination for a charcoal drawing. Our artist liked the idea that, although the coat did not hang so its left and right sides were identical, there was still a simple symmetry about the setup.

1 Look hard at your setup. Decisions made early on will help make your lines loose and free when you begin to draw.

Consider proportions. The distance from the top of the coat to the bottom of the scarf is roughly four times the width of the hood at its widest part. Similarly, the length from the bottom of the hood to the third button down is much the same as from the button to the bottom of the scarf. Look at all the angles in the folds of the coat and relate them to each other.

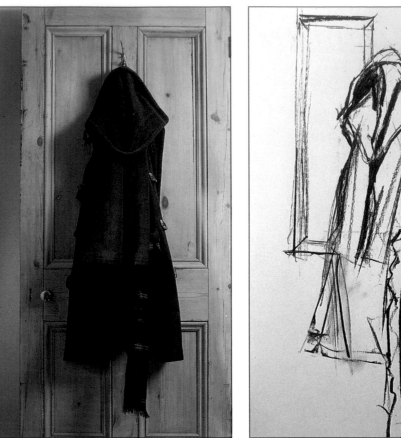

YOU WILL NEED

- ☐ *Several thin willow charcoal sticks, and one thick stick*
- ☐ *Sheet of 18- x 24-in. drawing paper*
- ☐ *Drawing board and pins or masking tape*
- ☐ *Tortillon*
- ☐ *Easel*

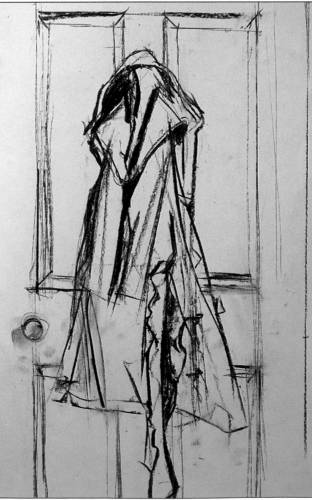

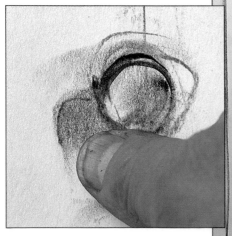

▲ **2** Using a thin stick of charcoal, loosely draw the coat and scarf. Once you have established these you can relate the door to them. Keep your marks fairly light, but do not be afraid to make bold defining lines. Drag the side of the stick down the paper, following the outline of the coat, then do the same with the rhythms of the folds.

For the scarf, hood, and collar, use the tip of your stick. Try to catch the layers of the scarf.

Draw the top two door panels. They are based on straight horizontal and vertical lines and 90 degree angles.

◀ **3** Draw the two bottom panels, the doorknob, and the door edges. Then start blending, beginning with the doorknob (see inset). Lightly scribble a few marks, then blend them by rubbing gently with your thumb. Remember to leave some white paper free for the highlights. Do the same for the shadow. Make a small mark to indicate the edge of the shadow, then use your thumb to draw it in with the charcoal dust, keeping roughly to this mark.

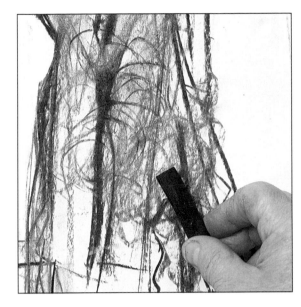

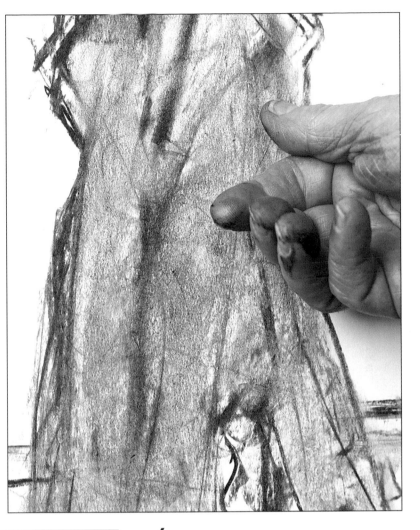

▲ **4** Now you need to lay down a general tone on the coat—you can work into this later. Using the side of your thick charcoal stick, make light scribbles all over the coat, leaving the scarf for later. Try not to create dark spots of charcoal in any one area, aiming instead for an even covering.

▶ **5** Blend the scribble marks with the flat of your knuckle to create a smooth, even tone. This represents the color of the coat, which contrasts with the lighter tones of the door and scarf. You will bring out the various tones within this "color" later.

 Do not be afraid to lose the lines of your underdrawing. Remember, you put them there in the first place, so you can put them back again.

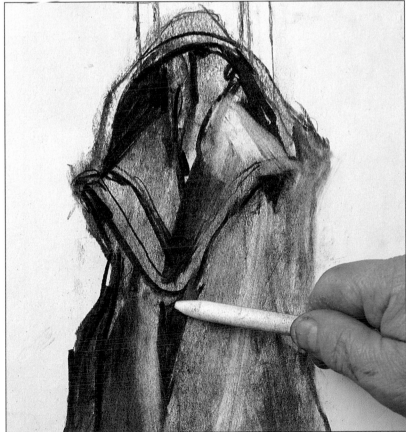

◀ **6** Using a small charcoal stick and the blending technique (see page 11), bring out areas of depth around the collar and hood. Light shining from the right makes the left-side tones darker.

 Draw in the collar edge and lines of stitching on the hood, then put in the dark fold between the sleeves. For deeper tones, make darker scribbles before you blend. Use a tortillon for blending up to the edges. The sleeves are brought out by the darker tone next to them.

▼ **7** Now work down to the bottom of the coat's left side in the same way. Half-close your eyes and let them travel along the peaks and valleys of the folds to pick out deep tones. Bring out the folds by drawing bold lines along their edges. Use a thin stick for small areas, and the thick stick for larger expanses.

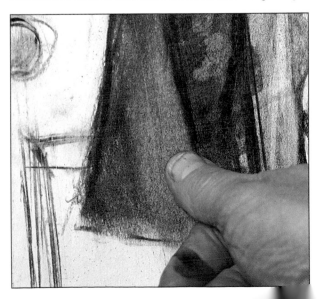

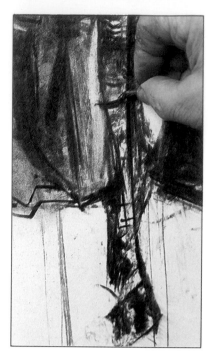

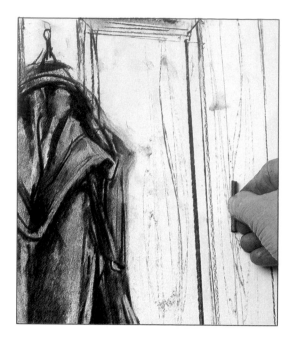

8 Now work into the right side of the coat. Once you have blended an area of tone, put in descriptive lines on top where needed—for the edge of the cuffs and sleeves, for example.

Use a small stick to draw lines that loosely indicate the scarf's plaid pattern. Draw the bottom edge of the coat to neaten it up, then add any finishing touches around the coat, such as the buttons, coat tag, and door hook.

9 Put in the shadow cast by the coat and scarf on the door. Draw faint lines to indicate its edges, then blend a light tone for the shadow.

Straighten the lines of the door panels. Show the door's grain by lightly dragging and twisting the side of a thin charcoal stick down the page. Our artist used his wooden drawing board to taking a faint rubbing (frottage) of its grain.

Tip

Straighten up!

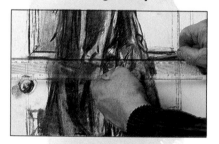

Drawing straight lines can be very difficult. On a subject that demands them, such as this door, you might find it easier to use a ruler or any other straightedge. Accuracy at this point can make all the difference to your drawing.

10 The finished drawing shows how the blended charcoal marks work together to create a sense of depth, bringing out the folds of the coat. The "mountain range" of these folds creates a dynamic feeling that contrasts with the static, solid quality of the wooden door. The plaid scarf adds a casual touch to this portrayal of a simple subject.

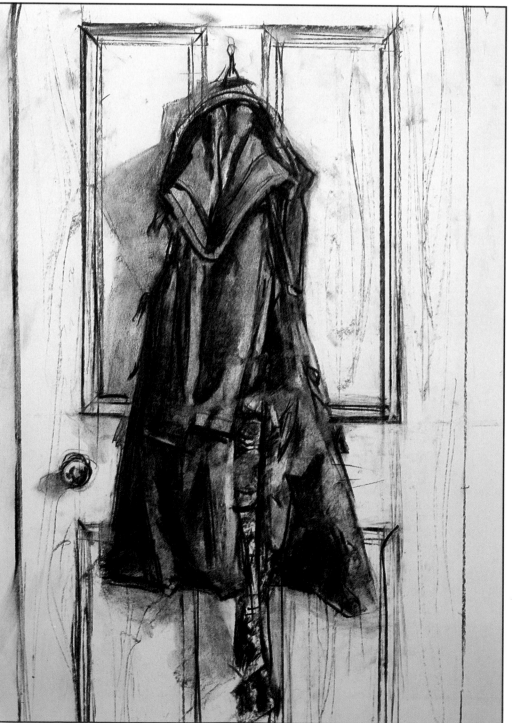

Lifting off charcoal marks

Creating highlights and light tones is easily done with charcoal drawings. Just lift off the charcoal marks with a kneaded-rubber eraser—or bread!

Charcoal is an excellent medium for beginners—it forces you to work boldly and strongly without worrying about minor details. Lifting off your marks is a useful technique, because the effects gained by carefully erasing or softening lines and tones are unobtainable any other way.

You simply use a kneaded-rubber eraser or a little piece of soft, white bread, either to subdue the charcoal or rub it off altogether, to create light tones and highlights. By lifting off your marks in this way, you are actually drawing in the negative. The paper you reveal is as important to the final picture as the charcoal marks themselves.

▼ Here, note that the subtle, light tones under the bridge have been created by lifting off some of the charcoal with bread. The fuzzy reflections on the water have been made in the same way.

Practice makes perfect

Practice using your kneaded-rubber eraser before starting your picture. Block in a solid area of tone with the side of your charcoal stick and draw into it with the kneaded-rubber eraser (**1**). Or pull a piece of bread from the middle of an unsliced loaf (**2** and **3**) and use it in the same way—it's just as efficient at creating subtle tones, especially over large areas.

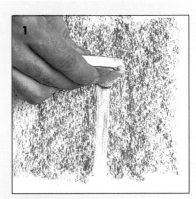

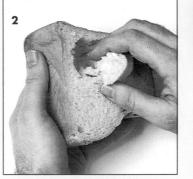

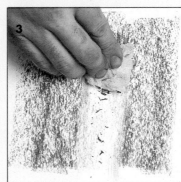

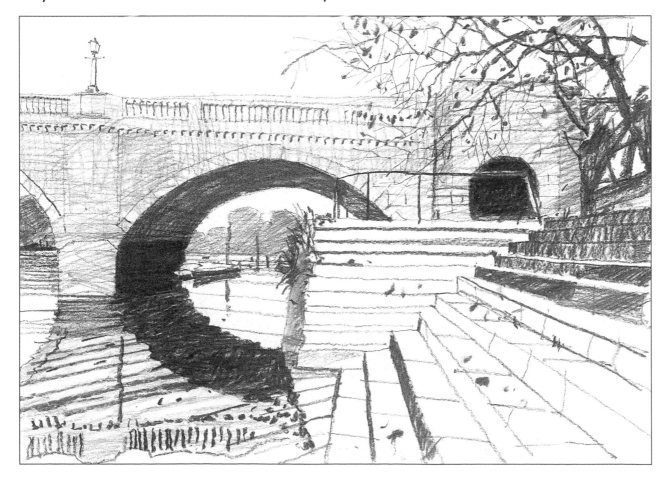

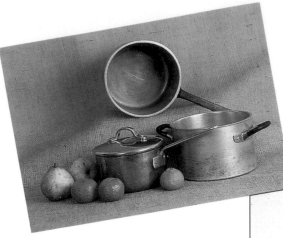

Simple still life

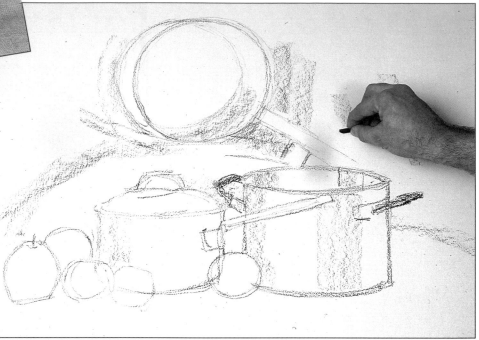

▲ **The setup** Copper and aluminum pots provide strong shapes and a full range of tones, and the bright highlights on their reflective surfaces offer the opportunity to lift off charcoal from the paper's surface. The irregular ellipses and organic textures of the fruit contrast well with the smooth, shiny pans. They also reflect attractively in the metal.

Our artist used a sheet of watercolor paper for this drawing. Note that the textured marks this produces are a little harder to remove than those made on smoother paper, because charcoal dust tends to sink into the lines and crevices of the paper's surface. As always, experiment to find the paper that you like best.

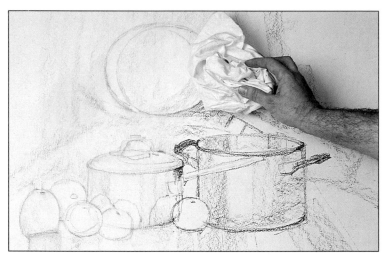

▲ **1** Lightly sketch the outlines of the composition with the point of a thin stick of charcoal. Do not make this drawing too small and tight— let it fill the whole page. Look at the negative spaces between the objects to help you get both shape and position right. Keep adjusting the lines until you are completely satisfied with the drawing.

Now use the flat of the stick to suggest the main tonal values of the pots and fruit as well as the planes in the burlap backdrop. Indicate the shapes and positions of the shadows and reflections too.

◄ **2** Using a large, clean, soft rag, lightly flick over the surface of the paper from a distance. This leaves behind a faint "ghost" image in charcoal that acts as a firm found-ation to guide you through the rest of the drawing.

It is easy at this stage to redraw any of the elements. If you do, make sure that you flick over the picture again before continuing.

▶ **3** Now begin to darken tones all over the drawing. Use the flat side of your small stick of charcoal to make broad strokes to shade in large areas, such as the outside of the pans and the burlap. The tip of the stick is good for hard edges and details. Use a worn-down tip to scribble in the reflections of the fruit on the small foreground pot and the shadows and dark handles on the larger pots.

Do not darken the tones all at once, but build them up slowly, trying to keep the whole picture at roughly the same stage all over.

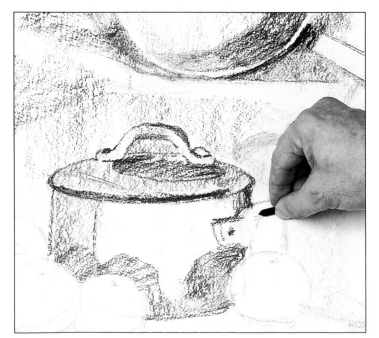

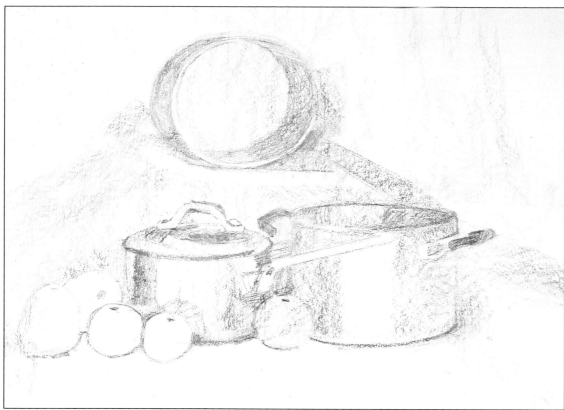

◀ **4** Continue working in the same way, slowly building up and darkening the tones all around your drawing. Give more detail to the pears and tangerines in the foreground, indicating the tones and emphasizing the misshapen spheres and the different angles at which they sit. If you find your tones getting too dark, use your soft cloth to lighten them.

▼ **5** Use a corner of your kneaded-rubber eraser to "draw" the highlight on the rim of the top pot. Do not rub with the eraser, as this pushes the charcoal dust into the paper grain. Instead, use smooth strokes to lift the marks.
 Now start to lighten the tones in the backdrop to the right of the top pot with the flat edge of your kneaded-rubber eraser. Cut off the clogged, unusable parts of the eraser with a utility knife.

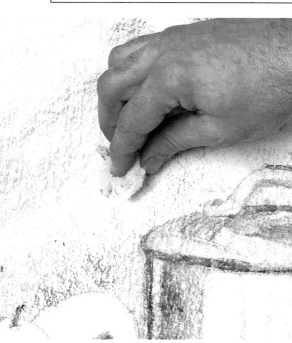

◀ **6** Work across the backdrop, lightening areas to vary the tones. Use some bread for this because it picks up marks over large areas better than an eraser. Break the loaf open and pull out some of the soft center. Use this to soften the tones on the left of the top pot, then move on to other background areas that need to be lightened. Notice how visible the tooth of the paper becomes once you have lifted off the charcoal.
 (When using bread, keep your board at an angle so the dirty crumbs fall to the floor.)

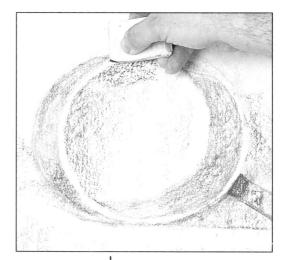

▶ **7** Still using the bread, lift out the highlights on the pots. Work over the whole of the picture, both putting on and lifting off marks where necessary. Aim for an overall harmony and simplicity. Do not finish one area at a time, but work on the whole picture to bring it together. Use your finger to blend any charcoal marks that look too harsh.

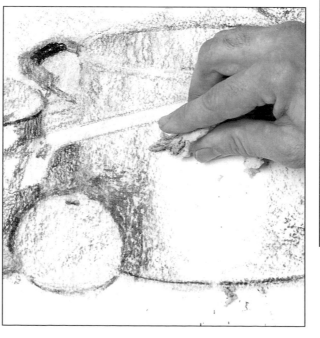

DID YOU KNOW?

Closing up
The items in this still life have been carefully arranged to lead the eye around the composition, from one thing to another, without being drawn out of the picture area. This type of setup is known as a closed composition.

► **8** Using your thick piece of charcoal, begin working on the darkest tones. Deepen the dark saucepan handles and draw fine lines for hard and distinct edges—around the rim of the bottom right pot, and the edges of the fruit. As the edge of the charcoal becomes blunt, turn it slightly to find a sharper edge.

Work across the picture, tidying up tones by darkening or lifting off charcoal as you go. Smudge the marks on the fruit to give them soft tones to suggest their irregular, rounded shapes. Darken the shadow of the top pot by scribbling the charcoal marks on, then blending softly. Use a little piece of bread to lift off charcoal to adjust the folds of the backdrop.

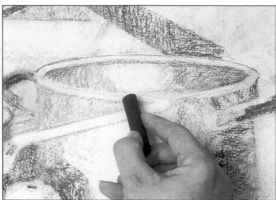

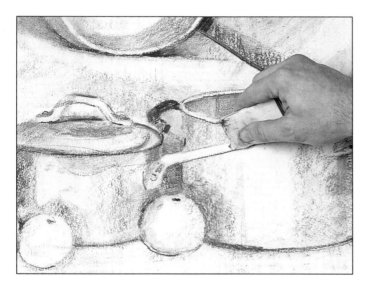

◄ **9** Continue working in the same way until all the objects look solid and three-dimensional. Now turn your attention to details, using your kneaded-rubber eraser and a thin stick of charcoal to lift off or add the finishing touches. Our artist decided to lift out the highlight on the handle of the small pot and define the fine dark lines between the objects.

When you have finished, spray the drawing with a coat of fixative so the charcoal does not smudge.

▼ **10** By slowly building the tones all around the drawing, the artist has created a feeling of depth and solidity. The irregular light tones in the backcloth, and the sharp highlights on the pots add a realistic touch, helping to make a success of this portrayal of a simple still life.

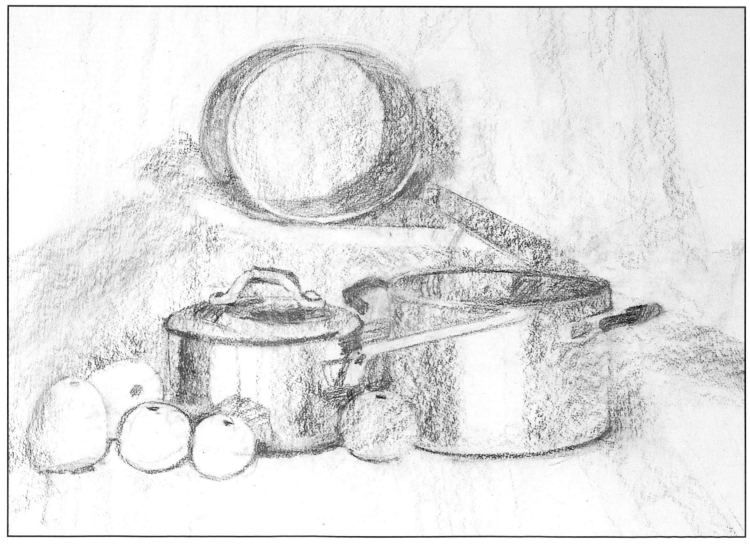

The appeal of graphite pencils

Graphite pencils are the most familiar drawing tools of all. Perhaps that is why we do not always value them as the amazing tools that they are.

Most of us learn to handle pencils as children, and then promptly forget their usefulness and flexibility. This is a shame considering the vast range available— from pencils so hard that they produce the palest of gray lines, to soft pencils that are perfect for dark, velvety shading.

But it is not only the hardness or softness of the pencil that you use that affects the kind of drawing that you produce. There is also the sharpness of the tip to think about, and whether it is rounded or chiseled. Add to that the amount of pressure that you exert on the pencil—and the surface of the paper itself—and you are nearly there. All except for the little matter of the *way* you apply the pencil, of course!

Pencil lines can be soft and sinuous, vigorous and bold, or controlled and crisp. Your drawings might be subtle and detailed, with carefully graded tones, or energetic works in which the expressive, flowing lines are important.

Softest to hardest
Artists' pencils come in 20 grades, ranging from the softest (8B) to the hardest (10H), with grades F and HB being in the middle.

As a rule of thumb, hard pencils (H to 10H) are best for very fine lines because they can be sharpened to the finest of

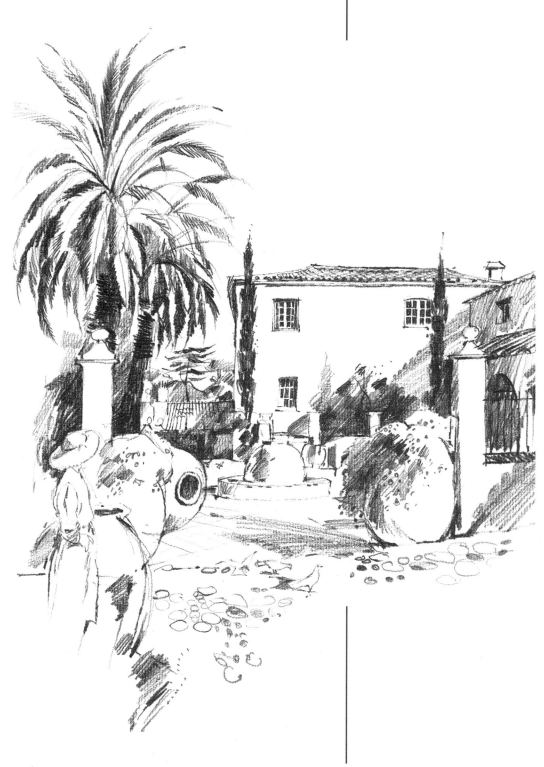

► **With its range of descriptive marks, this sketch is pencil drawing at its most expressive.**
Trasierra, Near Seville *by Albany Wiseman, pencil sketch, 12 x 8 in. (30.5 x 20 cm.)*

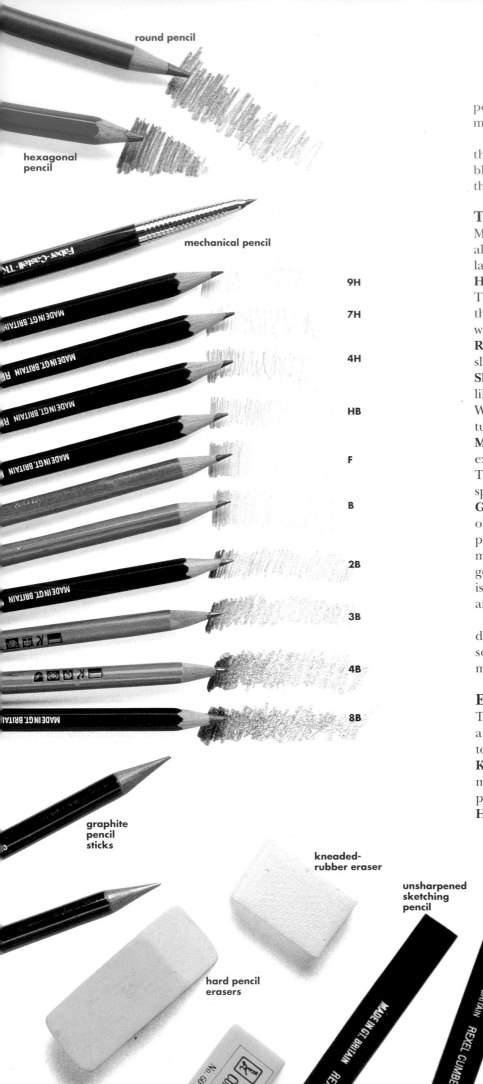

round pencil

hexagonal
pencil

mechanical pencil

9H

7H

4H

HB

F

B

2B

3B

4B

8B

graphite
pencil
sticks

kneaded-
rubber eraser

unsharpened
sketching
pencil

sharpened
sketching
pencil

hard pencil
erasers

graphite
sticks

points. They also keep this point for a long time, which means they are good for lines of a constant thickness.

Soft pencils (B to 8B) are in many ways more flexible than hard pencils because they have a tip that quickly blunts. When sharp, they make a fluid line of thicks and thins. When blunt, their marks become broad and dark.

Types of pencil

Most pencils are available in a standard 7-inch length, although the shape of the shaft may vary. Which you use largely depends on your own personal preference.

Hexagonal pencils are the most common drawing tools. They give you a firm grip, even when you are shading with the flattened side of the tip (a round pencil used like this would roll in your hand).

Round graphite pencils have great flexibility because the slightest turn gives you access to another side of the tip.

Sketching pencils (sometimes called studio pencils) are like traditional carpenters' pencils—rectangular in shape. With these you can produce a line of varying width just by turning the pencil slightly.

Mechanical pencils are lmade so that the lead can be extended by releasing a clutch lock or by clicking the end. They come in the complete 8B to 10H range, but need a special sharpener, or can be sharpened on sandpaper.

Graphite sticks are available in two forms—square sticks of pure graphite and rounded, thick "pencils" with a protective outer coating that stops you getting your hands messy. With a range that runs from HB to 9B, they are good for techniques such as smudging and blending. This is particularly true of the uncoated kind of stick, the sides and flat end of which are excellent for shading.

You will also find that pencils are available with different sized leads. Most are $\frac{1}{16}$ inch in diameter, but some have cores as thick as $\frac{3}{16}$ inch—invaluable for making bold, thick lines.

Erasers

These familiar items are useful for rubbing out mistakes, and are just as handy for creating highlights in areas of tone. There are two different types.

Kneaded-rubber erasers are used to erase soft pencil marks. They are kneadable so they can be worked to a fine point to rub out precise details.

Hard pencil erasers work best on hard pencil marks.

One pencil does it all!

Drawing textures is a challenge for any artist, and here is a still life that abounds with them. There is the basket itself, with its mass of weaves and plaits. Then there are the intricately grained logs and bark. To capture all of these, you need just one pencil and six kinds of marks.

YOU WILL NEED

☐ *A 18- x 24-in. sheet of good-quality heavy drawing paper*

☐ *4B pencil*

☐ *Kneaded-rubber eraser*

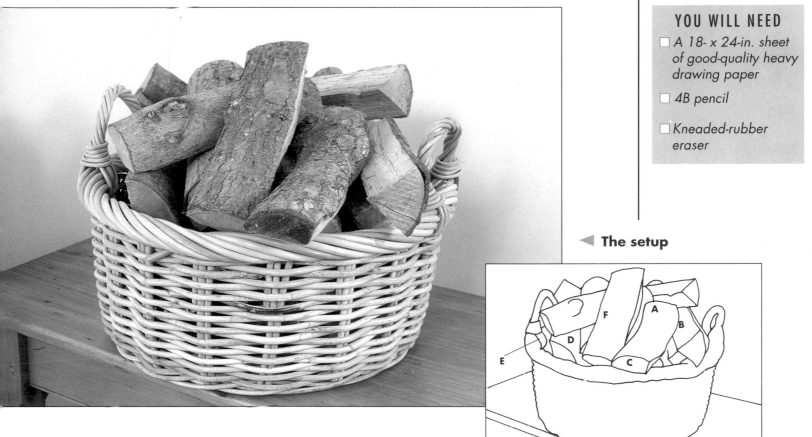

◀ **The setup**

The half dozen marks you need

Practice these six marks and you will have all you need for the *Fireside Basket*. Do not devote too much time to each one, though, or you will lose spontaneity. Do them quickly, using a 4B pencil and a sheet of heavy drawing paper.

◀ **A** Hold the pencil as you would to write. Now draw short lines close together. Adjust the pressure to give three weights, and vary the direction. Use this *hatching* technique to illustrate bark.

◀ **B** Hold the pencil fairly lightly and draw a series of long tremulous lines. These represent the wood grain.

◀ **C** Work the side of the pencil tip to a flat edge, then lightly shade with it—let the texture of the paper show through. This represents the grain of the wood at the end of some of the logs.

◀ **D** Blunt the tip of the pencil, then make crisp black lines with it, exerting lots of pressure. This useful line adds definition.

◀ **E** Hold the pencil as in **A**, press hard, and scribble. Do this in several directions and in several layers to build up good dark tones for the shadows.

◀ **F** As you hold the pencil on the paper, roll it in your hand. Then, by varying the pressure, you will produce squiggly thick and thin lines, perfect for the bark on some of the logs.

Warming up

Now you have practiced the basic pencil marks, continue as the artist did—with some warm-up sketches (there is no particular order to them).

As you are doing them, you will have the chance to study the make up of the still life, which will prove invaluable when you come to draw the picture for real. You can also work out the best angle to draw from.

For the best results, keep your pencil fairly blunt most of the time. You will still have to sharpen it first, though. Once you have done this, rub it back and forth on a scrap of paper or sandpaper to blunt the end slightly.

◄ You can either set up your own still-life log basket or work from the photograph on the previous page. If you are arranging your own, start by positioning yourself comfortably a few feet or so from it. Make sure that the setup is well lit and that you can see it properly. Also make certain that you have plenty of light to draw in.

Work into a pad of cartridge paper or on to a single sheet attached to a drawing board with pins or tape.

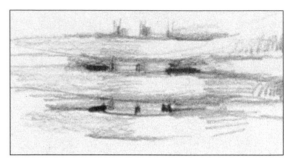

▲ One of the most prominent and fiddly features of the setup is the wickerwork weave of the basket, so it makes good sense to sketch it beforehand. Start by loosely indicating the verticals, then draw in the horizontal canes.

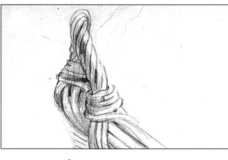

▲ With its loops, curls, and plaits, the handle of the basket is another excellent drawing to make in its own right.

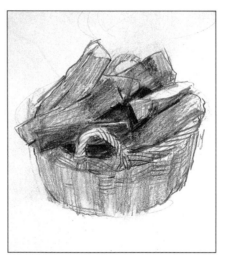

◄ This preliminary viewpoint of the setup proved rather an awkward one, so when it came to drawing the picture properly, the artist decided to draw from a different angle.

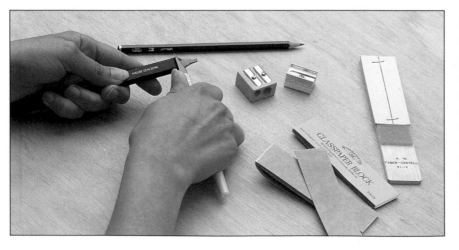

Sharpening your pencil

When it comes to sharpening your pencils, penknives, craft knives, and scalpels have the edge over pencil sharpeners, whatever their design. Using a blade, you can cut away more of the wood to expose more lead, which means you do not have to attend to the tip as often. You also have more control over the shape of the tip, making it fine, chiseled, blunt, or rounded, exactly as you wish. Rubbing the sharpened tip on a sheet of sandpaper makes it finer—or blunt, as you choose.

Fireside basket of logs

Once you have practiced the pencil marks and have completed some warm-up sketches, you are ready to start the actual drawing.

Equip yourself with a big piece of paper—it is good to work on a large scale. This does not mean that you have to put in lots of detail. Instead, get into the habit of standing back from your drawing to assess it from a distance. Above all, resist the temptation to overwork your drawing.

Make your marks quite light to start. As with watercolor paint, work from light to dark. There is plenty of time to make things heavier as you go along, and the actual layering of darker marks over lighter ones helps you build up interesting texture. With the 4B pencil and a textured paper, drawing the shading is easy, so do not press too hard or you will make an indent that no amount of erasing will remove!

1 Fix the paper to the drawing board with pins or masking tape. Sharpen your pencil, then rub it back and forth on a scrap of paper to blunt the tip slightly (here, you will achieve the best results by keeping your pencil blunt most of the time).

◀ **2** Then, working freely from your elbow, roughly and lightly draw in the outline of the whole image, making sure your composition fits neatly on the page. Do not worry about fine detail at this stage.

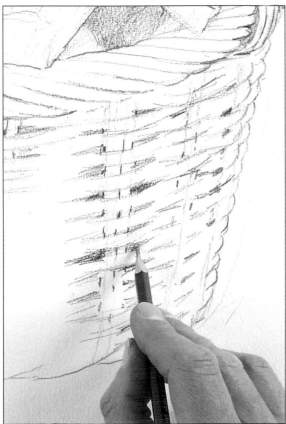

◀ **3** Draw in the twisted rim of the basket. Now start drawing the wicker on the right side of the basket. This is actually quite a complicated design, so you need to simplify it. Look closely at the basket for its broad forms. Loosely indicate some verticals, then start to establish the horizontal canes. Do not get too caught up in working on one small section—try to keep the whole thing going at once.

Do not worry either about putting in every detail—in this version not all the shadows are there, for example, but the eye is deceived into thinking they are.

▶ **4** With one side drawn in, turn your attention to the tones on the logs. Define the darker edges by laying in some crisp black marks—make these with a pointed pencil lead. Shade in the shadows, but do not make them too dark yet—the texture of the paper adds to this here and there. Draw a series of lines for the grain of the wood. Roughly describe the bark with patches of scribble running in different directions.

YOU WILL NEED

- ☐ A 18- x 24-in. sheet of good-quality drawing paper
- ☐ 4B pencil
- ☐ Kneaded-rubber eraser
- ☐ Spray fixative

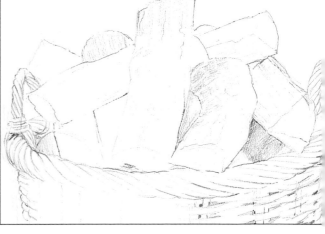

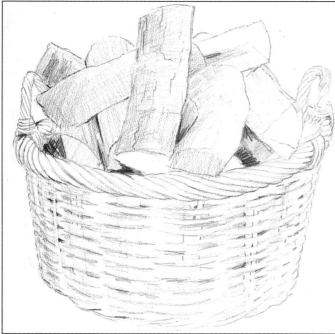

▲ 5 Draw in the other side of the basket. As before, put in the verticals first, then draw in the horizontal wicker in the panels, using lighter and heavier lines to indicate the different tones and shadows.

◀ 6 Now sort out the tones of the whole picture. Darken some of the shadows, for example. It may help you to see where these are if you stand back from the drawing and look at it with half-closed eyes.

▼ 7 Hold the pencil loosely and lay in some more scribbles for the bark. Work over it in little clusters to capture the slightly varying surfaces. Create some vertical shadows on the basket by smudging the pencil lines downward with your finger.

After you put in the final touches, spray the drawing with fixative, following the manufacturer's instructions.

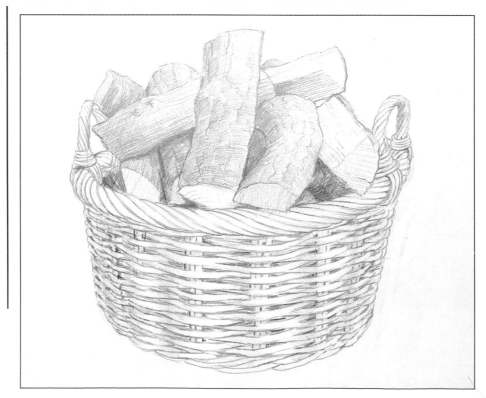

Five systems of shading

Pencils are capable of making a great variety of marks, although we seldom use them fully. Here we look at five easy systems of creating texture and tone with pencil shading.

Coming to grips with different methods of shading is well worth the effort. You will probably find these five systems soothing and absorbing to do, and it will improve your pencil control and technique.

You will need a good supply of paper, a range of pencils, a firm working surface, and about half an hour of uninterrupted time. Explore each system in turn and aim to create an area of even tone. First attempts may be disappointing, but you will soon discover the grip, gesture, and rhythm that give you most control.

When you are satisfied that you have these systems under your belt, experiment with making the same marks on different papers and with different pencils. Textures rendered on smooth paper are crisp and even, while on rough paper the recesses in the paper's surface interrupt the line, creating a softer, more velvety look.

It is a good idea to spend time getting to know your materials and practicing techniques. This is an important process that has great benefits. The more confident and competent you become, the more freely you can work.

▼ Here, a variety of shading techniques create form and tone. Softly scribbled hatching gives the tree trunks form, while regular hatching represents the veining on the palm fronds and also captures the lights and darks within the canopy.

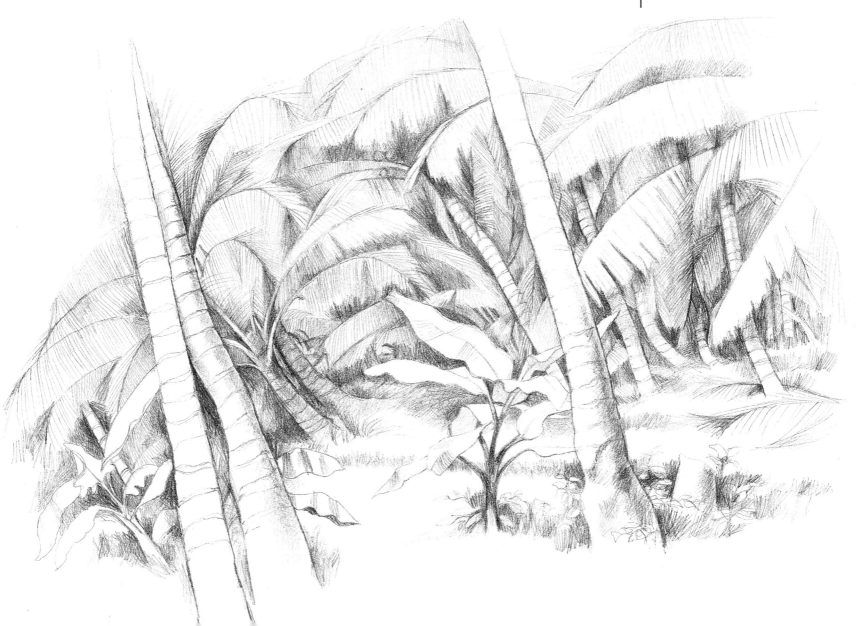

Four ways of shading

Below are four of the five different systems of shading. (There is one more on page 28.) To try them for yourself, all you need are four pencils—a 2H, a 4B, an HB, and a 2B. You also need a sheet of white, medium-weight drawing paper. With this good, all-round, serviceable surface you can exploit the full range of pencil marks, from black to mid gray to light gray.

As you draw, keep in mind that you are not trying to create a finished picture—the idea is to expand your repertoire of marks and practice your skill at using them.

(There is one more on page 28.)

Tip

Sharp and blunt

As well as changing pencils to create different shading effects, try using the same pencil, first sharpened, then blunt the tip. Softer pencils in particular are very flexible. A 2B, for example, can be sharpened with a utility knife to a very fine point, and then used to create dark, crisp lines or hatched marks. Blunt the same pencil on a piece of sandpaper and you can draw dark, wide lines or broad, soft lines depending on how much pressure you apply.

▲ **Random hatching with an HB pencil**
For slightly random hatching like this you need to let the pencil "dance" every which way. Hold it firmly, but not rigidly, close to the drawing point. Change direction constantly, pivoting from the wrist.

Your aim is a fairly consistent middle-tone gray that has quite a lively feel to it (unlike the regular mechanical cross-hatching system covered on page 28).

▲ **Dots with a 2H and 2B pencil**
Hold the pencil firmly and, resting your wrist on the drawing surface, tap the paper with the pencil in a rhythmic way.

You can create variation of tone in three ways. The first is by using different pencils; with the harder one you produce a range from mid gray to light gray (done at the top), while with the softer one the dots go from almost black to mid gray (done at the bottom). Second, there is the question of how much pressure you exert on the pencil tip. Third, you can make darker tones by increasing the density of dots, and lighter tones by sparsely spreading them.

▲ **Tight scribble with a 4B pencil**
Here you need a broad gesture, so grip the pencil farther up the shaft and hold your hand off the paper surface—if you need support let your knuckles skim the paper. Feather the pencil over the broad lighter tones, and then thicken it up in the center.

The resulting variation in tone is perfect for describing spheres. Notice how the scribble runs with the direction of the right-handed shader.

▲ **Curved hatching with an HB pencil**
This classical technique is somewhat like the hatching shown above left, but it is more controlled. Rest your hand on the paper as you work. Your lines should follow the natural three-dimensional curves of the subject—like the contours on a map. You still have to keep an eye on the variations in tone so you will go from dark to mid tone to light.

The four shading systems put to work

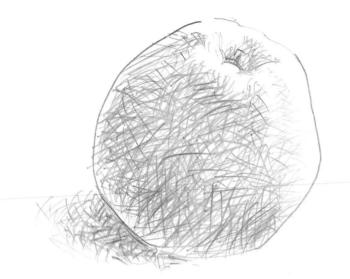

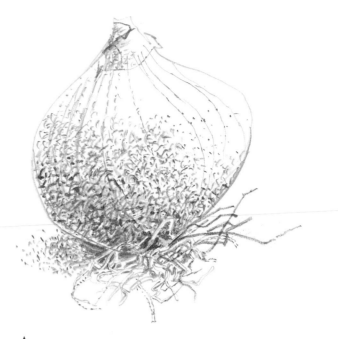

▲ Apple randomly hatched

This apple is a good subject for random hatching—it is backlit so the side facing you is made up of varying degrees of dark—all except for the "halo" of light around the edges. A simple, flat tone for this would have been very boring—the hatching breathes some life into it and adds sparkle. Notice how the darkest "stress" is applied where the apple is just turning under to meet the surface it is sitting on.

▲ Onion stippled with dots

Here, the dots have been used to describe the dark to mid tones, while the light tones are left to the white of the paper. Squint at the image to see how the density of dots provides the shading. The artist could not resist adding the vertical contour lines that run around the form of the onion. But look closely and you can see that even these make use of dots, so the line is grayer and lighter for being broken up.

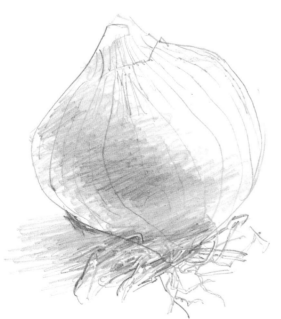

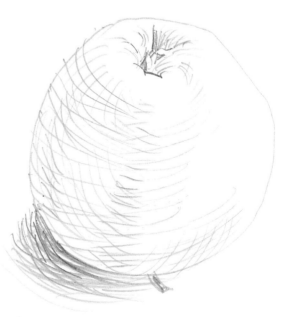

▲ Onion tightly scribbled

This image employs the direction of the light on one side and tone on the other, with help in describing the form from a small amount of reflected light on the bottom left. Good firm shadow gives the impression of a round form underneath. The tones are helped here and there by the use of delicately drawn contour lines within the form of the onion.

▲ Apple using curved hatching

The cross-hatching here is put to use in two ways. The variations in the tones describe the form, while the lines themselves are almost like a network of invented contour lines.

Regular cross-hatching

Another shading system is created with more rigid lines, criss-crossing at right angles. You can draw the lines in two directions, or—as here—in three, then four. The looser versions (with two and three directions) are the most versatile.

With softer pencils, the lines almost begin to break down and fill in (see below). To achieve the perfect regularity of cross-hatched lines, be prepared to practice. The gradations in tone needed to describe form are tricky to get. Smudging the lines with

your finger is one technique that is well worth trying.

Regular cross-hatching like this is at its most successful when used to fill in large areas of background. It is also good for giving the feel of an old engraving.

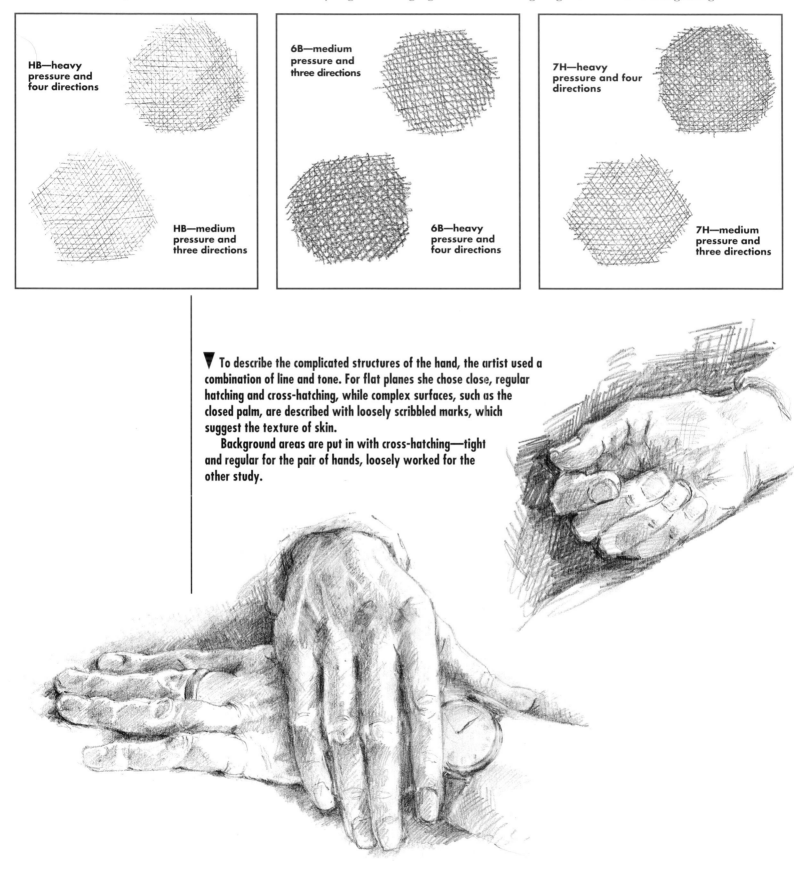

HB—heavy pressure and four directions

HB—medium pressure and three directions

6B—medium pressure and three directions

6B—heavy pressure and four directions

7H—heavy pressure and four directions

7H—medium pressure and three directions

▼ To describe the complicated structures of the hand, the artist used a combination of line and tone. For flat planes she chose close, regular hatching and cross-hatching, while complex surfaces, such as the closed palm, are described with loosely scribbled marks, which suggest the texture of skin.

Background areas are put in with cross-hatching—tight and regular for the pair of hands, loosely worked for the other study.

Using graphite sticks

If you like drawing on a large scale, try graphite sticks. Their robust nature and soft, dark lines are a joy to use.

In character, graphite sticks are like conventional pencils, but you will find that they are heavier and much thicker than a pencil. This is because they are made of compressed graphite. They make broader, bolder marks than pencils—perfect for large-scale work and drawing with the whole arm.

For exploratory work and sketches, graphite sticks are ideal. Although they can make delicate marks, you cannot get too fine a line with them, so they encourage you to concentrate on the overall look of your drawing, steering you away from too much detail. If your drawings are becoming too tight, this is the ideal medium to loosen you up.

Graphite sticks come in a range from hard to soft and in two different types—pencils and square sticks. The pencils are long and coated with lacquer, wood, or thin plastic. They make fine lines as well as broader shaded areas. The square sticks are short and chunky—you are drawing with something very solid in the hand, but still capable of delicate work. They allow for broader sweeps and fill in large expanses quickly; and you get bold, crunchy lines and rich, dark tones. Together, thick pencils and sticks provide you with a wide range of possibilities.

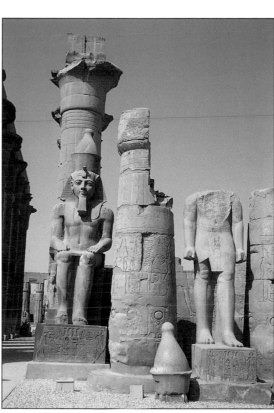

▲ **The setup** Our artist worked from this photo of ancient statues at Luxor in Egypt. He liked the strong, dramatic shadows and the varying heights of the columns, which made for an interesting skyline. Remember you do not have to copy every detail of a photograph. What you put in or leave out is up to you.

Some marks with graphite sticks

▲ With the end of a square stick, draw a line with one of the side angles. This sharp line contrasts effectively against softer, shaded areas.

▲ Using the side of the edge, draw the square stick toward you. Build up these soft lines side by side to make structured blocks of shading.

▲ Turn your square stick on its side and draw it down the paper toward you. You can work over this varied tone with some line work.

▲ Grip the stick firmly toward the top. With the point, make fine scribbly marks. Use light pressure and let the stick trace lightly over the paper.

▲ These dark, parallel marks make very strong, bold areas of shading. Hold the stick close to the point and apply heavy pressure.

▲ With your thumb and forefinger, hold your square pencil by its tip and drag it across the paper to create broader bands of shading.

▲ Using the point of the edge of the square stick, pull it toward you, twisting it occasionally to make interesting variations in the line.

YOU WILL NEED

- ☐ A 24- x 36-in. sheet of drawing paper
- ☐ Drawing board
- ☐ An HB pencil
- ☐ An HB graphite pencil stick
- ☐ Two square graphite sticks: a fairly hard 2B and a very soft 9B

▲ **1** Use an HB pencil to sketch lightly the outlines of the main elements. With your HB graphite pencil stick, draw the statue. Concentrate on the face. The light shines from above left, so the shadows fall to the right. Make them angular to give the face the look of stone, not flesh.

▶ **2** Continue drawing the statue and the column behind it. To make the lines angular, pause for a second whenever the line changes direction. Leave the stick on the paper and use a slight increase in pressure, sometimes making no more than a dot, before you check the new direction of the line. These small accents add interest to the drawing.

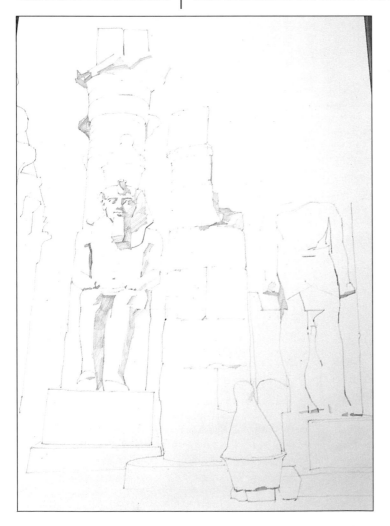

▲ **3** Still using your HB graphite pencil stick, put in the shadows on the face and on the body of the statue. Use a series of parallel strokes, changing the angle for different areas of shadow to indicate form. Keep the tones quite light at this stage—you can work up darker shadows later.

◀ **4** Now that the main statue and the first stages of shading are done, draw in the other elements of the composition. It is important to give yourself an idea of the whole picture so that you can retain a sense of balance.

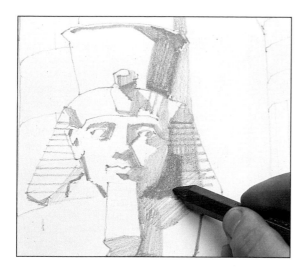

5 With your square 2B graphite stick, strengthen some of the darker shadows on the statue that are hidden from sunlight. Use the tip of the stick to put in the lines on the statue's headdress.

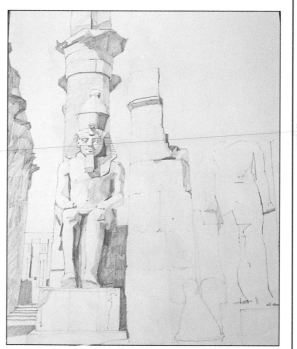

6 Concentrate on areas of shadow around the drawing. Do not overwork them—you can add richer, darker tones later.

Loosely block in the columns on the left as one large solid mass. Using the stick to make scribbly marks, put in the columns' shadows on the ground, too. Keep this area simple—too much detail detracts from the main statue.

Make sure the ellipses on the columns appear to go all the way around rather than just stopping at the edge. Use thick and thin lines between the blocks. Use the side of the tip of your 2B graphite stick for the bottom of the main column, behind the statue's legs.

Tip

Handling graphite

Graphite tends to smudge easily, so as much as possible keep your drawing hand off your work. In the early stages you might find it helpful to work from left to right, as our artist did here (or the other way around if you are left handed). This keeps your hand from smudging what you have already drawn. If your hand does start to pick up graphite, you should immediately wash it. You can use a utility knife to sharpen your square graphite sticks. Pencil sticks can be sharpened using either a utility knife or a pencil sharpener.

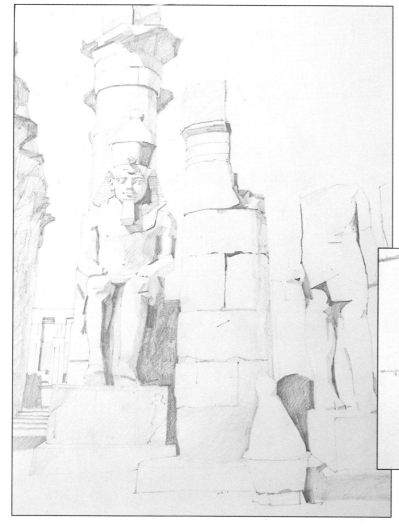

7 Put in the shadow on the middle column with just a few sweeps of the broad edge of the graphite stick (see inset). Strengthen the lines of the stone blocks with varying pressure to indicate the deeper cracks and shadows in the stones.

Deepen the shadow behind the statue's legs with parallel marks, using more pressure on your stick. Work all over in this way, putting in some shadows and strengthening others.

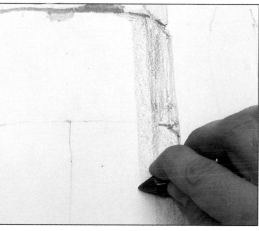

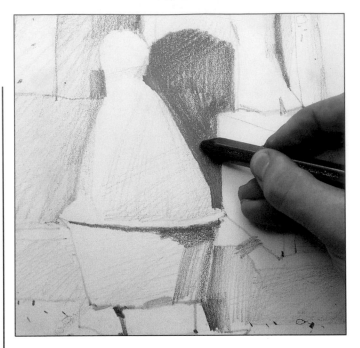

▲ 8 Work back into the darkest areas of shadow using your square 9B graphite stick. It is best to work all over the page—try not to concentrate on any one area so you keep control of the entire drawing. Look out for interesting shapes of shadow to emphasize.

Step back, study your drawing, then put in any finishing touches you feel are needed. Here, the artist felt the ground looked too flat, so he added some flecks and dots in the foreground to make it more entertaining.

Tip

Happy accidents
If you make a mistake or an accidental smudge, do not get annoyed—get creative!

Here our artist takes advantage of a smudge by using a kneaded-rubber eraser to turn it into a highlight. You can also use the eraser to clean away smudges you do not want.

▶ 9 Our artist's final drawing displays the loose feeling that is characteristic of graphite—a softness of shading contrasted against bold, crunchy lines. He has suited his medium to the subject—the angular shapes and smooth textures of the stone statues and columns.

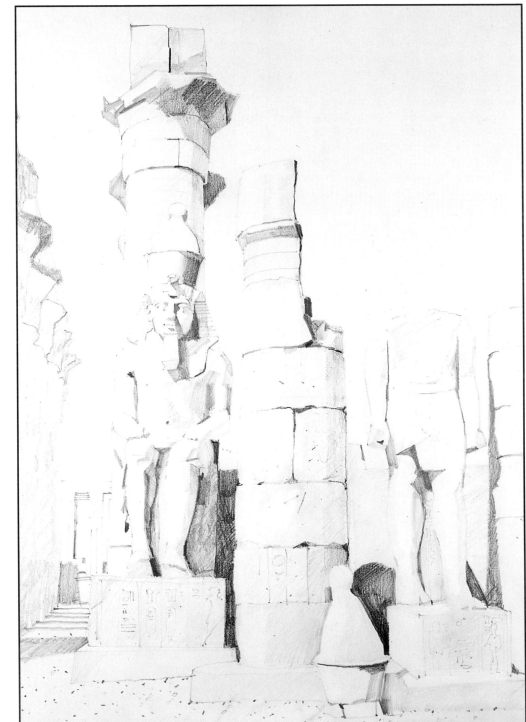

Using graphite powder

Graphite powder has a bold and direct appearance, giving soft, smooth tones and shadows. Ideal for rapid drawing too, it incites spontaneity and gives instant results.

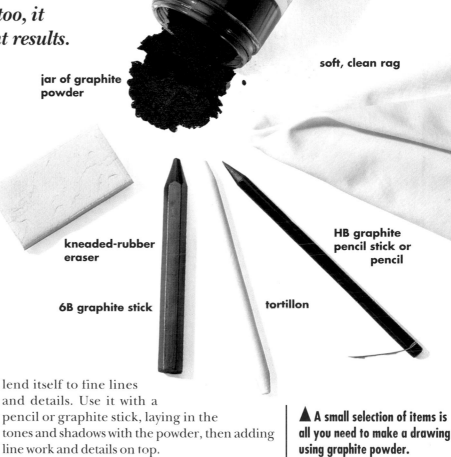

jar of graphite powder

soft, clean rag

kneaded-rubber eraser

6B graphite stick

tortillon

HB graphite pencil stick or pencil

If you have never come across it before, you would be forgiven for failing to identify graphite powder as a drawing medium. This fine, dustlike powder is simply pure graphite—a form of natural carbon. It is bound with clay to make pencils and graphite sticks—the more clay, the harder the pencil. The powder is graphite in its softest form.

Graphite powder produces rich, softly graded tones with a silky sheen. It is good for night scenes, dusky interiors, and any subject with a strong light source.

The flowing, swirly marks you can make are wonderful for describing the rhythms of motion. It is also speedily applied. You can quickly block in the main proportions of your subject before it moves too far out of position, then go on to develop them later.

With any moving subject—a figure, say, or an animal or shifting sky—speed is essential if you want to capture a sense of the movement itself and create a lively picture. Although you can achieve a similar result with pencils or graphite sticks, the process is more time consuming, and the result more static. Graphite powder does not lend itself to fine lines and details. Use it with a pencil or graphite stick, laying in the tones and shadows with the powder, then adding line work and details on top.

▲ A small selection of items is all you need to make a drawing using graphite powder.

Practicing with graphite powder

▲ Use the tips of your fingers to apply the graphite powder, creating broad areas of tone. Keep your palm well clear of the paper to avoid smudging your drawing.

▲ To apply the powder evenly (and to avoid dirty fingers) use a soft, well-washed cloth. Stiff cloth and paper towels are too hard for a smooth finish.

▲ You can create darker tones by overlaying one mark with another. Use fixative to coat each layer and allow it to dry before applying the next layer of graphite.

▲ A tortillon is ideal for removing or blending small areas of graphite powder. It is good for detailed areas where you do not want to use a pencil or graphite stick.

African elephant

Before you start your drawing, give graphite powder a trial run to get used to its slippery qualities. Graphite powder is at its best when used boldly and directly. After you have put down your tones, do not try to tidy them up, because you will lose the movement and freshness of the strokes. You can delete tones, though, with a kneaded-rubber eraser.

You can use this medium on any drawing or watercolor paper. Coarse, textured papers produce a dark, grainy result. On a hard, toothless, smooth surface, the powder looks paler because it does not adhere as well to smooth, shiny surfaces. Spray each layer with fixative before applying the next.

Graphite powder is not suitable for outdoor use because the smallest breeze will blow it away.

YOU WILL NEED

- ☐ A 12- x 18-in. sheet of medium-textured drawing paper
- ☐ Graphite powder
- ☐ A well-washed soft cloth
- ☐ Kneaded-rubber eraser
- ☐ A 6B graphite stick
- ☐ Spray fixative

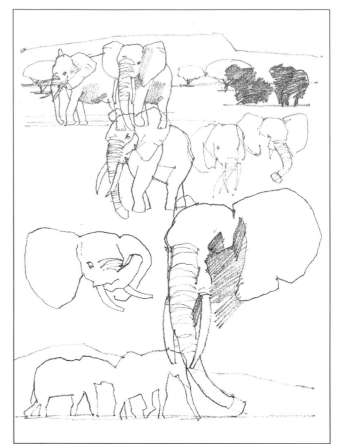

► **The setup** These sketches of elephants, taken from several different sources, make an ideal starting point for this drawing. They provided our artist with the information he needed on proportions and body shape. He built on this with his imagination to produce an image of a charging elephant. This subject allows plenty of scope for experimenting with bold swirls of tone as well as some descriptive line drawing.

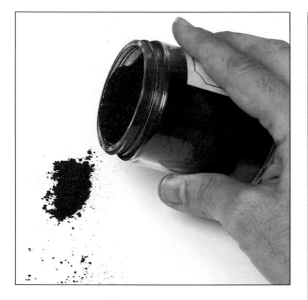

▲**1** Start by pouring a little graphite powder in the center of your paper.

► **2** Fold your soft cloth and use a corner of it to move the graphite powder around. Push the powder around the page to make swirly marks that suggest the shape of the elephant. Ignore details such as trunk, tusks, and eyes. Instead, concentrate on the shadows and tones that describe the internal contours of the elephant's muscles and bones. Carefully blow away any excess powder, or pour it back into the jar.

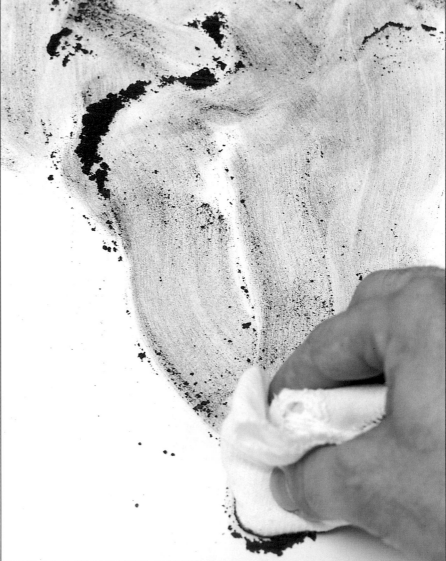

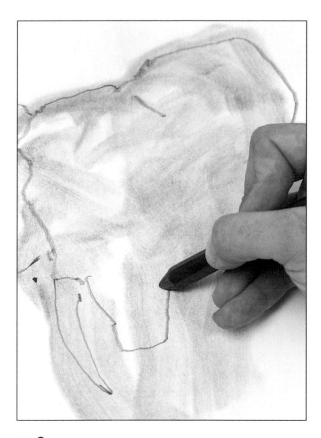

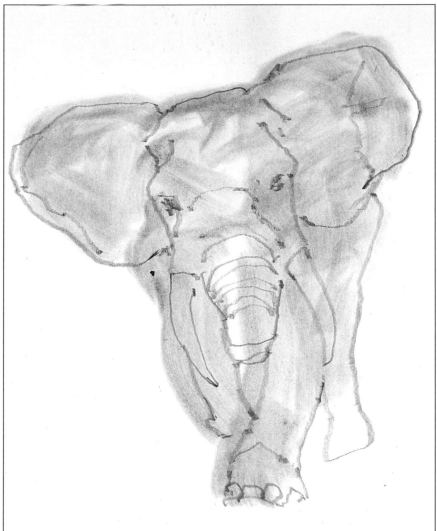

▲ **3** Use your graphite stick to draw the main features and outlines. Concentrate on making your drawing as accurate as possible—this could make or break the entire picture. Start with the trunk, tusks, and ears. Try to make an uneven, undulating line by holding your graphite stick firmly between your fingertips and working with a direct, slightly jerky movement.

▲ **4** Now draw in the legs, eyes, ears, and folds of skin on the trunk. Notice how the line drawing does not always coincide with the graphite powder. The artist treated the initial tonal drawing and the line drawing as two separate images, arranging them so they did not quite fit together, creating the illusion of movement.

◀ **5** Use a kneaded-rubber eraser to eliminate pale areas and highlights. Notice how much of the graphite powder our artist removed from the ears of the subject. For the folds of skin on the elephant's trunk, use your eraser to erase into the powder marks, making lines to describe the rounded form of the trunk.

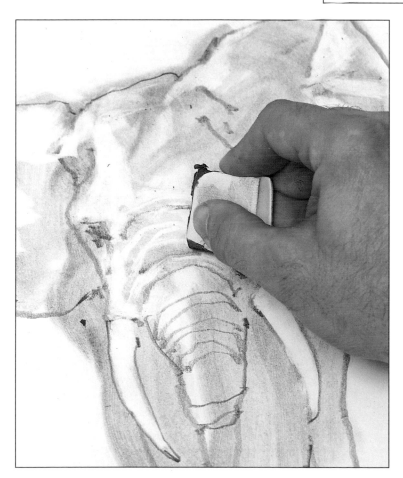

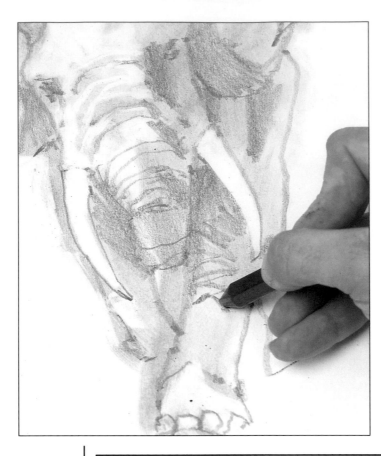

◄ **6** Add the final linear details with your sharpened graphite stick. Put in the folds of skin on the elephant's left foreleg. Try to curve these to show the shape of the limb. Put in areas of shadow that describe the form of the face and ears, and the shadow cast by the trunk on the elephant's legs. Make parallel marks with your stick, changing the directions of these to show, for example, the curves of the ears.

When you finish, remove any dust and dirty marks with your eraser, and spray the drawing with fixative immediately to avoid smudging.

▼ **7** The final picture is bold and energetic, with a sense of the heavy, earth-shattering movement of a charging elephant. Our artist chose not to put in any background, so all the emphasis remained on the animal itself. After all, if an elephant were charging straight at you, you probably would not see the surroundings!

Thanks to the immediate effectiveness of graphite powder, the entire drawing was completed in just a few minutes.

Tip

Loosen up

If you find your drawings are too tight and detailed, graphite powder is the ideal medium for loosening you up. Try making quick sketches with it, using your fingers or a soft rag to apply it in the broad shape and tones of your subject. Add just a few descriptive lines on top before moving on to the next sketch. This exercise should encourage you to develop a freer style in your drawings.

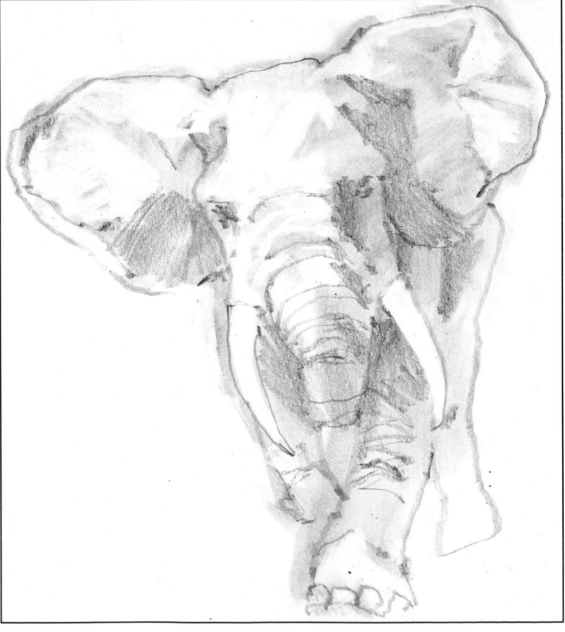

Water-soluble graphite pencils

Water-soluble graphite pencils are a wonderful invention—they combine many of the virtues of pen and ink with those of ordinary pencils. You can even create pencil washes!

Traditionally, when artists wanted more versatility than the humble pencil or charcoal could offer, they turned to pen and watercolor wash or pen and water-soluble ink. But these are both rather daunting for the inexperienced artist because ink seems so permanent and unforgiving, and beginners are always afraid of making mistakes.

Help is at hand. Using a water-soluble pencil you can draw and then erase, chopping and changing things as much as you like while scribbling in tones in the usual way. Then you can wash over some of the scribbled tones with a clean, wet brush, diluting and softening them to create misty washes in a range of tones. If you want to dissolve your scribbles completely, do not press hard with the pencil, and work over them firmly with a wet watercolor brush. If you want to keep some of the scribbles, then press hard and brush over them lightly.

When you wet the pencil marks they will look darker. If you wish to create pale tones, you need to press the pencil lightly or use a harder pencil that gives a paler gray mark. Alternatively, you can carry some of the diluted pencil from one area of your drawing to the next. If you want to create the soft, nebulous shadow of a lamppost on a dull day, for example, you could scribble the tone of the lamppost and then go over it with a wet brush, taking your brush on down to the pavement area to wash in the

shadow. (On a very sunny day the shadow would be as strong as the object itself, in which case you need to scribble it in.)

The wet pencil marks are darker than the dry ones, so if you want some really dark lines simply wet the paper and then draw over it. You can also draw into wet pencil washes or scribble over the washes once they are dry. And you can still erase your pencil marks once you have wet them, although it is not as easy—or as effective—as removing dry pencil marks. If you are wetting the paper, choose good watercolor paper that will not warp or tear.

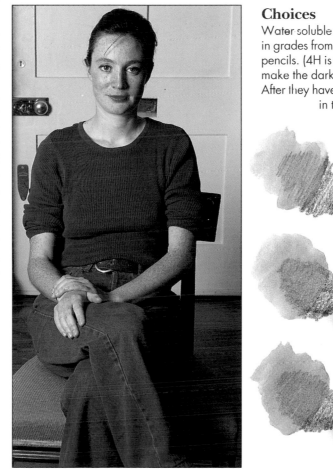

▶ **The setup** This was to be an informal portrait, so our artist asked Kim to turn up in casual clothes. She chose jeans and a stylish ribbed top.

Kim chose a comfortable seated position —the model will have to stay put for about an hour, so do not make her take an awkward pose. And before your model moves or takes a break, ask her to remember her exact position to make things easier when she sits down again.

Choices

Water soluble graphite pencils are available in grades from 6B to 4H like regular graphite pencils. (4H is the hardest.) The softer pencils make the darkest marks, both wet and dry. After they have been wetted, they are similar in tone to charcoal; the harder are more akin to ordinary pencil, while the medium are somewhere between the two.

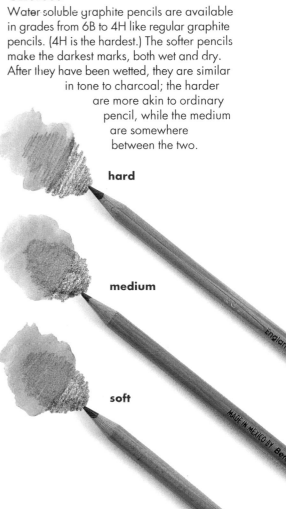

hard

medium

soft

YOU WILL NEED

- An 18- x 24-in. sheet of good-quality watercolor paper
- Three water-soluble pencils: soft, medium, and hard
- Clean water
- A watercolor brush —our artist used a No.10 round

Testing the pencils

If you are using water-soluble pencils for the first time, practice before you render a finished drawing. For light tones, such as the ones on Kim's hands (above), simply darken the outline to provide enough pencil marks for the tone. For darker tones, scribble over the whole area.

Wipe over the area with a clean, wet brush to dissolve some of the pencil and to make a wash (above). The more pencil marks there are and the softer the pencil, the darker the wash. You only need to use a light touch for pale washes, but to dissolve more color, rub into the area with the wet brush.

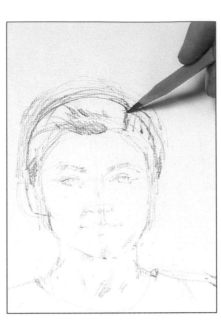

◄**1** Start with the hard pencil, lightly sketching in the outline of your model and indicating eyes, nose, and mouth. Check the proportions as you go, using the pencil as a measuring tool. When you are satisfied with the general drawing, start to emphasize the correct lines with your medium pencil and scribble in some of the dark tones.

►**2** Stand back and check the proportions. Do not worry about any lines in the wrong places—they add a lively touch to the drawing. Our artist worked with all the ease of experience, so do not worry if your picture is not as good— just keep practicing.

▼**3** Scribble in the dark tone of the hair with the medium pencil. Press quite hard so when you wash over it, the pencil lines remain to suggest individual locks of hair. Darken the eye sockets to make them recede, then shape the eye- brows and emphasize the upper eyelids. Make the lower part of the upper lip a shade darker than the bottom lip.

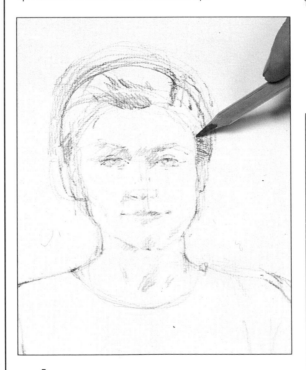

►**4** Stand back and check the likeness, then add any details you think are necessary, especially to the eyes, which are the focal point of any portrait.

Now the fun starts. Wash over the right side of the face and neck with clear water and the round brush, taking the color from the pencil marks on the side of the face, the eye socket, and the hollow of the neck. Then wash over the hair to darken the tone.

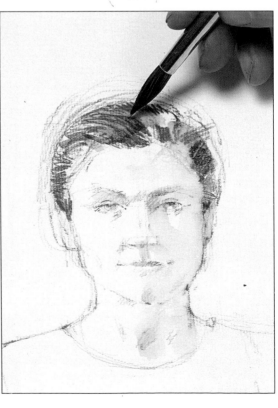

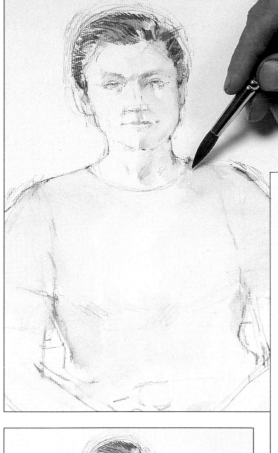

◄ **5** In the same way, put in the shadows on the ribbed top, arms and hands. Work lightly and quickly, but keep looking at the model to make sure that you put all the shadows in the right place. Never get so carried away with the process of picture making that you forget to look at your subject. If you do make a mistake, quickly blot the wet wash or dab it off with a dry brush or paper towel.

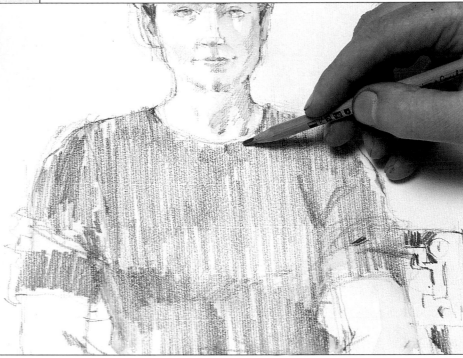

▲ **6** With the soft pencil, scribble across Kim's knit shirt, using long, vertical strokes to indicate the ribbing. Press harder for shadows—under the bust, on the rolled-up ends of the sleeves, and on the right shoulder.

Scribble horizontally to put in the belt, then press hard to get a dark line of shadow across the top of the belt. At the same time start to indicate the intricate structure of the chair. (Notice that this does not show up in the setup, proving that you cannot always rely on a photograph to provide details.)

◄ **7** Now lightly sketch in the legs and the sides of the seat. These are not the focus of the picture, so you do not need to put in much detail. However, with life drawing there is often the danger that your figure will look as if it is floating—by sketching in the chair back and seat our artist avoids this problem.

Put in the dark tone to indicate the turn of the right knee, but let your pencil marks trail off down the model's legs for a vignetted effect.

► **8** Dampen your brush again and wash over the chair back to block it in. Leave a gap about three-quarters of the way down the back strut to represent reflected light. Darken the tones of her belt and lap by washing over the pencil marks. Work over the hips and put in the shadows on the calves in the same washing motion.

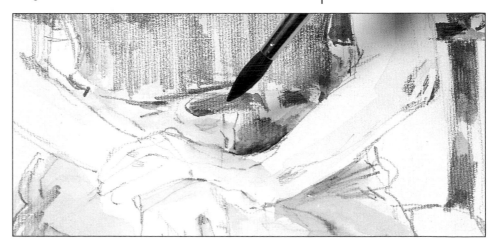

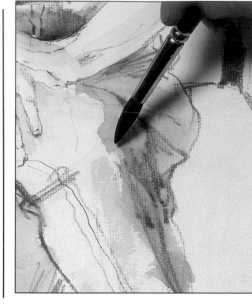

◄**9** Our artist decided that the tones on the lap and legs were not dark enough, so he rubbed over these areas with the wet brush to release more gray. If the tones are still not dark enough, add more pencil shading when the page is dry, then go over it with the wet brush.

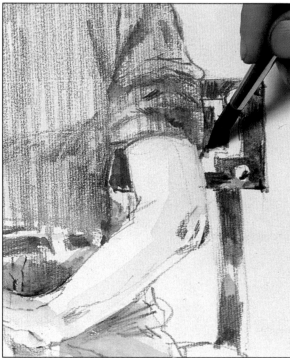

▲**10** Now put in the final shadows and make any other adjustments you think necessary. Our artist washed in the shadows on the rolled-up sleeves and tidied up the chair back. Be careful not to overdo the washes—it is the contrast between the washes and the pencil marks that give the picture its variety.

►**11** The finished drawing shows the restraint of an expert—it is lively and fresh with a pleasant light touch, yet it captures the quiet elegance of the model perfectly.

Notice how the pencil washes enrich the dark tones of the model's hair and the shadows of her slacks, yet provide subtly light tones for the shadows of her face and arms. The contrast between the dry scribbles on her shirt and the soft washes on her face emphasize the fresh bloom of her skin.

Using a wide range of pencils

If highly finished drawings are your aim, use as broad a range of pencils as you can. This will give you excellent scope for creating a convincing image.

There is much you can do with just one or two pencils, but when your subject is varied and complex, the results may be flat and dull. Using different grades of pencils gives the opportunity to convey form, tone, texture, and depth.

For the drawing here, our artist applied graphite powder with a dry sponge to lay the foundation for his drawing (as with a watercolor wash). Then he used different grades of pencils and graphite sticks to pick out and describe the huge variety of trees in this public park. The wide range gave depth and contrast to his drawing.

With a monochrome image, you use the direction and strength of the light to suggest three-dimensional space. A variety of soft pencils give you the necessary tonal gradations to model shapes. With a range from HB to 6B you can draw the subtlest variations, from the faint shadows in luminous white clouds to the dramatic contrasts of black and white seen here in the deep shadows cast on the sunlit field.

The amount of pressure you apply gives an even wider choice of tonal variations. With the HB, you can make a mark from almost invisible to a hard, deep, silvery one; the 2B can go from soft mid gray to a velvety jet black.

Tip

Traveling light
You do not need a lot of equipment to do sketches on site that will provide sufficient information for a more detailed drawing or painting later. Our artist

takes his small sketchbook, a graphite stick or charcoal, his trusty eraser, and a tortillon. If necessary, he can do studies of certain trees or buildings as a backup for his sketch.

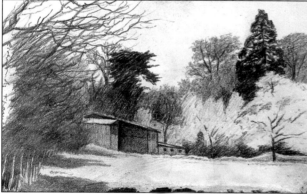

◀ **The setup** Our artist captured this landscape view of a public park in his sketchbook. In particular, he admired the proportions of the dramatic sunlit field in the foreground surrounded by a rich variety of different trees.

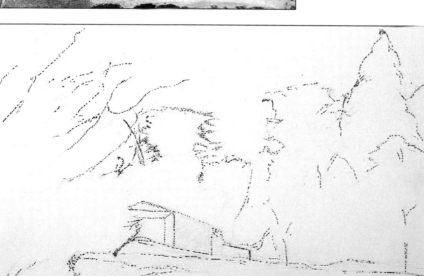

◀ **1** Using the HB pencil, draw the basic outlines of the composition, including the shadows on the ground. Keep your marks light and loose while you search for a feeling of the space.

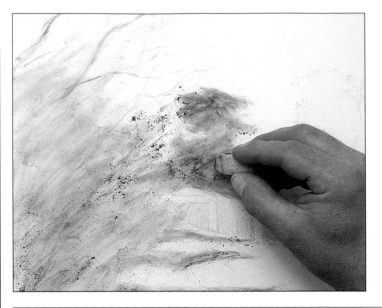

YOU WILL NEED

- ☐ *A 12- x 18-in. sheet of heavyweight, fine-quality drawing paper*
- ☐ *Drawing board and masking tape*
- ☐ *Utility knife and emery board for sharpening*
- ☐ *Kneaded-rubber eraser*
- ☐ *A thick tortillon*
- ☐ *Graphite powder*
- ☐ *Tracing paper for leaning on*
- ☐ *Small natural sponge*
- ☐ *Four pencils: HB, 6B, 2B, and 4B*
- ☐ *Three graphite sticks: 2B, 4B, and 6B*
- ☐ *One soft water-soluble pencil*

◀ **2** Hatch in shadows on the barn with the HB pencil. Then dip the end of a small, stiff sponge into graphite powder and smudge in the dark areas—the bare thornbushes and their shadows to the left, the background trees, and the shadows beneath the trees in front. Use your marks to indicate the direction of growth and the movement of the wind through the leaves.

This graphite layer gives you a good "ground" to work over. By blocking in the darks, you give yourself a clear idea of the positive and negative shapes in the picture.

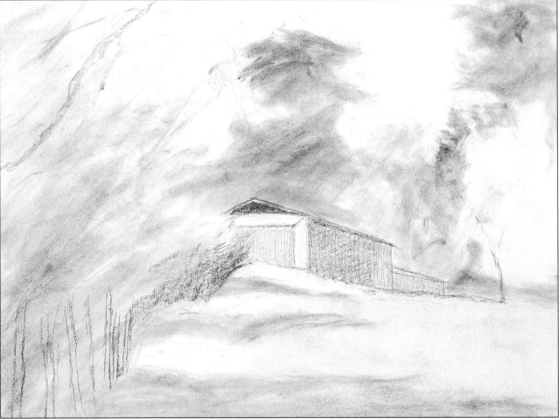

▶ **3** Sharpen the point of the 6B graphite stick and draw some of the more important branches of the trees, then redraw the barn and the low pigpen attached to it after you are confident of their positions. Darken the shading on the walls at the same time.

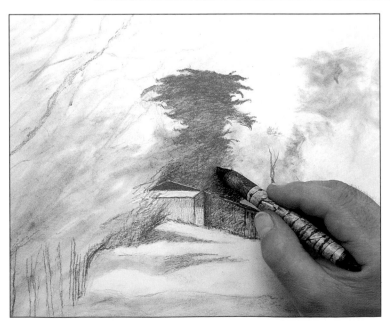

◀ **4** Our artist loves trees and often concentrates on a single tree in his drawings. Tree shapes are often unpredictable, so if you are working from life, treat the trees individually, looking hard at each one to capture its personality—they should not all look the same.

Using the 4B pencil, develop the cedar behind the barn. Make it very dark, and emphasize the shapes of the branches. To make the tree look three-dimensional, pull out some of the graphite marks with a tortillon to vary the tones.

Strengthen the dark tones on the barn with your 2B pencil. Pick out the dark grasses surrounding it, then define and deepen the shadows in the left foreground.

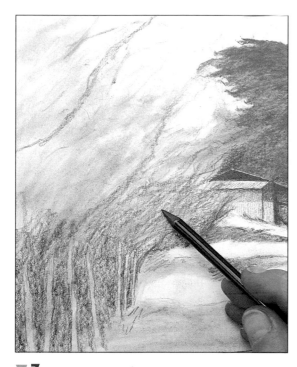

◀5 Scrub in the bushes on the left with the 4B graphite stick. The many branches are compacted together, so you will need to build up the bushiness slowly, suggesting years of growth.

▼6 Work over the bushes again. Use the soft 6B graphite stick to catch the wild character of the branches, by using bold, irregular marks. Then draw the shadows beneath the bushes with sweeping strokes from left to right to indicate the direction in which they are cast.

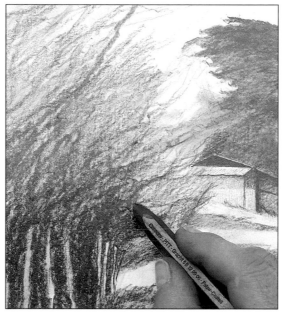

▼7 On the right side of the picture, loosely block in the lower trees behind the row of pale maples, applying light pressure to the 6B graphite stick. Change to the 4B graphite stick to work out the shape of the tall pine. Make this tree dark, but leave cracks of light here and there between some of the branches.

(When drawing trees, our artist finds it helpful to think of the outstretched branches as holding bunches of leaves, which are either catching the light or tucked under in shadow.)

▼8 Draw the trunk and main branches of the rounder elm tree to the right of the pine. Change to the soft water-soluble pencil. Sharpen it to a very fine point to draw thinner branches and suggest leaves, making tiny faint marks.

The beech tree to the left of the pine is softer and more delicate than the trees beside it. Put it in with the HB pencil, indicating the contrast of dark and pale tones and catching the shimmering light on some of the leaves.

Use the 6B pencil for the mid-tones of the small tree behind the pigpen. (Our artist adjusted the tree's tone for compositional purposes.) Switch to the HB pencil to pick out the branches of the foreground maples. Smudge some tone on the leaves with a dirty part of the tortillon.

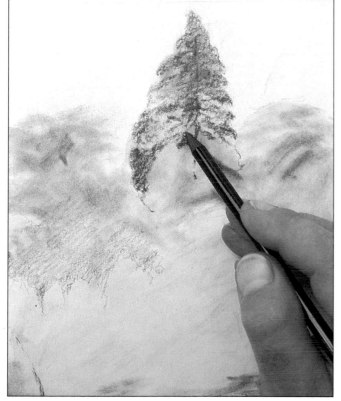

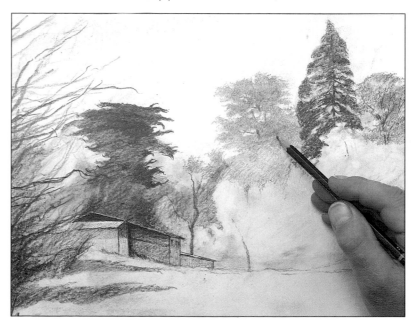

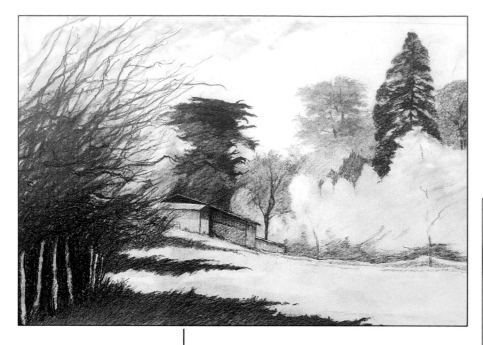

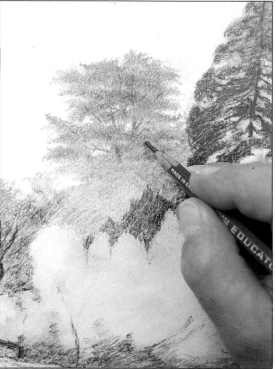

◄9 Emphasize the irregular shapes of the maples by developing the shadows around them. Deepen the foreground shadows, bringing out their grassy edges. Then darken the branches of the bushes further with the 2B pencil. Using the dirty tortillon, smudge in some clouds. Then step back and assess your drawing. At this stage, our artist rubbed out the top point of the pine to soften the skyline.

►10 Sharpen the 6B pencil to a point and stipple tiny marks into the central parts of each clump of leaves in the beech tree. These slightly darker, denser areas give the tree more body and depth.

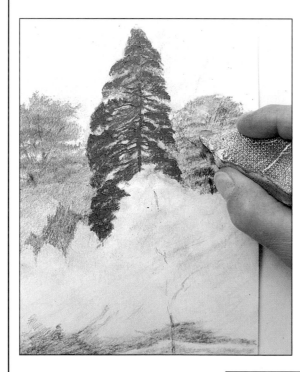

◄11 To give the pine tree a more solid, three-dimensional feel, dot along the branches making dense, dark blobs with heavy pressure on the 2B graphite stick. Make the trunk and branches very dark to create an even stronger contrast with the white cracks of sky between them.

Pull the kneaded-rubber eraser to a point and use this to suggest the light catching the tops of the leafy branches of the elm tree. Dab the eraser to lift out small highlights, then work around these with the 2B graphite stick, putting in darker tones (mainly on the shadier right side).

►12 Now that these trees are finished you can see the value of a wide range of pencils and graphite sticks to describe subtle differences of tone and texture. But the success here also depends on the artist's keen observation and understanding of the individual way each tree grows. He interprets this with his distinctive choice of marks.

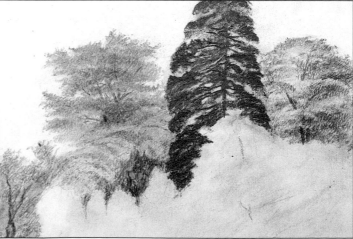

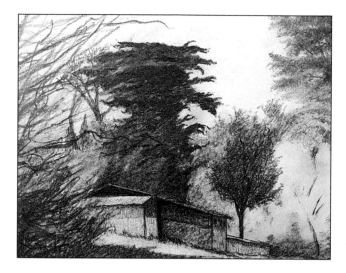

◀ **13** Put in the old, dead elm tree behind the cedar with the 6B pencil. This shape connects the bushes on the left with the trees in the distance. Give more body to the small tree behind the pigpen with the same pencil. Develop this area generally, working toward the pale maples.

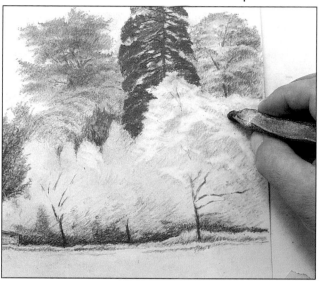

▶ **14** Define the trunks and branches of the maples with the 6B pencil. Lightly hatch in the range of tones in their canopies. Use slightly harder pressure to strengthen their shadows. Notice how the dark trunks at the bottom of the paler greenery give the trees their fullness and weight.

Pull the kneaded-rubber eraser to a point once again to work into the maples—erase in angular shapes to give highlights across the trees, especially on the left, since the right sides are mostly in shade.

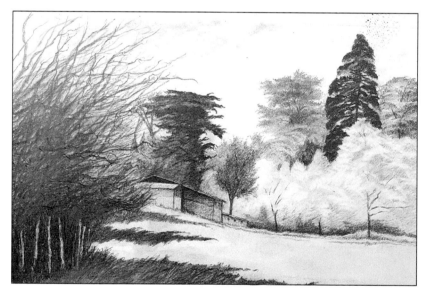

◀ **15** Stand back and take another good look at your progress. The dark and light areas in this drawing are well established by now. Deep tones in the left foreground pull it forward, helping to create a sense of space and distance. The various textures have emerged to give a strong indication of the nature of each tree.

▶ **16** Make the final adjustments to the bushes. Rework the upward curve of the branches with the 6B graphite stick. At this stage, our artist decided to make their trunks shorter. Sharpen any lost or blurred details, and use the eraser to remove the smudges between the branches.

Pull the eraser out into the tiniest possible tip to lift out some very fine highlights along the edge of the barn roof.

Go over the foreground shadows with the 4B graphite stick. To aid perspective, make these marks larger than the background ones. Also, slant them toward the trees to lead the eye into the picture.

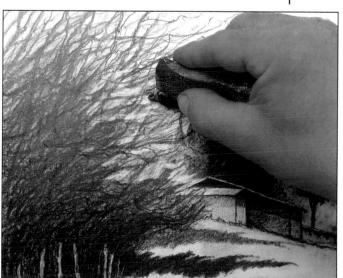

► **17** Lightly draw the outlines of the clouds with the 2B graphite stick, then smudge these lines to soften them and give the clouds some body. Use the tortillon to apply more graphite, then add the highlights on the clouds with the eraser.

You may find it helps to lean your hand on a sheet of tracing paper to avoid smudging the picture.

▼ **18** Finally, strengthen the shadows on all sides of the buildings. Then, with the eraser, lift off and clean up all the graphite that has smudged the field. Leave a few patches of shadow here and there so it does not look completely flat.

The renewed, fresh, bright white on the sun-filled field pulls the whole picture together and brings out the wonderful, rich contrast of tones in this drawing.

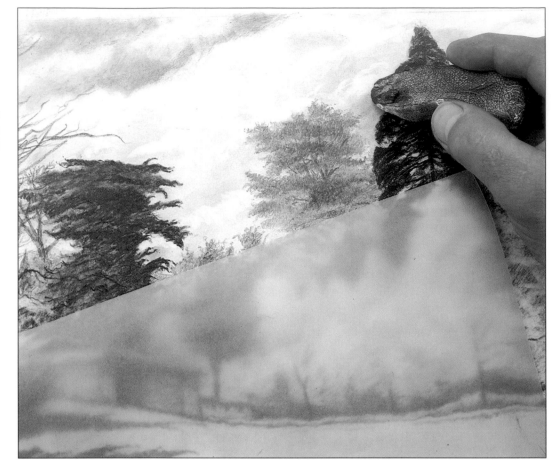

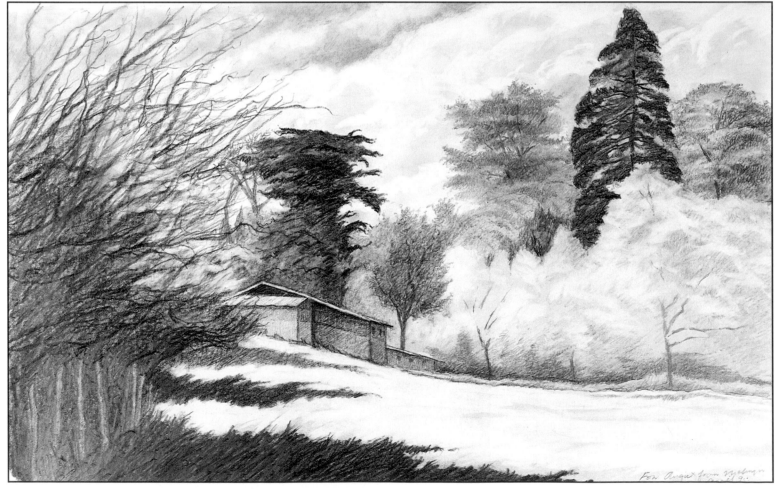

Drawing with erasers

Drawing is not just a matter of putting down marks. Erasers produce dynamic negative shapes that work wonders for your pictures alongside the positive lines and tones.

Drawing often relies heavily on tones. But rather than leave the light tones blank or apply them softly, you can introduce an interesting new mood and surface quality by using an eraser to rub out negative lines and patterns to represent the lighter areas. The crisp, angular shapes create a great sense of clarity and energy.

You start by building up a mid tone with graphite powder, a pencil, or charcoal, then use the eraser to create light tones. You can apply darker marks for the deeper tones. You actually use the eraser itself to draw into the tone. For example, if you are creating a dark form, rather than imposing a dark line around the edge, try "drawing" it with an eraser. In effect, you are taking away the background around the form to show its edge, which is still sharp and clear, yet softer than the dark line of a pencil.

Each eraser is suited to different functions and supports. Some work better on hard, glossy papers, while others are more efficient on a textured surface. Most are inexpensive, so practice with a selection.

Kneaded-rubber erasers are soft. Use the side edges to wipe away broad, generous shapes, or twist a corner into a fine point for details. With heavy pressure you return to the white of the paper, or simply lighten a tone by gently caressing the surface.

Vinyl erasers are firm, and because you can exert more pressure, they are good for crisp, angular lines. Pink Pearl is the most useful. Most pencil erasers are softer, since they are made of rubber. Ink rubbers have a pencil eraser at one end and a blue ink eraser at the other. The blue end is more abrasive and can lift off some of the paper surface to remove marks.

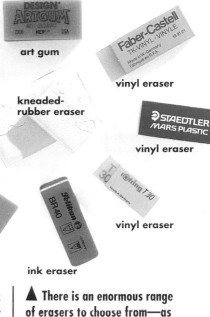

art gum

vinyl eraser

vinyl eraser

kneaded-rubber eraser

vinyl eraser

WS30

pencil eraser

vinyl eraser

pencil eraser

ink eraser

▲ There is an enormous range of erasers to choose from—as a visit to any art store will show. Each has its own use and function, so try out as many as you can.

Art gum is a bit different. It looks like a piece of peanut butter fudge, and it is softer and more crumbly than a vinyl eraser. It is good for erasing broad areas, cleaning smudges, and wiping around edges.

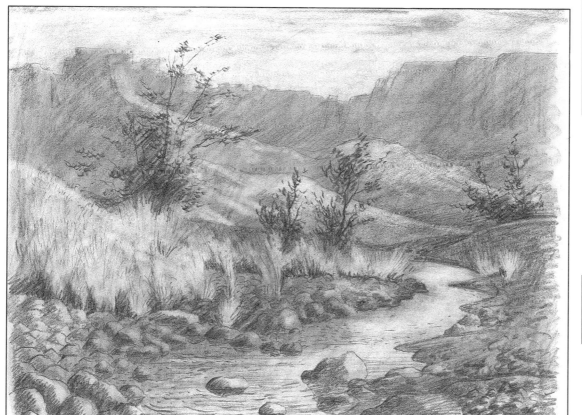

◄ Skilled use of erasers gives this drawing its luminosity. Where there is light—in the sky and playing on the grassy slopes, water, and rocks—the drawing has been rubbed out. In some areas, such as the grassy banks, the artist then used pencil to indicate form.

Giraffes in grassland

▲ **The setup** This photo gave our artist the inspiration for her drawing using erasers. The powerful tendons and muscles of the giraffes are ideal for a tonal drawing, yet sharp, negative shapes and angles can be used to convey a sense of their vigor.

Erasing negative shapes is perfect for the geometric patterning on the animals' bodies.

▲**1** Start by marking in the basic structure of the composition with your charcoal pencil. Notice how our artist smudges some of the lines with her finger to suggest vague tones.

Even at this early stage, make sure you do not speed along with one element (line) while neglecting another (tone). Try to make the entire drawing emerge as a whole.

▲**2** Continue in the same way, developing the details of your drawing and using a few scribbled lines across the bodies of the giraffes and behind their backs and necks to suggest a series of tones.

These scribbles act as a simple reminder for those areas that will need to be developed later.

YOU WILL NEED

- ☐ A 16 x 20-in. sheet of 90lb. Arches smooth watercolor paper or good-quality drawing paper
- ☐ Jar of graphite powder
- ☐ Charcoal pencil
- ☐ Four erasers: art gum, vinyl eraser, ink eraser, and kneaded-rubber eraser

▲**3** Use graphite powder to pick up on, and extend, those areas of tone you have already established. Apply the powder to suggest the basic forms of the giraffes as well as their solidity. Rub it in with your fingers to make a rich overstatement of the tones. You can work into these at a later stage with your erasers.

▲**4** Define the outlines of the giraffes' necks with the charcoal pencil to bring them forward. Build up the tones on the necks and on the body of the giraffe on the right with more charcoal scribbles. Put in some details—work on the faces and start to put in the patterns on the bodies. Do not put these patterns on flat—make them follow the forms of the giraffes.

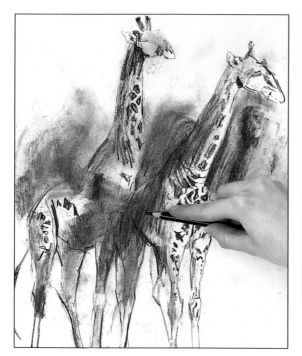

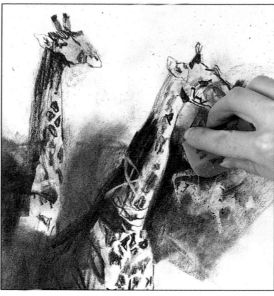

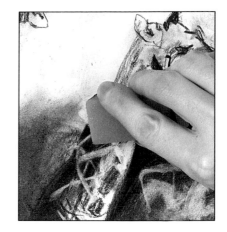

▲ **5** You can now see all the tones beginning to work together. Deepen the tones around the bellies of the giraffes with your charcoal pencil, applying the marks so that they travel around the contours of the rounded forms. Use more graphite powder to darken the background foliage and to darken and blend the charcoal marks on the necks, bellies, and legs.

▲ **6** With random, general sweeps, take away some of the background tone toward the right of the giraffes with a corner of your art gum to suggest the foliage. Use the art gum in a more controlled way to make a few swift lines that begin to suggest the patterns on the neck of the giraffe to the right. In this way, you are depicting the patterning using both positive and negative marks.

Sharpen the details around the giraffes' faces with the charcoal pencil.

▲ **7** Still using the art gum, extend those negative patterns that you began on the neck in the previous stage. Make sure your marks travel around the cylinder of the neck. By describing the giraffes' patterning, these negative marks work positively for you.

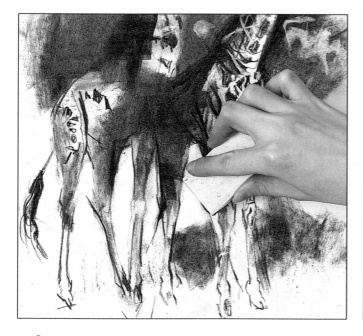

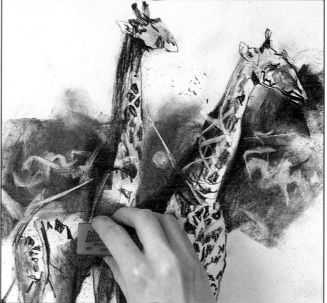

▲ **8** Our artist decided to rub some graphite powder around the legs so she could draw into it with an eraser at a later stage to suggest grass. By having both the necks and the legs rising out of foliage, you emphasize these characteristic features.

The long, thin legs are a vital part of this composition, so use your kneaded-rubber eraser to make sure they are well defined and to clean away finger marks and smudges.

▲ **9** Use the art gum in the background foliage on the left to make angular lines that give a feeling of light coming through the greenery. Suggest the outline of the left giraffe's back with the edge of the art gum. This negative line brings a sense of the energy to the animal. Add more of the crisscross patterns on the giraffes, as our artist is doing. (Keep cleaning off smudges, especially between the necks and legs.)

► **10** Extend the crisscrossing further with your vinyl eraser, making sure that the lines go around the forms of the bodies.

Use the same eraser to work into the background a little more. Add more charcoal marks to the background, then deepen some of the tones on the necks, defining their outlines. Our artist decided to make the neck and head of the giraffe on the right stand out clearly by erasing some of the surrounding area.

Use a corner of the vinyl eraser to wipe away the body patterns, and its sharp edge to rub out long, thin lines to suggest the tall, spiky grass.

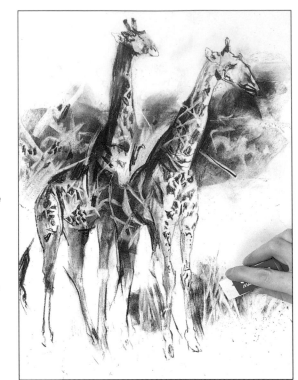

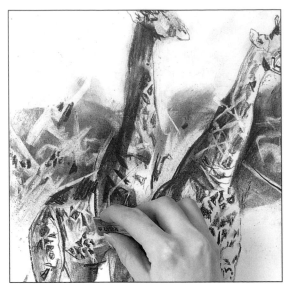

▲**11** The softer end of your ink eraser is excellent for cleaning up any areas you want to sharpen and to get back to the white of the paper. Here, our artist creates a white mark behind the shoulder of the giraffe on the left to convey a feeling of its bulk.

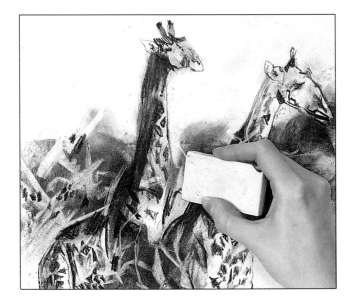

▲**12** Use your kneaded-rubber eraser to clean and sharpen the area around the giraffes' necks and shoulders. This helps to reinforce these elements and define their edges further.

Add any finishing touches you feel are necessary. Put some charcoal marks on the grass area and some lines and marks on the legs to suggest forms as well as patterns, and to emphasize the knee joints. Apply and erase some more marks in the background foliage.

► **13** In the final drawing, the lines, shapes, forms, and tones all integrate to make a fresh portrait of these splendid animals. The various marks made by the erasers add life and energy, which complement the elegance and strength of the giraffes.

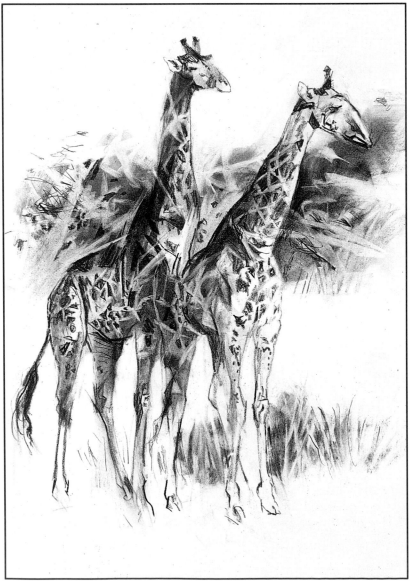

Discovering colored pencils

If you have not used colored pencils since you were in school, give them another try. They have graduated from the classroom to the studio, and proved to be a refined and versatile drawing medium.

You will be surprised by the beautiful results you can get with just a handful of colored pencils and a few basic techniques. They are good for line drawings and illustrations, and you can even achieve some painterly effects with them. You can use them in either a loose, expressive way or produce some very subtle, considered works.

Colored pencils are inexpensive, easy to use, and you do not need a lot of equipment to get started. There is no messy mixing to do, and they do not smudge easily. The color that you draw is the color you get—unlike paints, which often dry lighter or darker. Also, colored pencils are small and portable, so you can carry them when you go sketching and store them without trouble.

▲ Much of the charm of colored pencils comes from their sheer versatility. In this lively drawing, bold, loose scribbles, pressure techniques, and careful color mixing combine to portray the bright, sunny atmosphere of a French village.
La Garde Frinet *by Ian Sidaway, colored pencils on paper, 23 x 33½ in. (58 x 85 cm.)*

◄ Most art stores carry a wide range of colored pencils— some hard, some soft—and in an impressive array of colors. Try as many as you can to find the type you prefer.

There is also a wide choice when it comes to paper. With so many colors and textures, there is a perfect paper for every subject.

Two-color mixing

▲ This vibrant orange is mixed from vermilion and lemon cadmium.

▲ Mixing lemon cadmium and cerulean blue makes a vivid light green. Lighten it with more yellow or darken it with more blue.

▲ Light carmine and vermilion combine to produce a moody violet.

▲ You can make a neutral gray by laying vermilion over true blue.

▲ A cooler, darker green results from mixing Prussian blue and lemon cadmium.

▲ Viridian and vermilion combine to make a darkish brown.

Hard or soft?

Some colored pencils are softer than others, depending on how much wax they contain. The "lead" or core is clay, colored with pigment and bound with wax. The higher the wax content, the harder the pencil. Soft pencil has a softer core, so the color comes off smoothly and evenly. A hard pencil lays down color lightly and is ideal for delicate work. Try different ranges to see which you prefer. Many artists use both types—harder pencils for fine line work and softer ones for laying areas of solid, bold color, and for pastel-like effects.

You can buy colored pencils in large sets of 72, 96 and 120, but you really need only a set of 12 to mix a wide range of colors. If you prefer to buy them loose, a good limited range of colors for mixing are ones that are approximate to cadmium red, cadmium yellow, cobalt blue, ultramarine, alizarin crimson, Prussian blue, black, and white.

When purchasing, look for well-constructed pencils with firmly set, centered leads. Make sure color builds up quickly and uniformly without any grittiness or squeak. You will also need a utility knife or pencil sharpener and a kneaded-rubber eraser for erasing and highlighting.

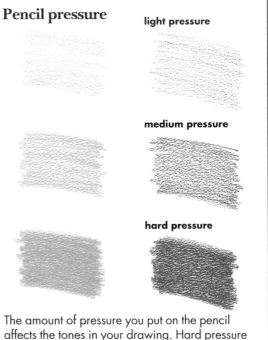

Pencil pressure

light pressure

medium pressure

hard pressure

The amount of pressure you put on the pencil affects the tones in your drawing. Hard pressure gives a dark tone; medium pressure, a medium tone; light pressure, a light tone. Use the sharp point of the pencil for fine lines. For soft lines and broad blocking in, work with the side of the core.

Overlaying color—scribbling

Color mixing with pencils does not require a lot of labor. You can work quickly and spontaneously, scribbling one color over another to create an enormous variety of effects and tones.

The technique of scribbling with colored pencils (or, for that matter, with ordinary graphite pencils) is quite similar to hatching, but instead of laying in the color with dozens of separate strokes, you use a continuous scribbled line. You do not have to take the pencil off the paper, with the result that one color can be laid over another with great rapidity and energy.

You can achieve pale tones easily by leaving wide spaces of white paper between the strokes. This works even with dark colors. For example, dark red looks like pink if it is applied with enough white showing through the scribble.

Overlaid scribble is particularly effective for creating areas of "living" color, when you want to avoid a flat, monochrome effect.

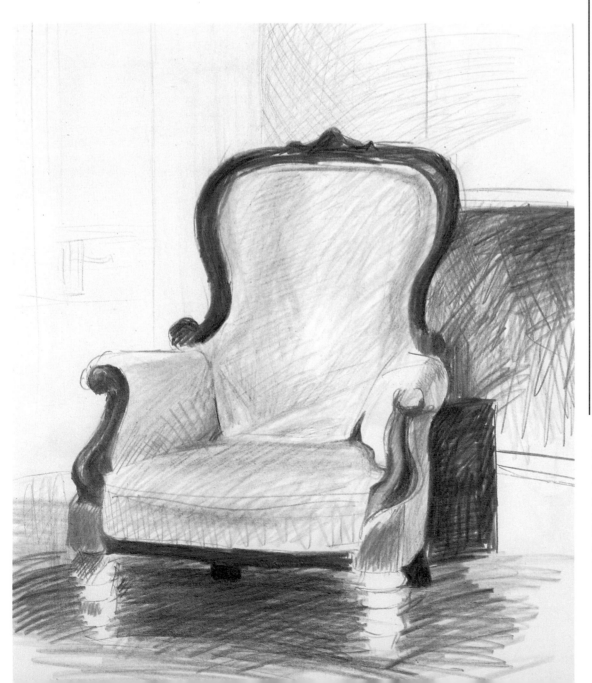

Tip

Making different marks
A very sharp pencil tip makes fine, very precise marks, while a blunt tip covers the paper quickly and, because you can press harder, more densely as well. Using the side of the pencil gives you richer scribble effects.
(It is u good idea to keep worn-down pencil stumps for making the blunt marks.)

◀ The more variety you can get in a colored pencil rendering, the more interesting your picture will be. In this drawing of an old armchair, every color is built up of at least two other colors, with lots of different scribbled pencil strokes to keep the whole picture lively.

Pink cyclamen

Petals, leaves, soil, and a ceramic pot—four very different elements, and all to be drawn with the same colored pencils. Yet these diverse elements can be made to look as different in the drawing as they do in real life.

The scribble technique is versatile and can be adapted to reproduce almost any texture, and any type of surface. The cyclamen flowers, for example, are smooth and velvety, so you must adjust your strokes to suit them; use a sharpened pencil and render the petals in finely scribbled lines. But the soil in the pot is chunky and coarse, so use equally chunky pencil strokes.

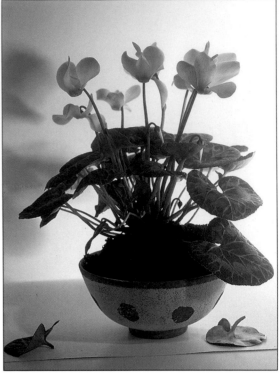

▲ **The setup** It looks daunting, but you do not have to draw every single petal and stalk. Our artist worked from life, but only the main stalks and leaves appear in the finished drawing. He left some out to avoid cluttering the composition.

◄ **1** Start your drawing in greens and blues, varying the color of the outline to match the tones of the subject. For example, draw the lighter top surface of the leaves in a paler green than the shaded side.

Block in the first flower with a mixture of magenta, rose pink, light violet, and cobalt blue. For the pale areas, leave plenty of white paper between the strokes. Redefine your outline drawing if needed.

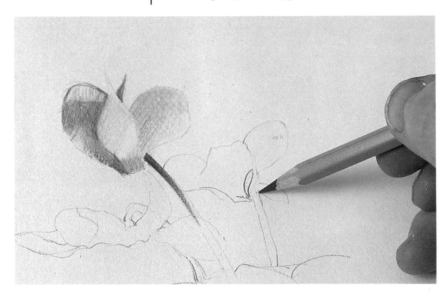

► **2** Before adding more detail, you will find it helpful to establish a few tones elsewhere in the picture. Here, our artist has approximated the tones of the dark soil with indigo and blue gray; a light leaf in olive green and grass green; and one of the darker leaves in juniper green and blue gray.

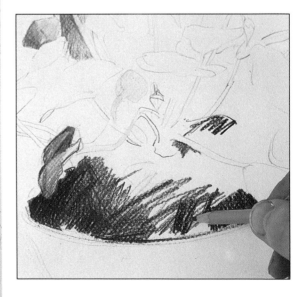

▲ **3** Scribble in the soil with heavily overlaid strokes of indigo, gunmetal gray, and chocolate brown.

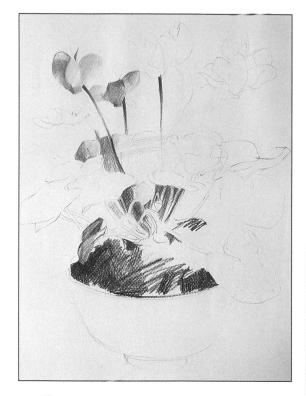

4 Do not attempt to include every single leaf and stalk—it is far too complicated. Instead, select the most important ones, and forget about the rest. (This editing process is a vital one in any drawing or painting—do not neglect it.) You will find this stage easier if you start by filling in the dark, leafy spaces between the pale stalks. Leave the white stalk shapes to be modified later.

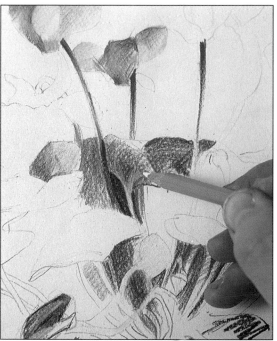

5 Render the leaf tones loosely, overlaying dark violet, chocolate brown, terra-cotta, olive green, juniper green, grass green, zinc yellow, and light viridian. Lightly draw in the stalk shadows in Venetian red and the pale areas in zinc yellow.

6 Work the incomplete flowers up in magenta, pink madder, crimson lake, pale pink, cobalt blue, and touches of silver gray and zinc yellow.

YOU WILL NEED

- ☐ A 18- x 24-in. sheet of drawing paper
- ☐ 23 colored pencils: cobalt blue, rose pink, magenta, Venetian red, Delft blue, blue gray, grass green, silver gray, light violet, zinc yellow, pink madder, juniper green, terra-cotta, gunmetal gray, indigo, crimson lake, chocolate brown, dark violet, pale pink, light viridian, olive green, burnt carmine, black

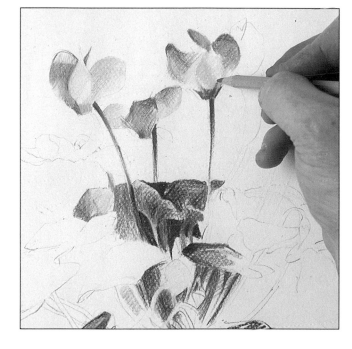

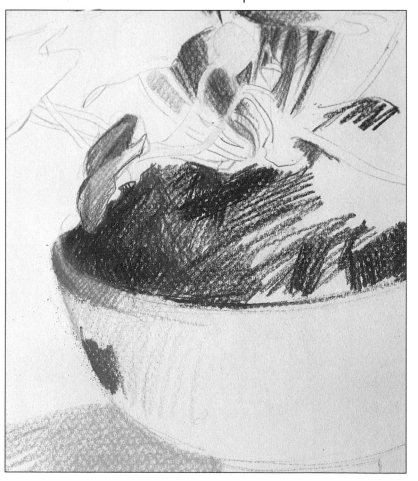

7 Now develop the bowl and soil a bit more—draw in the pot and shadow in silver gray with light violet and Delft blue markings, and the soil with added touches of burnt carmine and Venetian red. Repeat the soil colors on the shady leaves, visible between the stalks.

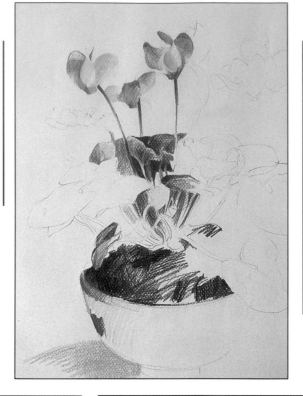

▶ 8 Your main tones and colors are now established, and the hardest part is over. All that remains is to complete the rest of the rendering using the same pencil colors. Take the time to study your drawing carefully before continuing. Decide which parts need to be adjusted and which need highlighting.

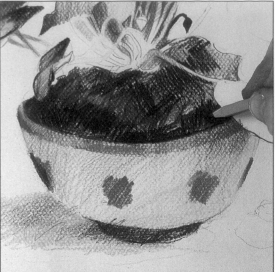

▲ 9 Finish the bowl and the soil, darkening the outer soil tones to indicate the shadow cast by the edge of the pot.

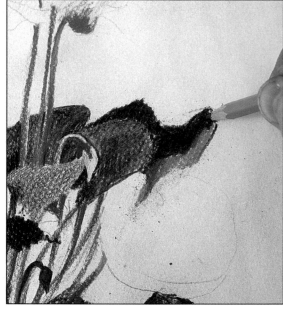

▲ 10 Without tightening your pencil strokes, finish scribbling in the leaves. Here our artist introduces black into one of the darkest shadows.

▶ 11 Add any final touches, including the dark tones on some of the outside stalks. Finally, add the two fallen leaves at the base of the pot.

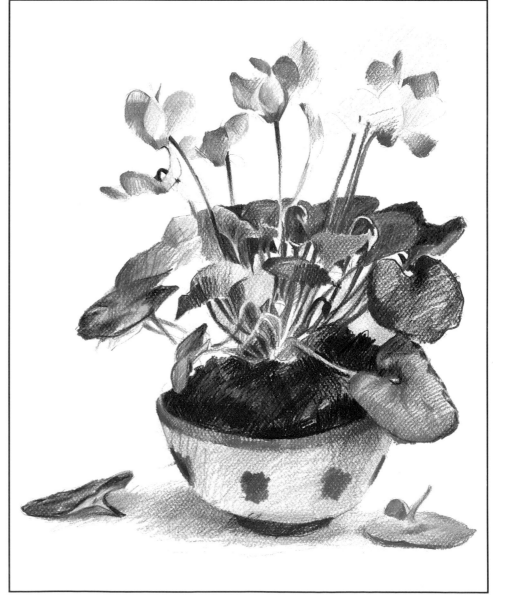

Planning lights and whites

It probably comes as a surprise to many children to find they can't erase red pencil marks from wallpaper as easily as ordinary pencil marks. This discovery is significant to the artist, too.

Colored pencil is very much harder to erase than graphite pencil. This means you have to think about which areas of paper you want to leave white. In this respect, the medium is similar to watercolor. You must plan the lightest tones at the start, and then work from light to dark.

Of course, colored pencil is not entirely indelible, and if you have used light drawing pressure, you can erase it without much trouble. But as you increase the pressure, particularly with waxy pencils, the color becomes harder to rub out. If you start to push the color into the texture of the paper, it becomes impossible to remove completely with an eraser. Then the only way of getting back to the paper is by scraping away the pencil with the edge of a sharp blade. As a remedy, this is far from satisfactory. It damages the paper and, if you draw over it again, usually results in a dark, fuzzy patch. On the whole, scraping is unsympathetic to the medium and should perhaps be reserved for special effects.

You cannot make a white by using a white colored pencil to draw over a patch of color. At most, a white pencil softens and lightens the base color. Often it slides off, having no effect at all. White is most useful on dark papers.

There is no substitute for careful observation before you start. Try to spot the lightest areas in your subject. For example, some objects might have pale local colors where you will have to build the tones sensitively, letting the white peaks of paper lighten your colors. Shiny surfaces can throw up strong highlights and you will want to keep the paper pristine for these. Do not forget touches of reflected light among the shadows. These help you to describe the forms.

▼ Here, the white of the paper gives the highlights and local color of the newspaper and provides a vignette. The artist has used her eraser creatively to draw into the background.
Sunday Morning Still Life by Anna Wood, 23½ x 17 in. (60 x 43 cm.)

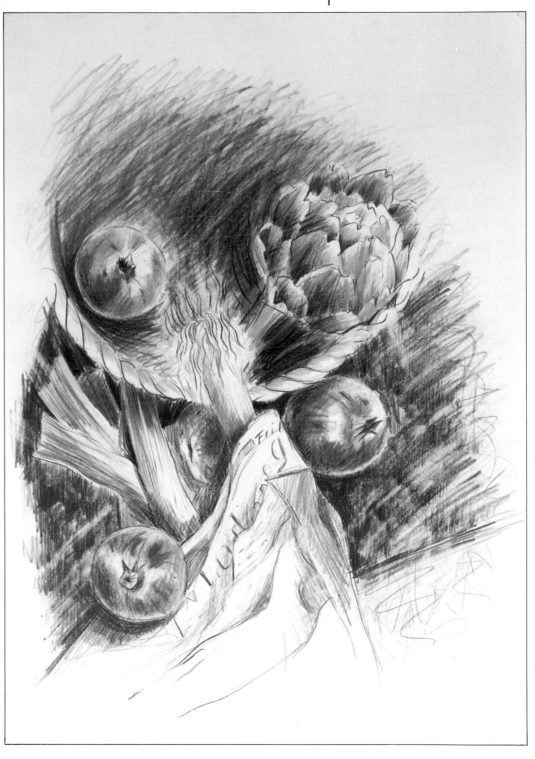

Eraser test

▲ Try erasing a patch of colored pencil and a patch of graphite pencil. Traces of colored pencil still remain but the graphite has gone.

▲ A light line made with a soft graphite pencil is about as easy to erase as a heavier one. With colored pencil, the harder you press, the harder it is to erase.

▲ Even within the same brand of colored pencils, some colors are harder to remove than others. The only way to find out is to experiment. Here, the green proves to be more tenacious than the yellow.

▶ Curling, twisting pencil marks show the bulb's roots, while strokes around the core create a star-burst impression. Compare these with the marks used to illustrate the weave and the background (far right).

Garlic bulbs on burlap

Look at the stages of this drawing—the setup, the intermediate stage, and the finished drawing, and details taken from it. Try to see how the artist used the white of the paper to help him.

▶ **The setup** Although we know that garlic bulbs are small, this isolated pair, when seen close-up, take on an almost monumental quality. Notice that the arrangement has good picture-making value too: strong tonal and textural contrasts, interesting negative shapes between and around the bulbs, and, when you look closely, endless detail!

The pale, local color of the bulbs, the direct and reflected light on them, and the lights seen between the weave of the burlap call for a thoughtful approach.

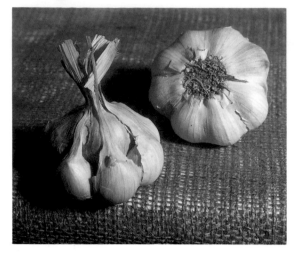

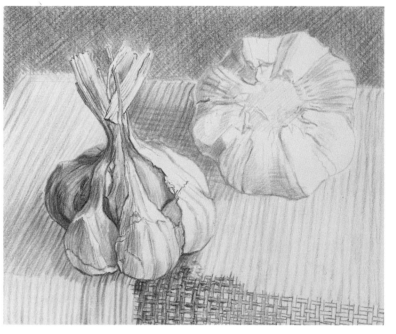

◀ Contour lines in colored and graphite pencil emphasize the bulb in front. Drawn in violet contours, the far bulb appears to recede. The white of the paper serves to remind the artist of the lightest tones. Many of these are where light strikes objects directly—such as on the right side of the bulbs. But it is also essential to remember the less obvious, although equally important, reflected lights.

▼ Details—such as this close-up of the clove's stalk—show how close observation, an imaginative use of color, and sensitive treatment of texture, transform the subject.

◄ Having started to pick out individual threads at an early stage, the artist committed himself to drawing the burlap in detail. Changes in the direction of the threads tell you that the planes are at 90 degrees to each other. Changes in tone draw your eye in—dark on the front of the hessian, light right on the edge of the table, dark into the shadow, and light again on the other side.

▲ Look closely at the far garlic cloves in the setup photo. The undersides of the cloves are in shadow. But notice that at the edge, where they are about to tuck under the bulb, they grow lighter. This is because light bounces from the burlap and hits them from underneath. The artist used only a thin covering of color at the edges so that the paper still shows through. This gives the impression of reflected light, and helps to make these forms appear rounded.

▼ By blending colors, the artist created new ones, including tertiary browns and grays. The white of the paper itself gives the lightest tone. Eleven colored pencils were used: yellow ocher, violet, olive green, cadmium yellow, cadmium red, viridian, alizarin crimson, ultramarine, raw sienna, cobalt blue, and Prussian blue.

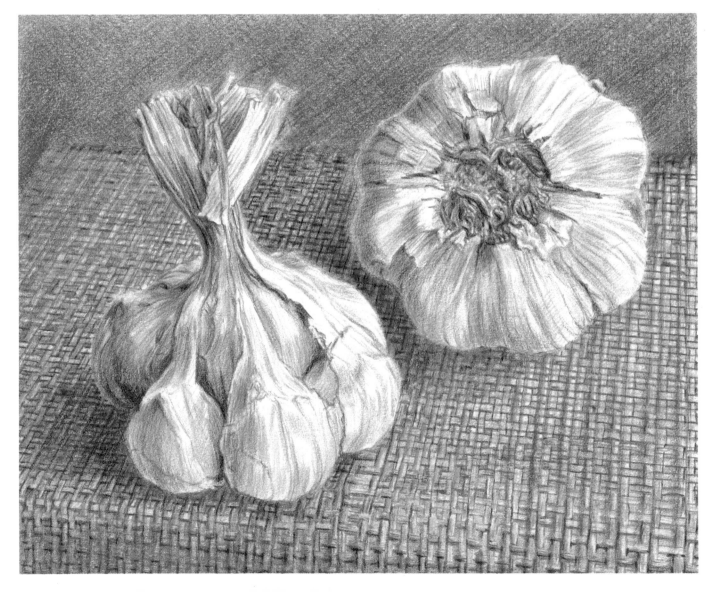

A fresh look

Simply by using it, David Hockney has done a great deal to elevate colored pencil to the status of a serious artist's medium. This drawing is highly formal in composition (it is both symmetrical and static) but the liveliness of the medium imbues it with fresh invention.

Look at the two vases and the window frame. You can see how the white of the paper breaks these shaded areas. It modifies the overall tones (in the case of the window frame, making it much lighter so that it appears to lie farther back than the vases) and it also adds vitality to the drawing.

Study of Louvre Window, no. 1, Paris by David Hockney, colored pencils on paper, 1973, 41 x 29⅛ in. (104 x 74 cm.)

Rendering whites

How do you portray white objects in a color medium? Try it yourself with colored pencils. They are excellent for picking out the many hues subtly reflected in white.

Drawing or painting a still life based on white can raise all sorts of questions. For instance, how do you show the outline of a white object against a white background? And what about the tones of white? Do they simply become black or gray as they get farther from the light?

The answer to this last question is no—as you will see from the drawing in our demonstration. The tones of the white objects show hints of many colors, because white reflects the colors that surround it, as well as being heavily influenced by the color of the light. Place a white object on a red surface and notice how much red you see on it. Now put it on a blue surface, and you will see that it reflects blue. The more colors around it, the more hues you will see reflected on your white object.

Knowing and seeing this makes it easier to depict white things convincingly. For example, showing the outline of one white object against another becomes less of a problem—you look for the different colors reflected in their tones.

Colored pencils are particularly good for drawing colorful tones on white. Laying strokes of different colors side by side, then blending them, creates just the right effect—suggesting hints of many hues. Press lightly, so you can overlay many marks without clogging the surface, and feel your way into the colors. Use heavy pressure only when you need a dense color. Gradually building up the surface like this gives it a shimmering quality, with many different colors working together to produce rich, complex layers.

▼ **The gleaming whites in this drawing are created by leaving the paper uncolored or by scraping it with a utility knife. But where the white areas are in shadow or reflect colors nearby, they look quite colorful.**
Footballers by Phil Wildman, colored pencils on paper with scraffito, 16½ x 23½ in. (42 x 59.5 cm.)

Anyone for cricket?

▶ **The setup** White and many neutral colors work well together here, while the cricket balls provide a touch of contrast in color, shape, and scale. The artist used many different colors, overlaying and blending them to pick out the subtleties and nuances of the different white objects in his still life.

▼**1** Draw the composition using light strokes of French gray. Then start on the upright cricket stump with raw sienna, overlaying toward the top with sepia for a warmer tone. Use a complementary light blue and light violet for its shadow. Shade the shadows on the cricket pad with cobalt blue, Chinese white, and light blue, blended with silver gray. Lightly block in the wood paneling with flesh pink.

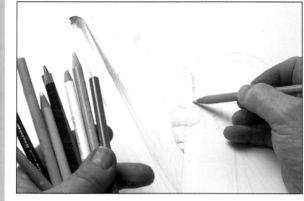

▶ **2** Work up the dark tones at the top of the stump with golden brown and sepia, continuing with lighter strokes of sepia down the side. Add a few touches of orange chrome finished off with raw sienna to blend the colors. Put in some extra touches of bronze and golden brown over the top for a richer surface. Leave the white paper to represent the highlight on the stump.

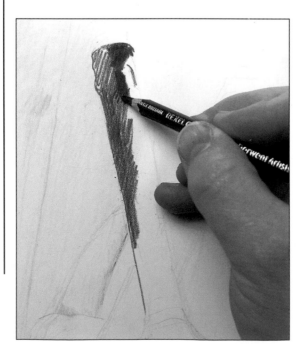

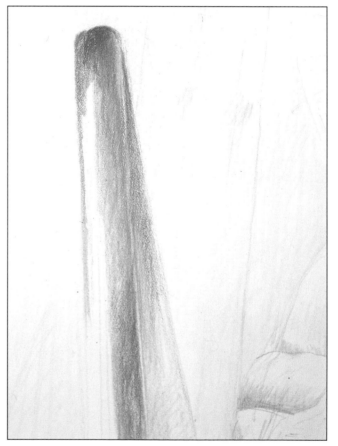

◀ **3** For the bat handles, apply blue gray as an undercolor, with indigo on top. Use small strokes to build up the density. You can apply more pressure on the handles because their color is quite flat. It also provides a strong element in the picture that contrasts with other, more delicate, areas.

Cool the pink paneling using pale gray, working with broad, downward strokes. Add a touch of light blue. Suggest the knots with silver gray and the lines between the paneling with cobalt blue.

◄ 4 Add touches of orange chrome and bronze toward the bottom of the stump to increase the depth and the warmth of the color. Finish it with raw sienna and copper beech over the top. Use Venetian red for the three lines at the top of the stump, and cobalt blue for the light shadow of the bat handle.

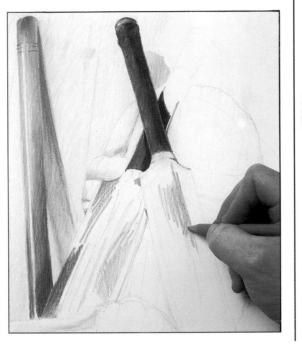

Tip

Different strokes

It is a good idea to vary the type of strokes you use with colored pencils to create a pleasant contrast in your drawing. For flat surfaces with no perceptible pencil lines, use small, circular pencil movements rather than directional strokes. For large areas, backgrounds for instance, make large, loose strokes using your entire arm.

► 5 Now start to build up the bats with orange chrome. Do not make the color too strong, but build it up gradually, feeling your way all the time.

Add strokes of raw sienna, putting some sepia over the top to darken the tone. Increase the depth of the stump's shadow with more cobalt blue and dark violet, and also the color at the bottom of the stump with copper beech.

◄ 6 Blend a series of orange-brown colors to build up the rich wood color of the cricket bats. Our artist used sepia, bronze, Venetian red, raw sienna, and copper beech. Make the direction of your pencil strokes work in the same direction as the form of the bats.

▼ 7 Continue working up the bat handles and their shadows as you did before. Add some browns to suggest the wooden ends.

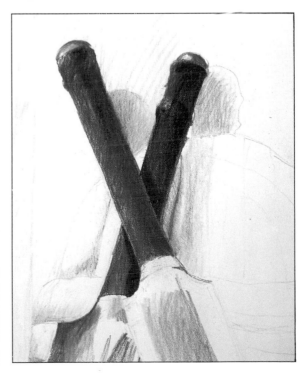

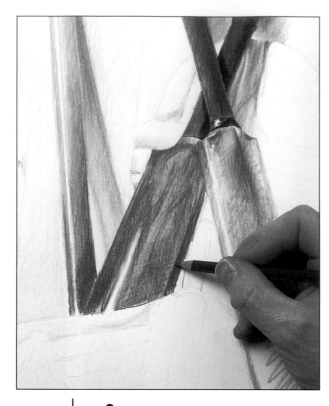

◄**8** Keep building up color on the bats. Remember to leave blank areas of the paper free for highlights. Apply a touch of light blue around the highlights and some blue gray in the darker areas to increase the depth of darker tones. Use bronze lightly to indicate the letters at the ends of the bats.

►**9** Finish the bat with raw sienna and orange chrome. Start on the cricket ball with an underdrawing of rose pink overlaid with rose madder lake. Now shade the shadow on the shin pad with Vandyke brown, overlaying this with light violet and light blue. Fade out the shadow toward the bottom using gunmetal gray and orange chrome.

▼**10** Draw the shin pad with cobalt blue using a hard, sharp line, softening it with silver gray. To enrich the shadows, use gentle strokes of light gray, cobalt blue, silver gray, dark violet, light blue, sepia, and blue violet lake. Blend the blues with flesh pink.

 Use flesh pink and blue violet lake lightly over the background. Keep the strokes loose to cover the large area quickly. This loose border helps the composition—it keeps the emphasis on the details.

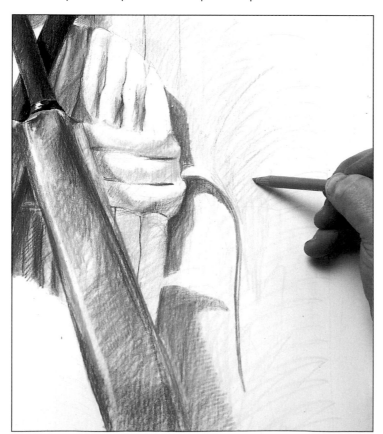

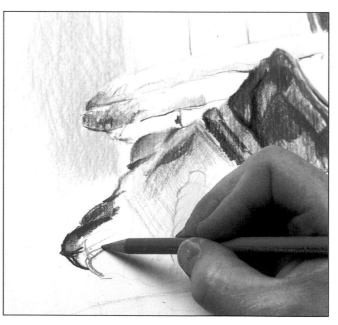

▲**11** Start drawing the glove with gunmetal gray, applying blue gray over the top and indigo in the darker shadows. For the leather, use French gray and bronze with raw sienna, golden brown, and copper beech. Outline the fingertips with light blue. Use raw sienna for underdrawing the bails (the cross pieces on the top of the wicket.)

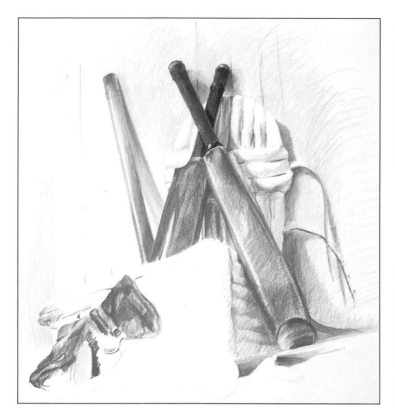

◄ **12** Continue working around the drawing in the same way, gradually building up the colors. Build up the ball with crimson lake, overlaying with blue violet lake to reduce the color. Make your strokes follow the rounded form of the ball. Draw the lower shin pad with raw sienna, light blue, light violet, and silver gray in that order.

▼ **13** Now start on the ball next to the glove and the area around it. Use crimson lake for an underdrawing on the ball (**A**), then work over the top half with orange chrome and deep vermilion, and the bottom half with madder carmine and dark violet (**B**). Try to build up rich, dense colors. Then scratch out the stitching with short strokes of your utility knife (**C**). (First use a pencil to draw a guideline.)

Draw over the bail right of the ball with flesh pink, then finish off the glove with Vandyke brown, golden brown, and blue gray. Do not forget to add the shadow of the cricket ball using violet blues.

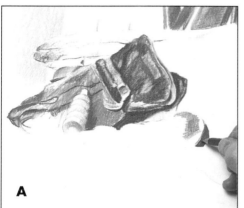

A

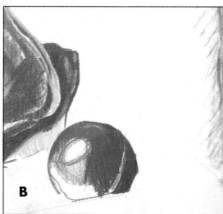

B

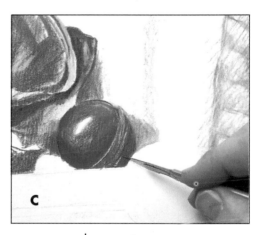

C

► **14** With the exception of the foreground, the picture is almost complete. Build up the foreground stump with raw sienna, overlaying with bronze. Use Vandyke brown for the shadow. Add flesh pink to the ball on the right to blend the colors. Draw the white ball with raw sienna and light blue strokes on top, using bronze for the stitching and Vandyke brown and light violet for the darker shading.

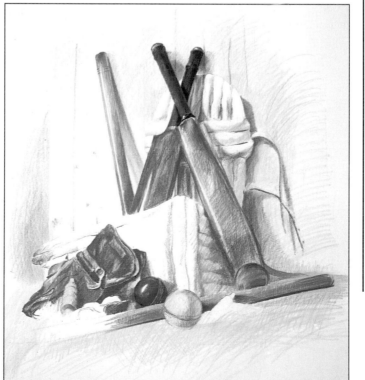

Tip

Artistic license
Part of the artist's job is to provide visual entertainment, not simply record what is in front of him or her (a camera can do that perfectly well.) Exaggerate the colors that you see if you wish.

◄15 Build up the objects in the foreground in the same way as the others. Fill in the straw mat under them with blue violet lake, raw sienna, and burnt yellow ocher. Use loose, broad strokes that follow the form, making sure the colors blend well.

If any colors appear too vivid or marks appear too strong, reduce them by blending in tones and marks in a lighter color. Similarly, you can enrich and deepen colors by using darker colors.

►16 Build up the fingers of the second glove using the colors you used for the first glove. Work up the front bail with raw sienna, golden brown, Venetian red, and sepia. Use a touch of orange chrome and deep vermilion for the reddish glow at the front of the bail.

The final drawing seems to shimmer, with all the colors merging in the distance but becoming richer and more diverse up close. Although there are many colors reflected onto each of the white objects, the artist conveys their essential whiteness convincingly.

Water-soluble colored pencils

Water-soluble colored pencils are extremely flexible and easy to use. They give you the control and precision of a pencil combined with the blending, soft edges, and washes you get with watercolors.

Water-soluble colored pencils have all the qualities of regular colored pencils—you can use them for linear work, hatching, laying blocks of color, or mixing colors optically by over-laying them. However, their water-soluble quality gives them another dimension. By blending the marks with water you can produce soft gradations of color and tone as well as areas of delicate color washes. These pencils are ideal for subjects with intricate detail. They are good for drawing birds, animals, and plants—flower studies gain much from the combination of line and wash.

The following three basic techniques for these pencils are simple to follow (see page 69). Try laying down some color, then washing over it with a wet brush. This gives a range of blended effects and washes. Soft pencils create intense, even washes, while harder pencils give paler washes, and the drawn marks tend to remain visible.

You can also draw on damp paper, or into wet, preblended color. The lines are softer than those drawn dry-on-dry, and the pigment dissolves less than brush-washed color.

You can even dip a pencil into water and draw on dry paper with the moistened tip. This is only practical for small details since the tip absorbs very little water. But if you are prepared to keep dipping, you can build up areas of texture—fur and feathers, for examples.

◄▲ As a general rule, water-soluble colored pencils are softer than conventional pencils. The degree of softness varies from brand to brand, so it's worth buying a few singles first to see which range suits your style. If you concentrate on linear and textural qualities, with limited areas of blending, go for a harder variety. If you like to work boldly and loosely, using larger washes, you are better off with softer pencils. Or combine the two types.

When you have chosen your pencils, spend time exploring their characters. Try different papers—the results can be remarkably diverse.

Thistles and nigella

▶ **The setup** A combination of delicate details, soft tones, and a splash of bright colors make this arrangement of thistles and nigella (love-in-a-mist) perfect for a drawing in water-soluble colored pencils.

If you are interested in textures, there are plenty for you to experiment with here—the crisp tissue paper, the crinkly nigella petals, the spiky thistles, and the solid wooden tabletop.

Pencil marks

blue gray

Prussian blue

cobalt blue

light violet

bottle green

grass green

zinc yellow

primrose yellow

raw sienna

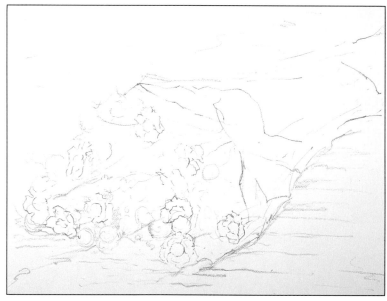

◀ **1** Start by roughly placing the objects very lightly on the paper with the bottle green pencil. Then, using Prussian blue, draw the outlines of the flowers and tissue paper. Try to show the crinkly edges of the nigella petals and the shapes of the centers. Indicate a few of the stems, and circle in the main thistle heads.

Now draw the tabletop in raw sienna, suggesting the quality of the wood grain with irregular strokes.

▶ **2** Dampen the flat brush with clean water and start to blend the marks. Use horizontal strokes for the raw sienna of the tabletop. Then do the same with the edges of the tissue paper.

Notice how the water deepens the lines, giving them a rich, velvety quality.

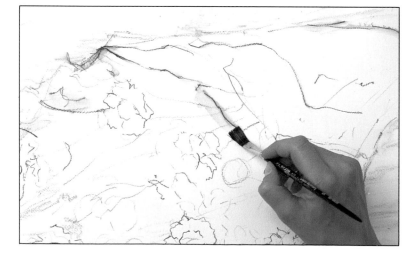

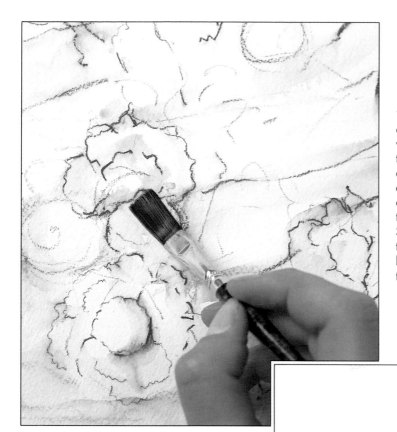

Three ways with water

▲ Draw, hatch, or scribble with a pencil on some watercolor paper. Blend the color by washing over it with a wet brush and clean water.

3 Pick out some of the darker stalks, drawing them in with bottle green. Then blend the outlines of the nigella petals and centers with the brush and clean water. The color spreads out gently and unevenly, giving the flowers softly graded tones. Soften some of the outlines of the thistle heads with water too, before you begin to develop them further.

4 Now that you have laid in the basic composition, start to introduce more colors. Do not be afraid to work over the areas where you have already added a wash. Draw into the nigella flowers with light violet, showing the way their petals overlap. Add more stalks with the side of the blue gray pencil, then strengthen the outlines of the thistle heads— some with light violet, others with blue gray. Scribble these two colors onto the thistles in varying amounts, then blend in the scribbles with some clean water.

Do not use your colors according to a formula. Vary them—and their amounts—on all the flowers so they do not all look the same. This creates a much more interesting picture.

▲ Wet the paper with some clean water and a brush, then draw into an area with a dry pencil. The marks bleed, yet still retain their main shape.

▲ Dip the tip of your pencil into some water and draw on dry paper. The wet pigment crumbles off to leave a highly textured mark.

5 Bring some brighter colors into the picture. Use grass green to add lighter stalks, washing them down with clean water. Notice how this green turns toward yellow when diluted.

Now work up the flowers, starting at the bottom right of the picture. Scribble varying amounts of grass green and primrose yellow onto the thistle heads for lighter tones, and soften the scribbles with water. Then stroke in spikes on the thistles with blue gray.

Add touches of primrose yellow for light tones on the nigella centers. Reinforce the petal outlines using blue gray and bottle green. Change the pressure you apply on the pencil for varying tones.

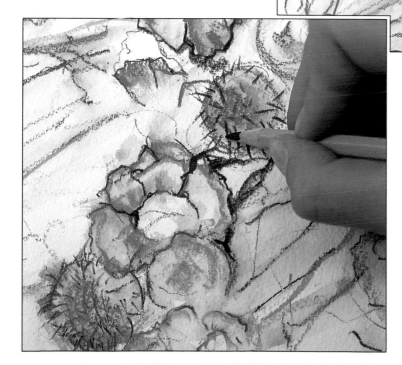

◄ **6** Put in more stems with grass green, making strong, jagged lines with the side of the pencil. Remember—you can be selective about which stems to include.

Stand back and assess your progress. You need to continue to work around the picture as you build up all the elements. Rest your hand on a piece of tissue paper to avoid smudging your drawing.

▶ **7** Develop the thistles by blending varying amounts of the same colors as before. For the spikes, use blue gray, cobalt blue, and light violet. Use both greens to strengthen the stems, washing down the lines as you go. Add zinc yellow to some nigella centers.

Use your technical pens for fine details. Add dark spikes to the thistles, and outline some nigella petals. Draw fine scribbles on the petals for their crumpled texture. Add black dots to the nigella centers for texture.

▼ **8** Build up the tabletop by laying more raw sienna at a different angle over the existing marks. Allow the paper's texture to show through. This contrasts well with the delicate detailing on the flowers and hints at the texture of the wood. Add more stalks with bottle green and grass green.

The finished picture shows both qualities of water-soluble colored pencils. The subject demands attention to fine details, such as the tiny spikes on the thistle heads. Yet the areas of softly blended colors add a sense of delicacy to complement the subject. They also give the flowers a more rounded quality, suggesting the gentle folds of the petals.

CHAPTER TWO
Essential drawing techniques

Drawing ellipses

Knowing how to draw good ellipses is essential to drawing cans, bottles, jugs, wheels, and a host of other circular objects.

If you look directly onto the top of an unopened can of beans you will see a circle. But lower your viewpoint slightly, and you no longer see a circle but a circle in perspective—an ellipse. Badly drawn ellipses create a sense of imbalance and can spoil a drawing. You will meet ellipses often— even a simple drawing of flowerpots or coffee cups can involve a number of them—so it is important to learn how to draw them well.

Ellipses present two problems. First, if you have ever tried to draw a circle freehand (without the aid of a compass) you will know how tricky it can be to draw a smooth, regular

> ## " Ellipses are a wonderful aid to getting distance in a picture. "

curve. Ellipses are smooth regular curves and, in this respect, just as tricky to draw as circles. The second problem is that they change shape relative to eye level. In other words,

ellipses can be deep or shallow depending on your viewpoint. We will look at this in more detail on page 79. For the time being, let us assume you have observed your ellipse from the correct viewpoint and all that remains is to draw a smooth curve. It is much easier to draw a square seen in perspective and then to draw an ellipse within, than to draw the ellipse straight off, but you should also practice drawing them freehand.

► Drawn well, ellipses play a useful compositional role— helping to lead your eye into a picture and creating a sense of depth. See how many ellipses you can spot in this picture.
Whiskey Blending by Albany Wiseman, pencil and watercolor, 16 x 10 in. (40 x 25 cm.)

Freehand ellipses

▲ To draw ellipses freehand, keep your wrist and pencil fixed. Let your elbow provide the sideways movement and move your arm back and forth at the shoulder. This way the arm acts as a helpful constraint. By varying the movement, you can draw shallow (flatter-looking) ellipses or deeper (more rounded) ones.

Guides to construction

▲ Here a circle has been drawn as if viewing a cylinder head-on. Think of the circle as fitting into a square. The intersection of the square's diagonals (the point where they meet) coincides with the center of the circle.

◄ ▲ Now imagine that the square is tilted away from you so that it is seen in perspective (left). The circle within is seen in perspective too—as an ellipse.

You can use the square construct, with its centerlines, to help you draw an ellipse (above). Rather than drawing it in one try, sketch in the curve at the four points where it touches the square (a, b, c, d). Then try to gauge where the curve passes through the diagonals and sketch in these (e, f, g, h). When you can "see" the whole figure, join up the sections of curve smoothly to make an ellipse.

When an ellipse is drawn within a square in perspective, the square's centerlines make it appear as though the ellipse is not symmetrical—as though the near side is larger than the far side. This is in keeping with the rules of perspective. But in fact an ellipse is symmetrical around its true centerline (seen above as a black broken line.) Three good ways of checking to see if your

ellipse is symmetrical are to turn over the paper and look at it from the reverse side, turn it upside down, or look at it in a mirror. A fresh point of view helps you spot faults you have grown used to. Then you can make any necessary adjustments.

Two common mistakes

The square method of construction is only a guide. A common mistake is to make an ellipse pointed—like a rugby ball. Remember that it is a continuous curve and as such, does not have ends.

Another common mistake is to squash the ellipse to make it fit into the square. The result is a figure with curved ends and flat sides. Your ellipse should just "kiss" the inside of the square.

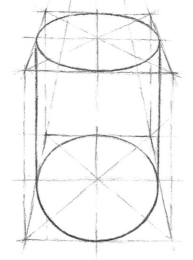

◄ Use the same method to draw a cylinder in perspective. First construct the box in which you want your cylinder to stand. Draw the ellipses at each end and put in the sides. No matter how well your ellipses are drawn, they will not sit properly if they are too shallow or deep—that is, if they are not positioned correctly relative to your eye level. You must draw your box in the correct perspective.

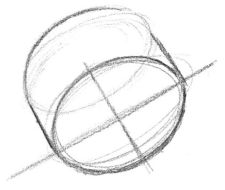

▲ Often you will want to draw a cylinder resting on its side. As a rule the sides are perpendicular to the longest centerline; you can observe this for yourself.

Ellipses in a still life

The most important aspect of drawing ellipses is putting them within a composition—relative to your own viewpoint. Give it a try.

Choose any group featuring ellipses. Cups and saucers, jugs, vases, bottles, and bowls are obvious candidates, but do not rule out dusty corners of your loft, cellar, and tool shed for more offbeat articles. Rooftop scenes of smokestacks or the stumps of felled trees at the edge of a forest would provide interesting outdoor subjects.

Make a simple, structural line drawing before you start using color. (Charcoal is easy to remove, making any adjustments to your ellipses easy, and you can dust it down to leave a ghost image.) Carefully observed, your ellipses should lead your eye into the picture. You can then develop your drawing by using oil pastel or wax crayon, for example.

Remember that you are not drawing to a mathematical formula. The idea is to create a picture. So give due consideration to light, tone, reflected light, shadows, negative shapes, texture, and color. Often, you can transform a mundane subject. The inspiration is in your interpretation.

66 *The inspiration is in your interpretation.* 99

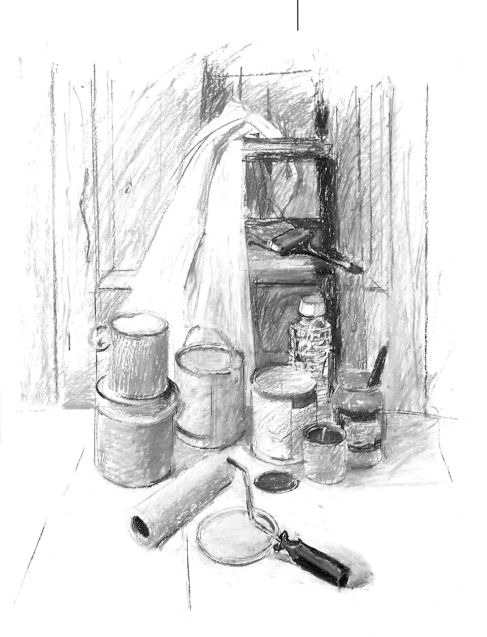

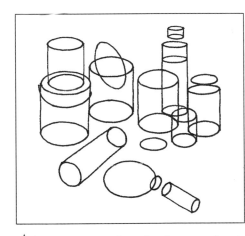

▲ ▶ **You can see from this diagram (above) where the main ellipses occur in the finished drawing (right). Notice how ellipses resting on the table become shallower as they recede— depicting the surface as a flat plane. The deepest ellipse is the lid right in the foreground. The handles of the paint cans are made up of ellipses, too.**

The decorator's table

YOU WILL NEED

- [] A 18- x 24-in. or 12- x 18-in. sheet of good-quality drawing paper
- [] A few sticks of willow charcoal
- [] An assortment of oil pastels or wax crayons
- [] Easel, drawing board and masking tape, drawing pins, or clips

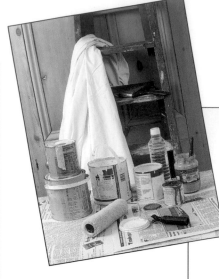

▲ **The setup** This collection of paint cans, decorator's brush and roller, bottle, jar, drop cloth, and ladder has plenty of elliptical shapes and cylindrical forms. It provides an attractive, if unusual, subject.

►**1** If only for the purpose of this exercise, start with a fairly careful, analytical drawing to provide a basis for your picture. Make sure your ellipses conform to the rules of perspective as they are seen from your own viewpoint. Here I have drawn in the two true centerlines of symmetry for each ellipse and then drawn in the curve around these. You can use this method or, if you are struggling, use the square construct shown on page 74.

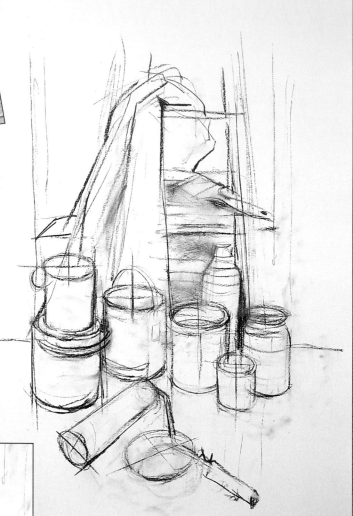

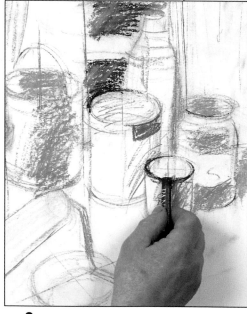

►**2** When you are happy with your drawing, develop it in oil pastel or wax crayons. Do not lose sight of the structure, though. For example, you might find an ellipse at the top of a can is drawn too deep (too rounded) in relation to the one at the bottom. If this is the case, do something about it—make it shallower. Labels, such as the one around the jar on the right, help you to describe cylinders.

►**3** Look at the setup through half-closed eyes and you will see that the lightest tones are on the drop cloth and the darkest are framed within the ladder. But many of the forms (such as the cans) are seen as subtle grays—mid tones. To this end, scribble in some grays and blues on the cans and just hint at a few other colors.

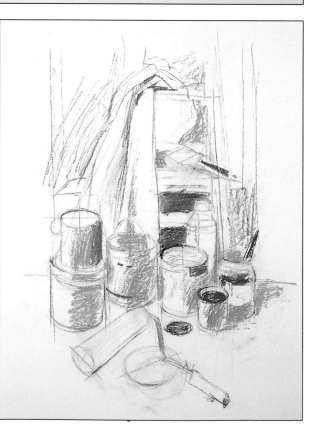

◄ **4** Use your medium sympathetically. Unlike a dip pen, which is a sharp tool, a stick of oil pastel is essentially a blunt instrument. Rather than struggling to describe fine detail, enjoy the coarse marks and broad treatment it has to offer.

After blending in more blue (roughly equivalent to a cerulean), lighten the tones with white. (Oil pastels are well suited to this and differ from soft pastels in this respect.)

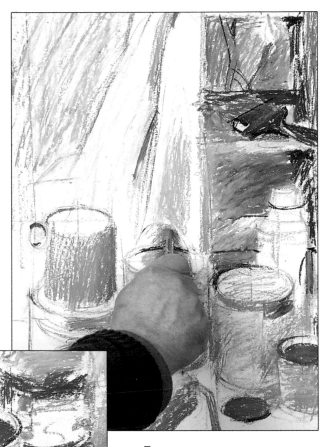

▲ **5** The handle of the paint can provides a good example of how negative shapes can help. Here, the artist is drawing the darker tones in the creases in the cloth and, by doing so, describing the negative shape inside the handle—a semiellipse.

◄ **6** Whether you are drawing a paint roller or a motorcycle, it is important not to flaunt the laws of mechanics. The roller ought to look as if you could pick it up and paint with it.

Give due regard to texture. Here, broken flecks of pink, gray, and ocher give the roller a warm, feathery appearance. The handle is made of a dense black plastic that looks harder.

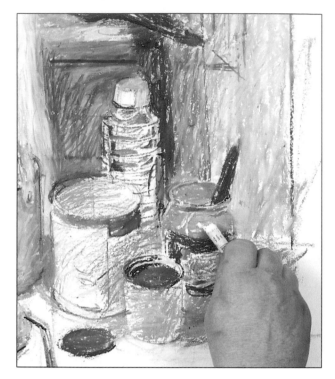

▲7 Where there are large areas of reflected light—such as on the transparent bottle of mineral spirits—you will find it helpful to use the white of the paper. For little points of reflected light—such as those on the jam jar—try white pastel, as the artist is doing here.

A number of third colors have appeared in grays and browns—but often they have been modified with a selection of warm yellows and complementary violets, so they do not look flat and dull.

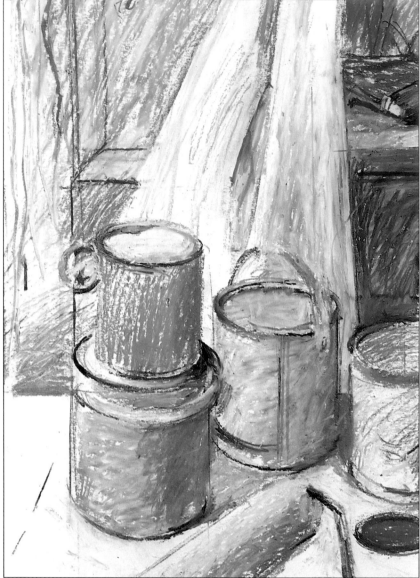

Tip

Resting cylinder
When you come to draw a cylinder resting on its side—such as the paint roller shown here—refer to the little rule mentioned on page 74. The sides (edges) of the roller go back from the ellipse at the front, at right angles to the longest centerline. (In step 1 you can see the centerlines drawn in.) This is true for any cylinder, resting at any angle.

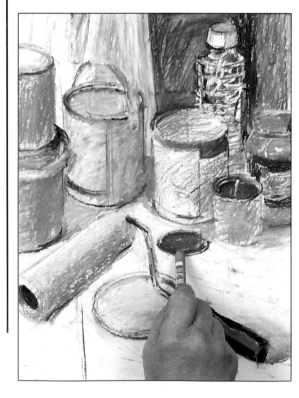

▲8 When you have in the background an object that is a warmer color than the color of an item in the foreground, such as the door and cans, the danger is that they will try visually to exchange places. You can prevent this by drawing the background object more loosely—with less emphasis—and also by introducing a hint of warmth to the objects in the foreground, and a hint of coolness to the background.

◄9 Although many of the grays and blues have been blended, quite a few of the strokes of brighter color simply lie next to one another—so that they mix optically. This is similar to the way the Impressionists used color.

One of the joys of drawing is that you never quite know where you are going to end up. This exercise, which started with ellipses, has ended in quite a blaze of color!

Drawing in perspective

Make an exciting picture out of everyday objects – and learn a few lessons in perspective. Also discover some devices and techniques to help you plan and construct your compositions.

Inexperienced artists sometimes complain that they cannot find good subjects for a picture. Actually, inspiration is right under their noses—it is just a question of seeing a subject's potential.

> *66 You might dismiss a scene like this as inappropriate or lacking in romance, but your own interpretation can give it any quality you like. 99*

In this exercise, the artist suggested that his student draw the countertop, which is set for breakfast. The idea was to show how large items appear smaller the farther away from you they are placed. So although the teapot in this setup is much bigger than the egg and eggcup, it appears the same size from the artist's viewpoint,

as the student found when she used her pencil to measure and compare the sizes of the objects that she was drawing.

Although the setup is of ordinary objects, it is no easy matter to draw them. There are quite a few ellipses to contend with—the plates, jars, glass, mug, and eggcup—and they all have to be drawn in perspective. In addition, the student is quite close to the countertop, so she is looking down at the objects nearest to her, while those farther away are seen more in profile. This makes it difficult to get the plates to "sit" firmly on the countertop in the drawing.

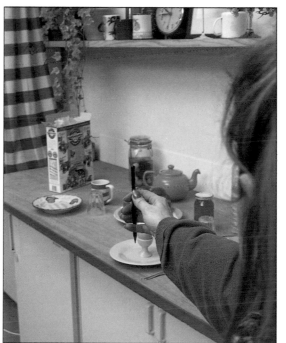

◀ **1** It is important to measure and compare the sizes of the objects in the setup—getting these right helps create pictures with a ring of truth.

Consistency is vital to good measuring. The student extends her arm to its full length (if she bends it, the measurements can vary each time). It is also a good idea to put some masking tape on the floor in front of each foot so you can easily return to exactly the same position.

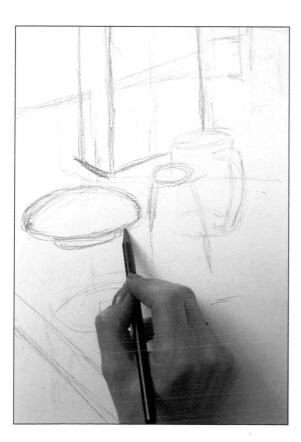

◀ **2** Drawing is a process of constant assessment and adjustment, so the student is starting boldly here, putting in a few objects at the back, and then seeing how they work together on the paper. It does not matter if the first marks are incorrect—until there are some marks on paper, however rough, the artist has nothing to work with.

► **3** The student has made a good start, but before she goes any further there are a few things she should think about. In particular, the artist points out the way objects change in perspective when they are closer—or farther away. The ellipses of the plates and the cup and saucer at the front are rounder than that of the plate at the back of the setup because she is looking down on them, whereas she sees the plate at the back more in profile.

It is easiest to get these right if you use construction lines to draw in the cross sections before you draw the curves, as the artist is doing here.

Remember, too, that the countertop has a role—it comes up to support the objects on top of it. So if you establish this first, it is easier to place the items on top.

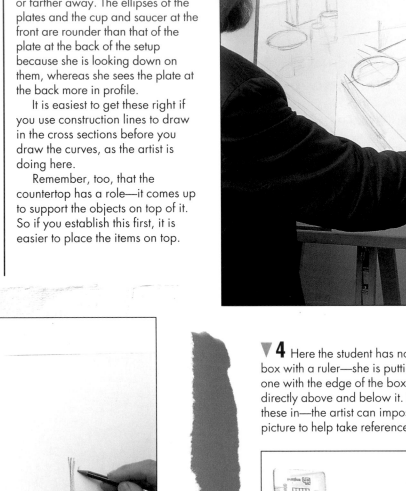

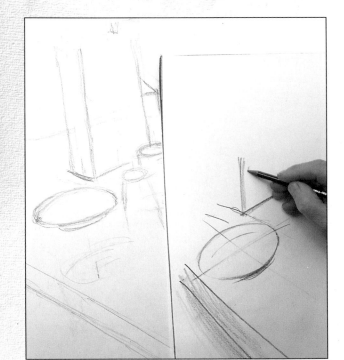

66 Start by putting in the countertop itself—think of it as a surface that rises up to support the items on top. Now it is easier to plot the plates, cereal box, and so on. Draw them in relation to the countertop and to each other, putting in the ellipses of the plates by first plotting their cross sections, as here. 99

▼ **4** Here the student has not drawn the edge of the cereal box with a ruler—she is putting in a few plumb lines, aligning one with the edge of the box as a reference to see what falls directly above and below it. It is not always necessary to draw these in—the artist can impose an imaginary grid on the picture to help take references.

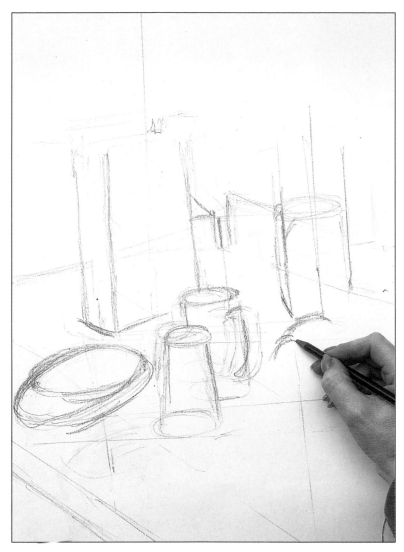

◀ **5** As mentioned in step 2, drawing is a matter of assessment and adjustment. The student has made some amendments to the ellipse of the plate at the back and the lines of the worktop. She keeps her pencil traveling over the whole surface to assess the relationships between items.

The student has placed her easel so she can see both her drawing and the setup. If you place your easel at 90 degrees to the setup, you carry the memory of the composition to paper for an inventive result.

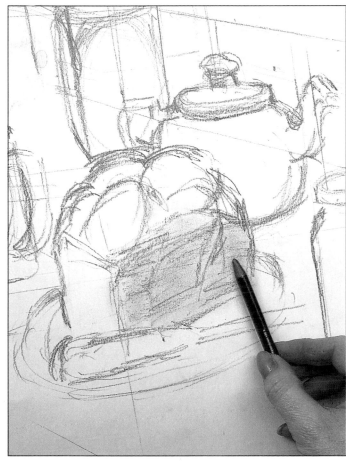

❝ *You have to use lines to get structure, but you do not want to make the whole picture so linear that it does not "own" any tone. Tones help to create a three-dimensional image and establish atmosphere. Start to indicate some of these early on so they integrate into the picture— they should not be an afterthought.* ❞

▲ **6** The loaf of bread may look complicated but you can think of it simply as a shoe box with an uneven top. The plates, on the other hand, are more or less flat, and you will need to make sure the conjunction of these different items works.

One of the ways of doing this is to use tone, as the student is doing here. This is important; by reducing color areas to light and tone, she is making the items look more three-dimensional. She must also remember to check back on the placement of the various items. Using the shapes of the shadows and the negatives as well as the identifiable forms of the objects themselves helps produce a more accurate drawing.

▲ 7 Most of the basic elements are now in the picture, so it is a good point to stop and get an overview and think about the way the drawing can progress. The student needs to carry on refining her ellipses and to put in the remaining elements, such as the curtain at the back, the eggcup, knife, and so on.

▲ 8 You can check your ellipses by turning the picture upside down. It is a good idea to do this whenever you are drawing ellipses—it gives you the chance to take a fresh look at your drawing. Often your mistakes jump out at you when you see them at an unfamiliar angle.

▶ 9 The student is using the eraser not to remove her mistakes but to clean up after she has adjusted her ellipses. It is not a question of erasing all the extraneous lines—these construction lines make the drawing lively—but it is important to remove any that have become distracting. For example, at a later stage she will erase the contour of the plate where it cuts right through the egg.

You can check to see that all of the objects are drawn correctly by looking at the shapes between them. Observe the nice interplay between the objects, leading the viewer's eye deeper into the drawing and encouraging it to roam between the plates, glasses, jars, and everything else on the countertop.

It is helpful to compare drawing a picture to constructing an engine—if one part goes wrong, the whole thing will not work. Therefore, it is important at every stage of your work to keep reevaluating the drawing and correcting anything that is slightly wrong.

The student featured here is following the good practice of building up the whole picture together. She is not concentrating for too long on any one area, and she is adding a few tones as she progresses.

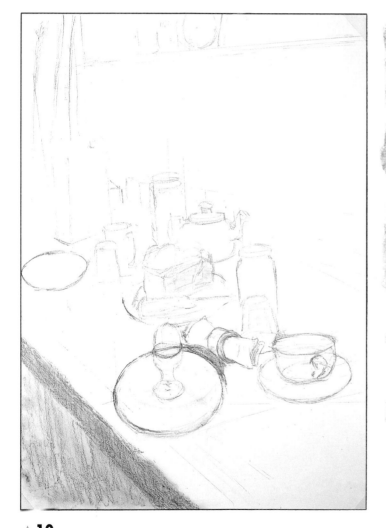

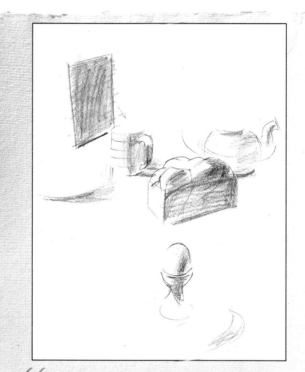

▲ **10** The student is using the softer pencil to stress a few contours and to work on the tones and shadows. Notice how the shadow between the plate and napkin serves to "push" this space back, as does the dark tone on the front of the kitchen units. However, she is not going to take the tones too far, otherwise she could end up simply filling in a line drawing.

❝ *The tones and shadows play an integral part in the picture, helping to describe the dimensions of the objects. Take the loaf of bread, for example. The artist has scribbled some tone onto its side to indicate the plane, just as she would if she were drawing a skyscraper or a double-decker bus. Likewise, some quickly scribbled tones give form to the curving sides of the mug and egg.* ❞

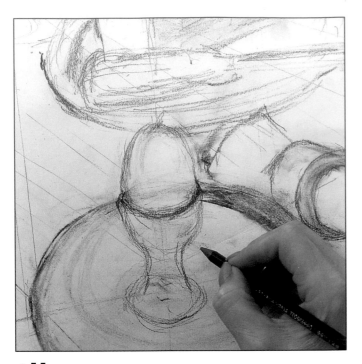

▲**11** Continuing the process of adjustment, the student has redrawn the ellipse of the plate, taking it right through the egg. If you work like this, as if everything is transparent, you will be able to see how each item and each angle relates to the others. Once you are happy with the placements, clean up with the eraser.

❝ *The napkin ring is a short cylinder with an ellipse at the front, but this time the ellipse is standing upright. It is best to start with the ellipse, putting in its axes to help you draw accurately. Remember that the napkin is penetrating the napkin ring—try to get a sense of this in your drawing.* ❞

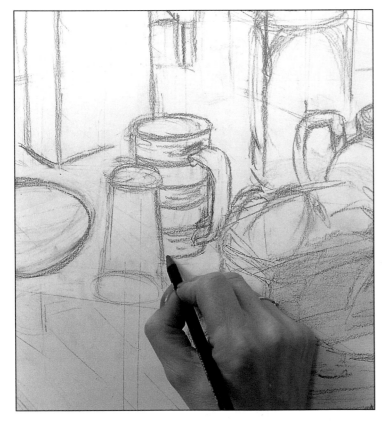

◀**12** In order to ensure unity, the student chose not to duplicate the elaborate patterning on the china, but decided to indicate the stripes on the mug. These add a decorative element to the drawing and, by wrapping around the cylinder of the mug, help to delineate its form.

▶**13** Notice how well the student has drawn the knife—with economy and assurance. The blade is an extension of the handle, not a separate entity—which would make the knife look broken.

The drawing is now almost finished, so she is making some final adjustments, reemphasizing a few contours and lifting out lights from the dark charcoal tones with the eraser—as on the side of the egg.

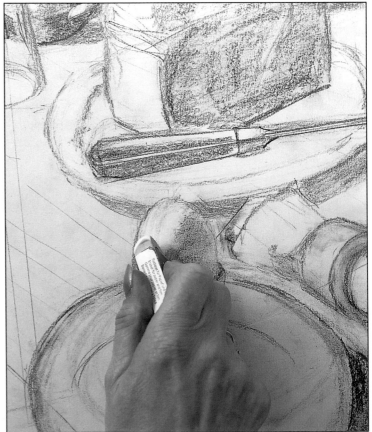

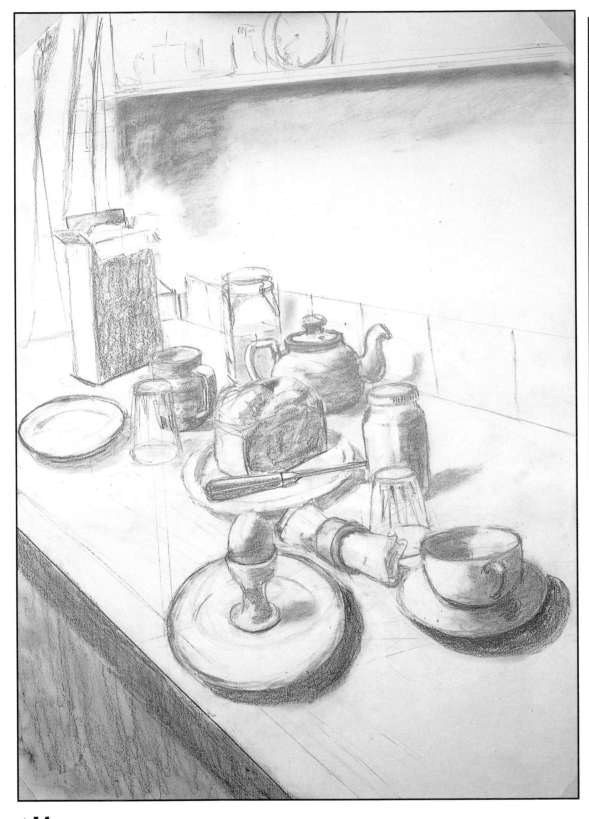

▲**14** A few more shadows and tones give the objects greater solidity and help to provide a firm footing. The shadows cast by the teapot spout and farthest jar, for example, travel across the countertop and up the wall, not only giving substance to the items themselves but also revealing the form of the areas around them. It is not necessary to put much work into these background areas, but it is important not to overlook them, otherwise the items will appear to be floating in space.

For the area of shadow under the shelf, the student stuck masking tape along the shelf edge, then simply scribbled up to and over it. In this way she could work neatly and yet still give energy to the marks.

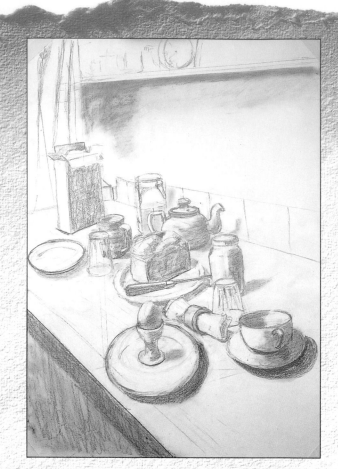

66 *The plate with the eggcup on it is not sitting quite firmly enough on the countertop. To avoid this, think of all the items as being aligned to the edge of the countertop rather than to the edge of the paper (see below). Then draw the cross sections of your ellipses, remembering that the axes running across the countertop converge on a vanishing point to the right.* 99

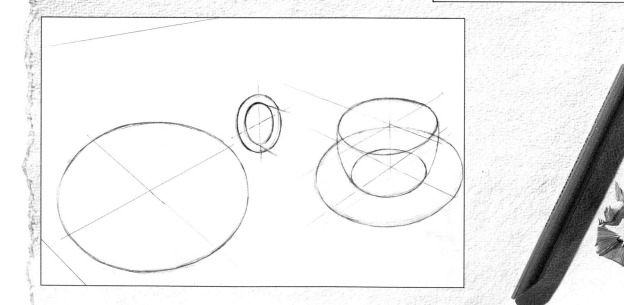

YOU WILL NEED

- [] *A new HB pencil*
- [] *A sheet of 12-x 18-in. drawing paper*
- [] *Drawing board; pins, clips or masking tape*
- [] *Colored pencils*

Measuring with a pencil

Try your hand at measuring horizontals and verticals using your pencil. Distance yourself sufficiently from your subject so you can work on the received scale—that is to say, so you can put marks down directly without having to scale up or down to fit them on the paper. When there is an angle—the slope of a roof, for example—pinpoint each end of the line by taking note of horizontal and vertical measurements, and then join the points.

Taking measurements from your subject

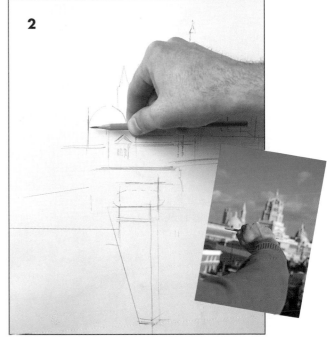

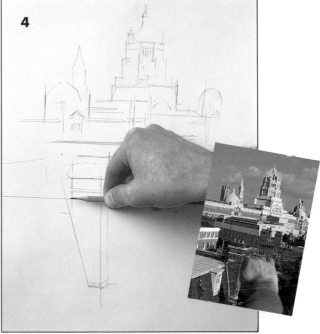

Look for a convenient dimension—one you can use more than once. The artist is using the height of the chimney as a yardstick (**inset**). Hold your pencil at arm's length so it falls alongside the chimney. Line up the pencil tip with the top, and slide your thumbnail down the pencil until it coincides with the chimney's base. Keeping your nail in place, transfer this measurement to your drawing (**1**). Measure horizontally in the same way by turning the pencil through 90 degrees (**inset** and **2**).

Repeat key measurements across your drawing. Here (**3**) the height of the chimney is laid on top of itself and the pencil tip reaches almost to the top of the tower. The width of the chimney (**inset** and **4**) is used as a key dimension for the horizontals. (Notice that this is equal to the width of the dome on the left. Such relationships provide short-cuts to accuracy.)

A tonal strip

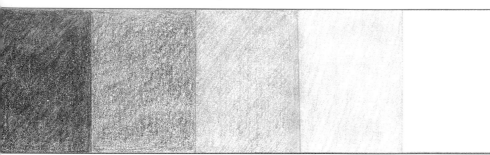

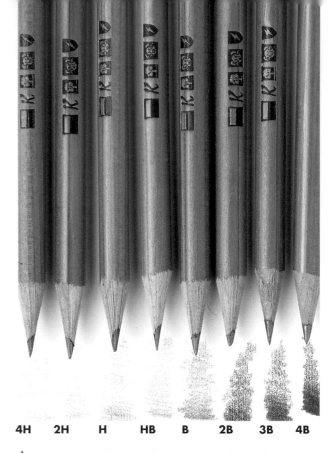

4H 2H H HB B 2B 3B 4B

▲ Before you start drawing, it helps to try out a few marks on a scrap of paper. Choose several different strengths of pencil—a good range is shown here, from 4B (very soft) to 4H (very hard). Draw a few lines using the pencil point and the side of the pencil; do the same with shading, pressing lightly, and then more firmly.

You may find it helpful to refer to your range of marks when you begin a picture.

THREE GOLDEN RULES
1. Draw what you see, not what you know to be there, even if you think it looks peculiar.
2. Do not focus on one part of the drawing at a time. Develop the entire drawing and keep the whole thing moving.
3. Remember that in an exercise the process is much more important than the finished picture.

The minimum number of tones you need to achieve a three-dimensional effect on paper is just three—white, black, and mid gray. These make a strongly contrasting image. Five tones give more subtle effects. The more tones you build in (nine or 10, say), the more three-dimensional it becomes.

By seeing—and interpreting—the tones carefully, you can begin to depict solid forms convincingly in your paintings and drawings.

To help you see how tone works, make a tonal strip like the one here. Draw five squares on a sheet of white paper, then using a soft 4B pencil, color the last one black. Working back along the squares, color each a lighter shade of gray until you reach the final square, which is white. (You may find it easier to put a mid gray in the center, then work lighter and darker tones on each side.)

2B

HB

H

▲ Smudging is a very useful technique. Make some pencil marks, then soften and blend them by rubbing gently with your finger. This gets rid of hard lines and gives greater subtlety of tone and texture. Keep the scrap of paper handy in case you want to check marks later.

1

2

Try this for tone
Seeing tone clearly takes practice; this experiment will help. Put a white jug or cup in a darkened room, then light it from the side with a single light source—a desk lamp, for example (1). You can see that the jug has a very bright side nearest the lamp and a very dark side furthest from it. Notice too, in particular, how the light travels across the curving side of the jug, creating a gradual transition between the strongest lights and the darkest darks.

Now try the experiment again, this time folding a small piece of white matboard and standing it up so that one flat surface is at q right angle to the light, with the angle of the fold facing you (2). Again, you can see one bright surface and one dark surface—but this time the transition between the light area and the dark area is abrupt, creating a crisp "edge" along the fold. Look for these transitions in your subject as you draw.

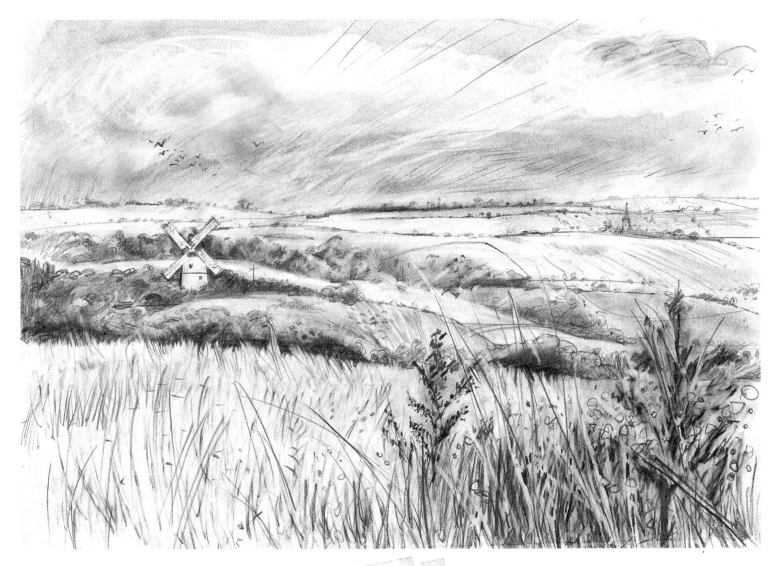

Being selective

The essence of composition is decision-making—what shape support to use; what to put into your picture, and what to leave out; and how to organize the elements within your chosen format.

If all this sounds straightforward, it is —once you know how to do it. However, faced with a multitude of possibilities—in a panoramic landscape, say—being selective can be very tricky.

In this simple exercise you will see how best to arrive at some decisions about composition. To try it for yourself, you need a large photograph, a picture from a magazine, or a sketch like this one made on location. See how many compositions you can get from the image. But before you start, here are a few words of advice.

L-shaped frames

A pair of L-shaped frames makes the task easier. Simple, effective, and inexpensive to make, they are a vital part of any artist's equipment.

10 to 18 in.

Frame your composition with the Ls

Cut them from a piece of heavy matboard so that they are rigid and sturdy. Choose a neutral color like gray or matte black so they will not distract from the composition itself.

The size depends on the size of your drawing; it is better to make the frames too large than too small. You can focus on a small area with big L's, but you cannot enclose a large area with tiny ones. A frame of between 10 and 18 inches long on each side by 3 inches in width is about right.

◄ Move your homemade pair of L's around the image—it might be a panoramic sketch of a landscape like the one shown above—composing pictures as you go. Change the size and shape of the various compositions. The best way to compose pictures is to divide the drawing into thirds in your mind, both vertically and horizontally. One of these imaginary dividing lines is an effective place for the drawing's focal point, i.e. the main point that draws the eye. Where the dividing lines meet are the four key points. Any one of these spots is an ideal place for the focal point. Also try it in the center.

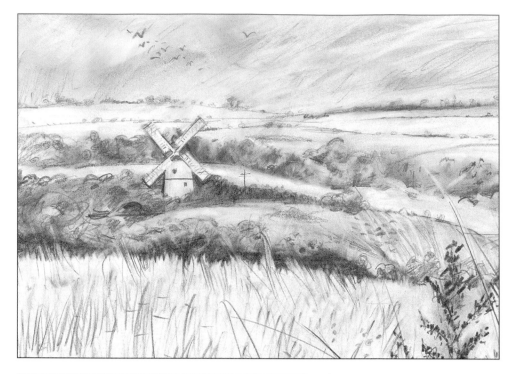

Using your L's

Move your L shapes across the surface of your chosen image, looking for interesting subjects. When you find one that pleases you, explore different formats—different shapes suggest different emotions and moods.

With the landscape format (horizontal) the eye can roam from side to side and there is a sense of calm and restfulness.

With the portrait format (vertical) the rectangle is tipped on its side and the eye is restricted in its side-to-side movement. It can't go deeply into the picture space either. There is, however, a great deal of up-and-down movement, which creates a feeling of grandeur, stillness, and formality.

The square is the most neutral support shape. Stable and compact, it invites the eye of the viewer to focus on the central point of the picture.

As well as formats, look at different compositions. Try the focal point on the left third, the right third, on one of the four key points, and in the center.

Once you have mastered the art of using your L frames, you will wonder how you managed without them!

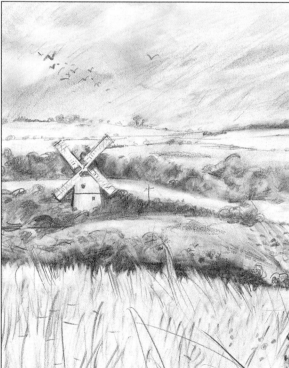

▲ Landscape format. The main focal point (the windmill) is located on a vertical third, and because the picture has a landscape format, the viewer's eye is invited to travel around it. Notice that the horizon is on a horizontal third.

◀ Portrait format. Again, the windmill is one-third in from the left, and the horizon one-third from the top. With the picture in this format, the mood is different. The viewer is taken deep into the scene on an undulating journey through the contrasting angles of the foreground grasses, mass of foliage, and strips of light, up to the clouds in the sky.

▶ Square format. The foreground occupies about half the picture area here and takes on the role of a much more important feature.

The energy of the varying angles in the grasses—together with the fern bracken—creates a foreground that holds attention and entertains the eye. From there, the "journey" back toward the horizon takes up about the same area but contains many more features.

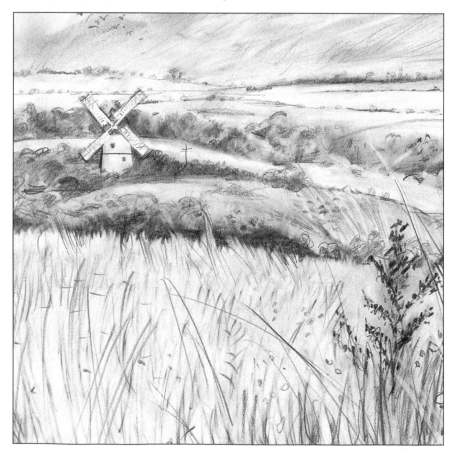

Gridding-up

Use a grid to change the scale of an image—making it larger or smaller to suit your purpose.

There are many reasons for making a drawing. You might want to try out a new medium or technique, or to produce a highly finished drawing (for your own pleasure or perhaps even to sell or as part of a school requirement), or to record something—a person's expression, say; or you might make a preliminary drawing for a painting. Whatever the reason, at some time or other you will probably want to make a copy and you might want to make it a different size from the original, scaling it up for a painting for example. The demonstration on page 92 shows

copy paper—such as canvas, or even drawing paper for that matter—you will have to make another transfer.

The method advocated here is the traditional one of drawing a grid onto the original image (gridding-up), and then transferring essential features to a second, larger or smaller grid. If you do not want to spoil your original, draw your grid onto a piece of vellum or tracing paper and place it over the original. It is a good idea to spray fixative on the surface of your drawing first to protect it.

> ❝ Often you will see evidence of a grid in the finished painting—it is a traditional method that has been used by many great artists. ❞

you how to use a grid to do just that.

The quickest means of making a copy is to use a photocopier, and if it can enlarge or reduce, you can change the scale of the image, too. However, you might not have access to one, and in any case photocopiers have certain limitations.

If the image is already quite large—covering a 12- x 18-in. sheet, for example—you will probably have to tape several photocopied sheets together. If you want to make an enlargement greater than 200 percent or a reduction less than 50 percent, you will probably have to make copies of copies—each time losing more definition. Furthermore, if you want your drawing on anything other than

▼ **You might want to use a small drawing or sketch from your sketchbook as the basis of a larger painting or drawing. If so, grid-up your original drawing in the traditional way to transfer it. Here, the artist gridded-up a sketch prior to making a painting.**
Still Life on a Piano and a Table, with a Seated Woman *by Walter Richard Sickert, ink, pencil, and watercolor 11½ x 10¼ in. (29 x 26 cm.)*

YOU WILL NEED

- ☐ A drawing board
- ☐ A T-square (see below)
- ☐ A sheet of good-quality drawing paper, masking tape
- ☐ A large triangle (30 to 60 degrees or 45 degrees)
- ☐ An HB pencil
- ☐ Medium of your choice—pencil, charcoal, or ink

Scaling-up a drawing

▶ **The setup** Any small drawing will serve for the sake of this exercise—you could even use a photograph, photocopy or a picture from a magazine. We chose a pencil drawing of two Portuguese fishing boats (far right). It is accompanied by a colored sketch (right).

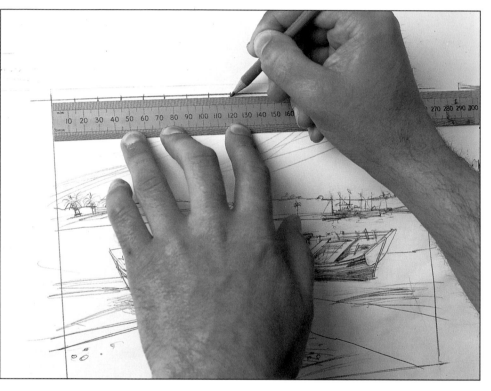

▶ **1** For the sake of neatness, first ensure that any true horizontal—such as a horizon over water—lies parallel to your T-square, then tape your drawing to the board. Draw a border around the image or the part you want to copy. Use the T-square to draw the horizontals. Rest the triangle on the T-square for the verticals.

Now choose a grid with a mesh fine enough to capture important features, but not so fine that it obscures the image (⅝-in. squares are used here.) Use a ruler to mark off the intervals along one of the horizontals.

▶ **2** Measure and mark out the same intervals down one of the verticals. Then, with a sharp pencil, draw the horizontal lines across the image at regular intervals. (Press your T-square firmly against the edge of your drawing board so the lines remain parallel.)

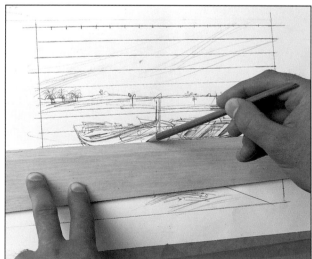

▼ **3** Again, making sure your T-square is pushed against the edge of the board, rest your triangle on top and draw the verticals. Keep an even pressure so the lines are equally thick and dark.

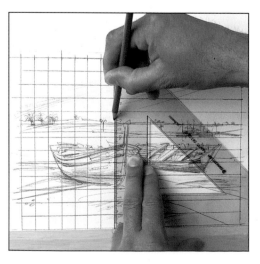

◄ **4** Draw the grid where you want your new image. If you want the copy twice the size, make the squares twice as big; half the size, make them half as big. We used a 1-in. square (just less than twice the size). Use the same format as you did for your original grid. (There are 17 x 13 squares drawn here.) Then label the axes—numbers for the columns and letters for the rows. These are labeled 1 to 17 across and A to M down.

► **5** The procedure for transferring points is similar to using an A to Z street-finder map. Choose a useful point (where a line changes direction abruptly, for example), check its co-ordinates, and plot these on the new grid.

Suppose you wanted to pinpoint the left corner at the back of the left boat. Look at the original sketch and you will see that the corner comes a bit over two lines across (just into column 3) and just over half way into row G. Find square 3G on the new grid and place the mark precisely in the square.

▼ **6** Do not look exclusively for points; often a complete line can be transferred—especially if it is horizontal or vertical. Here the vertical at the prow of the boat is a prime example. It falls on the line dividing columns 8 and 9.

▼ **7** Avoid making a stilted "connect-the-dots" type of drawing. Try to make the new image as fresh looking and spontaneous as the original. The secret is to redraw, using the coordinates to navigate your way around the paper.

Gridding-up for a composition

Here the artist used a grid with diagonals both to scale-up and arrange his composition (above).

The trench runs along one diagonal while the soldiers emerge along opposing diagonals (below left). The contrast between the highly ordered arrangement of figures and their dejected appearance creates a sense of vulnerability.

Over the Top by John Nash, in pen, pencil, chalk, and watercolor on paper, 12½ x 17 in. (32 x 43 cm.), © the Imperial War Museum, London

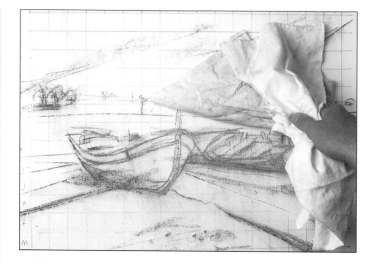

▲ **8** Rather than copying everything in sight, just transfer enough information to suit your purpose. If you are painting in opaque water-based paint (gouache), charcoal will be too obtrusive. Tap the drawing with a piece of clean rag to leave just a faint image.

▼ **9** There are a multitude of uses to which you can put a copy other than making a painting. For example, starting with a colored photograph taken from the TV, you might end up with a large, cartoon-style line drawing in black ink!

Remember, however, that if you enlarge too much, details become protracted—the information is too spaced out on the page. Conversely, if you make an image too small it looks cluttered, so find a happy medium.

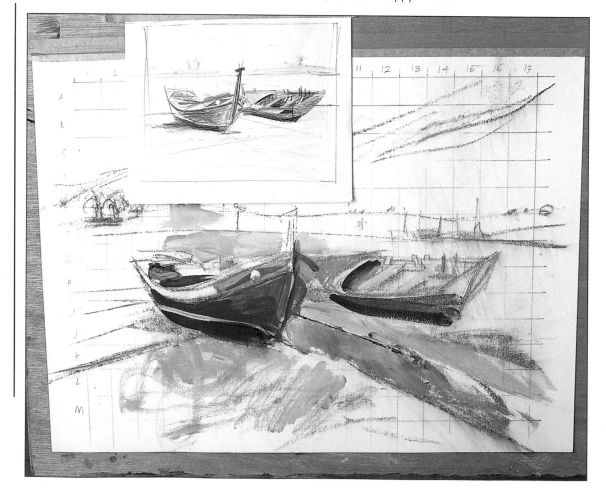

Drawing from a tracing

Use a photograph to discover more about tone and to learn how to render form convincingly.

The art of drawing is to create the illusion of form. If you think about it, it has to be an illusion because forms are solid things, whereas a drawing is flat—two-dimensional. So the artist's problem is how to depict the subject in three dimensions while using only two. The secret to drawing forms convincingly is to capture the tones. Whether it be eggs, flowers, melons, people, animals, or anything else that you are drawing, it is the tone that describes the form.

In the following exercise, a tracing of a photo portrait is used as the basis for a tonal drawing. The aim of the exercise is to analyze the tones and draw a solid. A photograph is useful because the tones are already laid out in two dimensions for you—all you have to do is look for them. However, do not make all your drawings by

> ❝ *The eye should be able to penetrate the surface of the drawing and enter into the picture.* ❞

tracing or copying photographs—that would be a very lazy thing to do. This is a special case.

When doing the exercise, bear in mind that you are making a drawing and not simply copying. One of the secrets of using a photograph to make a successful drawing is to think of it as a point of departure rather than a point of arrival—if you end up with a stiff copy you have defeated yourself. So do not be afraid to let yourself go on the final stages of the drawing. Your interpretation will bring it to life.

▼ **This drawing was made using only five tones. Although the artist took a tracing from a black and white photo, the result does not have a photographic quality—it looks like a drawing. The tones describe the form convincingly—a solid head and shoulders in space.**

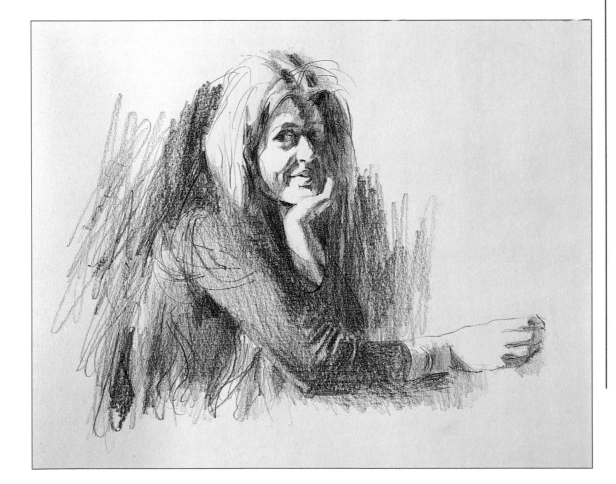

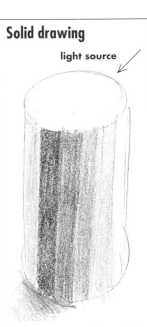

Solid drawing

light source ↙

The best way to render a solid is to look at the light, then the tone, then the shadow. The cylinder is lit from behind and slightly above by one source. The darkest tone is directly opposite the source. The tones gradually get lighter as they move around the cylinder toward the light. The surface is divided into six strips and there are five distinct tones (two are the same). Four are rendered with different pencils: H the hardest, to give the next lightest tone to white; HB to give a medium tone; 2B to give a darker tone, and 4B, the softest, to give the darkest. The fifth tone—the lightest—is provided by the white of the paper. The H pencil is repeated on the left side of the cylinder to create the impression of reflected light and the curve of the cylinder. The tonal strips are left as they are so you can see them but if blended together, they would make a convincing solid. A carefully placed shadow makes the cylinder look like it is resting on something. The same principles apply in the portrait here—as they do, in fact, in all drawing.

Portrait of a lady

The idea is to use a different pencil for each tone, as with the cylinder on page 95. You can get several tones with the same pencil by varying the pressure you apply, but that is not the aim here. Counting the white of the paper as the lightest tone, look for a total of five separate tones.

A head is a good subject because you can proceed almost as a sculptor would, picking out the hollows, but using tone instead of a chisel. If, at the end of the exercise, your eye can penetrate the drawing and roam in and out of the features, around the head, and into the space beyond, you have succeeded in creating your illusion.

It is always best to work on a comfortable scale. Most photocopiers can be set to enlarge and it is relatively inexpensive.

YOU WILL NEED

- ☐ A 12- x 18-in. sheet of good-quality drawing paper
- ☐ Masking tape; rag
- ☐ Tracing paper
- ☐ Easel or drawing board
- ☐ Four pencils—H, HB, 2B, and 4B
- ☐ A good-quality photo portrait

The setup Choose a photograph with plenty of contrast. The artist used a good-quality 5- x 8-inch black-and-white photo in which three tones are distinguishable between the extremes of black and white—five tones in all. You can use a color photo but it is harder to pick out tones. This image was enlarged by 200 percent, using a photocopying machine, which makes mapping out the tonal areas even easier.

▶ **1** Tape the image to a tabletop or board. Lay the tracing paper over the image and tape that in place. Keep the photo handy so that you can refer to it as you go along.

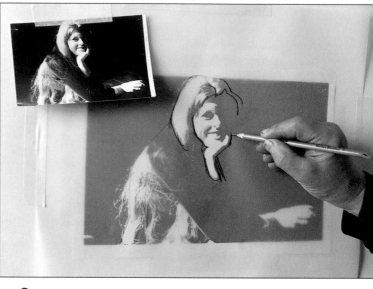

◀ **2** With your H pencil, trace the outlines—such as the side of the face—and map out separate areas of tone. Here you can see that the artist has mapped the lightest areas—for example, the whites—on the left side of the face, on the hand and wrist, and on the hair.

Do not be afraid to use your imagination. On the right side of the face there is little tonal variation, but the symmetry of the subject means that the detail is there. So map in the eye socket and the side of the face. Drawing from photos is one of the few times when you can depart from the rule of drawing only what you see.

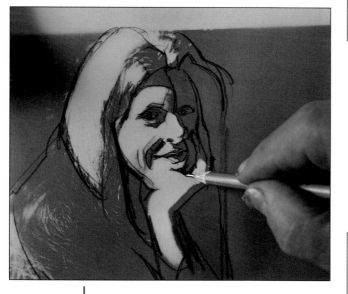

SOLVE IT

Consistent tone

The secret to achieving a consistent tone is to apply a light, even pressure with the pencil. If you hold your pencil in the usual way—close to the tip, as you hold a pen—you will find this difficult. Hold it about 4 inches from the pencil's end, with the tip resting lightly on the paper.

▶ **3** It is easy to miss lines, so from time to time lift the tracing away from the image. Keep the tracing paper attached to the drawing—that way you can sketch in missing lines without having to reposition the tracing.

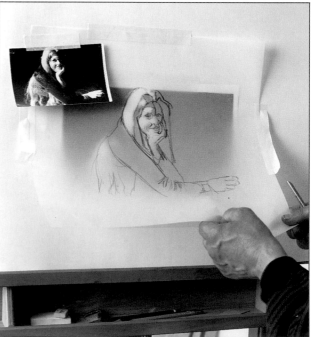

◄**4** Remove the tracing paper and turn it over. On the back, rub over the lines with your H pencil. What you are doing is making a kind of carbon paper so that you can transfer the outline onto a fresh sheet. Tap off the excess graphite with a clean rag.

▼**5** Remove the tracing and turn it over again. (You will see that you have already made a mirror image on the paper—so you will have to turn your drawing paper over too.) Tape the paper in place and tape the tracing to the paper. With your H pencil, go over the original outline.

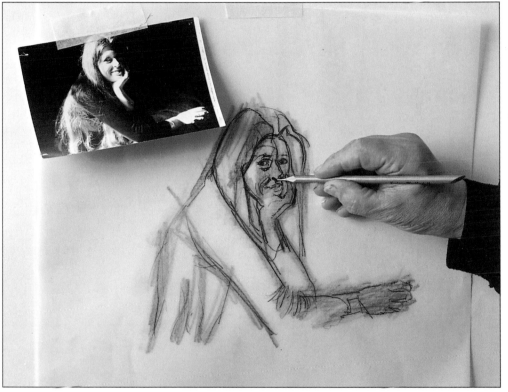

▼**6** Lift the tracing from time to time to check your progress. When you have retraced all the lines, you should be left with a faint image. Remove the tracing paper.

►**7** Look closely at your photo and identify areas of the next lightest tone to white. In the photo used here, the tones were everywhere—in the face, the hair, the wrists, and on the sleeve. Shade these areas with a light gray using the side of your H pencil. Press lightly and evenly and try to keep the pencil marks running in the same direction.

Tip

Tonal strip
The idea is to space the tones equidistant from one another. If you make the first two tones too dark, you will have very little room left for the last two. You might find it helpful to make a tonal strip to establish the tones for each pencil before you start (see page 88). That way you can refer to the strips as you go along.

►**8** When you feel that all the light tones are in place, have a look at your drawing from different angles to check that you have not missed any. Do not go on to the next tone until this stage is complete. The two tones—white and light gray—should already give you a sense of volume.

▼**9** The artist used the HB pencil to shade the medium tones: in the hair, in the eye socket, under the hand resting against the face, under the chin, and on the other hand. It is important to apply the same pressure each time. Do not forget that there are still two darker tones to add.

Let your eye rove over the whole drawing as you work, keeping a sense of the overall organization and all the while bearing in mind your aim: to create the illusion of a solid.

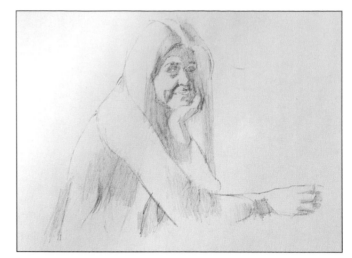

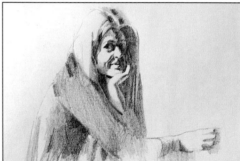

▲**10** Here, all the next-to-darkest tones are shaded with the 2B pencil. The jumper is left until this stage. Because of its color, all the tones are darker. By shading these with softer pencils you can convey a sense of this color with tone.

Look at how tone tells you about the nearest arm. The shoulder and upper arm are parallel to the picture plane but the forearm and wrist—because they are darker—appear to fold away. The light tone on the back of the hand tells you that it is back in a plane parallel to the shoulder again.

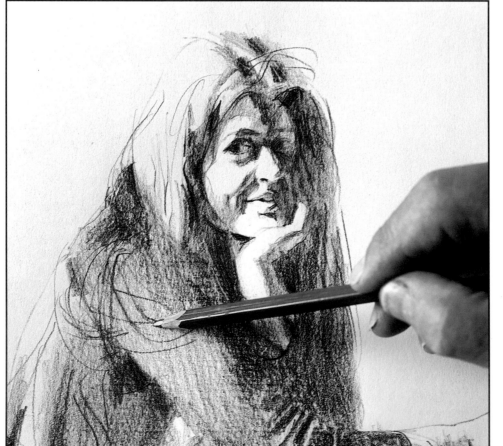

◄**11** Use a 4B pencil to shade the darkest tones: the creases on the jumper (helping to describe the cylindrical form of the arm), shadow under the chin and lower lip, the cavity where the lips meet, the nostril, and the very darkest tones in the hair.

The artist has departed from the photo by adding some wisps of hair, using loose, energetic pencil marks to bring the drawing to life.

Looking at line

Use the freshness and directness of line to describe form.
You will be surprised at the variety of effects you can achieve.

In the previous demonstration, shaded tonal areas were used to describe form. Patches of tone created the illusion of a solid head and shoulders. A different technique is to use line by itself.

Whether you are drawing with charcoal, pencils, or ink, you can use line to capture not only light, tone, and shadow, but texture as well. A convincing line drawing is often more sophisticated than it looks, and has a variety of beautiful qualities. With a bit of practice, you will soon learn to capture these qualities.

> *Line is so versatile—you can create a fine, tight, closely observed description or simply put a line around an idea— like in a cartoon.*

The qualities of line

Think of line and you will probably think of outline—the kind of result you get when you put your hand flat on a piece of paper and draw around it. In order to make a drawing of a solid, you also have to describe the contours of surfaces. An excellent line drawing should lead the eye in and around the object. To achieve this effect, you need to make the lines work particularly hard. You can use an HB pencil to produce a whole range of lines of different quality: rich, dense, shiny black lines; fine, gray ones; thick lines; thin lines; elegant, flowing, rhythmic lines; and broken, stuttering ones. Tips on how to achieve these results are described on page 100. Practice the techniques before trying them in the exercise that follows, a simple still-life drawing.

▼ The artist has used a variety of lines in this simple ink drawing. Fairly thick, considered curves describe the outline of the plate in the front. Much lighter, quickly drawn straight lines stand as the prongs of the forks, while thick rhythmical lines capture the decorative edge of the napkin.

A little crosshatching adds some light and shade, but the forms themselves are drawn in contour and outline.

Table Setting *by John Crawford-Fraser, ink on paper, 6 x 6 in. (15 x 15 cm.)*

Outlines and contour lines

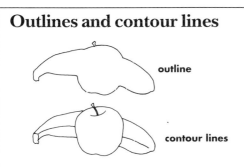

outline

contour lines

When you are drawing with line it is essential to understand the difference between outlines and contour lines. You can see the difference if you look at the two drawings above. In the top one, the apple and banana are drawn only in outline, giving a mere silhouette of the two objects with no details at all. In the bottom one, contour lines describe outlines as well as the basic forms of the two objects—including the dimple and stem in the top of the apple.

Irises in a Coca-Cola bottle

The quality of the line you produce depends very much on the type of paper used. A soft pencil on a heavily textured paper appears soft, whereas the same grade of pencil on smooth paper appears quite hard. Good-quality drawing paper is ideal in most cases. If you want a slightly more textured

Different qualities with an HB

1. A thin, continuous line of consistent tone made with a sharp point and an even pressure.

2. A line varying in thickness and intensity by changing the pressure made with a sharp point.

3. A thick line varying in tone across its width, made with the side of the point.

4. A fluid line made by keeping the pencil flowing as smoothly as possible.

5. A discontinous, stuttering line made up from short, quickly made marks.

6. A shaggy line made by drawing from the wrist and moving the pencil back and forth.

surface, try working on a piece of cold-press watercolor paper.

The hardness of the pencil is an essential factor and you must never be afraid to change to a different grade during a drawing if it will help you. You can vary the tone of a line either by using a harder or softer pencil, or by varying the pressure. So for example, you might take an H or 2H and press very lightly to give a pale gray. More pressure might give you a line no darker than a mid gray. Whereas if you used a 3B and applied light pressure you would start where you left off—with a mid gray—pressing harder to build up to a rich, dense black. In fact, an HB is often a good general-purpose grade to start with.

To some extent, the scale of the drawing determines the drawing medium. The bigger the surface, the larger, bolder, and darker your lines need to be. A surface bigger than 22 x 30 inches is too big for anything other than very soft pencil. A surface of 8½ x 11 inches or 9 x 12 inches is manageable, giving you control with rather a wristy feel.

Common sense should always prevail. Try to keep your drawing clean. If you are going to work over the whole of the drawing, be careful not to get graphite on the heel of your palm and smear it over your working surface. If you have to lean on your drawing, slip a piece of clean paper under your hand. When you have finished your drawing, spray it with fixative or protect it by covering it with a piece of tracing paper.

◀ **The setup** So many everyday objects become enchanting when they are interpreted through the eyes of the artist. Here is a very simple motif to work from—two irises in a Coke bottle.

It is the combination of the natural and man-made that makes this subject so interesting. The symmetry and brittleness of the glass bottle contrasts with the natural, living forms of the flowers and stems.

Notice how the light plays on the bottle and how the glass modifies the shapes inside.

▼**1** Starting with your HB pencil, simply draw the bottle. Look carefully at its circular cross section. When seen in perspective this becomes oval and it is important to get these ovals right—particularly at the base and the neck. Notice how the fluid quality of the lines suits the smooth texture of the glass. Do not overdo the name on the bottle or it will dominate the drawing—just suggest the lettering.

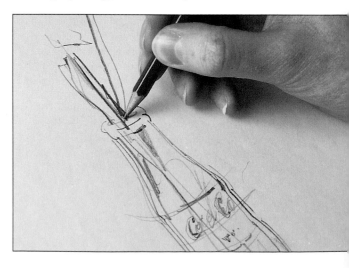

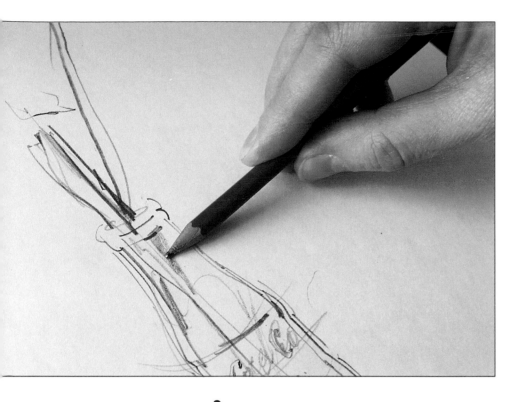

◀**2** Part of the stalks are put in with a fairly blunt pencil using a confident, flowing line—stronger in tone than those of the bottle in order to give a sense of the color and life. By drawing away from the ellipse you can get them shooting naturally from the neck.

Keep working over the whole of the drawing. At this stage, leave the stems outside the bottle and, using the same pencil, start to strengthen the stems inside. This will help to give a sense of continuity.

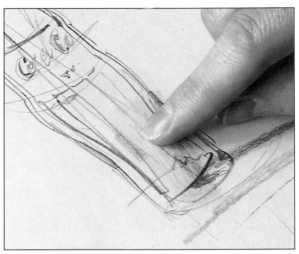

▶**3** You can stay entirely with lines if you wish, but you could also try using the tip of your finger to soften the pencil. The idea is to bring an overall tone to the body of the bottle, but do not obliterate the line entirely. Try to retain a sense of solidity at the same time as capturing the bottle's transparency. A clean, dark fluid curve in the base, and shadows on the table help to make the bottle look as though it is resting on something.

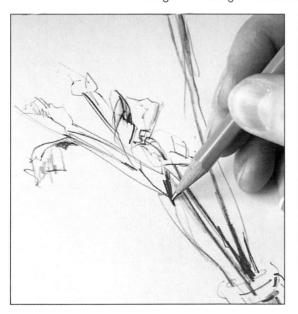

Tip

Bread eraser
After carefully blending areas of tone with your fingertip, you can use a kneaded-rubber eraser to remove some of the smudging to give lighter tones and highlights. Also, a piece of clean, white sliced bread rolled into a little ball serves equally well.

▲**4** Now draw the flowers with the 2B pencil. Freer use of a soft, sharp pencil helps you keep a crisp, fresh feel. This is where you can really change the tone and thickness of a line so it appears to move in and out of the paper. Look at the curve on the left-hand edge of the middle petal. The nearest part is stressed to bring it forward, while the "back" is less emphatic.

▲**5** Remember that although the petals are curled, flat surfaces they still have form. Try to capture this by using all the qualities of line drawing.

Sharpen the pencil again so that you can get a really thin, concentrated line from the thin point—almost like ink! Compare this with the much thicker but softer line in the petal above.

▲**6** Use a kneaded-rubber eraser or bread to wipe out some of the rubbed areas of tone on the body of the bottle where the light is shining through. Here the artist is working into the rubbed tone with the kneaded-rubber eraser. She has also rubbed out an area in the shadow on the table where the light manages to penetrate between the stems.

Do not use the eraser as an eraser in the normal sense, to rectify mistakes. Try to stay with the marks you have made and modify them as you go along. This way you will learn far more quickly.

◀**7** The bottle has an elegant, almost classical, shape, and you can see these same curves in the stem of the iris on the left. A horizontal line helps to push the bottle forward into space.

The finished image shows a wide range of marks made with both blunt and sharp pencils. It looks simple, but there is actually quite a lot going on when you look closely.

Line—in pen and ink

Use the boldness, sensitivity, and simplicity of pen and black ink lines to draw a plant.

The pencil drawing of the iris in the Coke bottle demonstrates how to render form using line. You can use a dip pen and ink to do the same job, but the result has an entirely different quality.

Unlike pencil, which gives a range of tones, India ink dries to give a dense, shiny black line of an even tone. However, by varying the pressure on the steel nib, or penpoint, you can change the thickness of the line, making anything from a fine incisive mark to a rich, thick one. By using ink, lines of consistent width, smooth flowing ones with a beautiful fluid quality, and stuttering, discontinuous lines are all at your disposal. Add to these a range of exciting blobbing, spattering, and pooling effects and you can see why ink is so versatile and yet so unique.

Of course, you can render extremely fine detail with a pen—imagine drawing a flower such as a dahlia, going around each petal—but the aim here is to give the plant fairly broad treatment using simple line.

> 66 *Ink is almost irremovable but it need not be as daunting as you think.* 99

A few practical hints

● Match the nib to the scale on which you are working. Choose a medium nib rather than a very fine one.
● Plan your composition carefully before putting ink to paper—there are methods of correcting an ink drawing but it is best not to rely on them.
● Work flat so that the ink does not run.
● Position the ink on the same side as your drawing hand in an area where it will not be knocked over, so you do not have to carry a nib full of ink over the drawing and risk dripping it on the paper.

▼ **Whether you work boldly with thick, dense lines or as the artist has done here, loosely but precisely using very light lines, you can create drawings with an unmistakable character.**
Untitled *by John Ward RA, pen and ink, 19 x 12½ in. (48 x 32 cm.)*

Chinese evergreen

YOU WILL NEED

- [] An H pencil
- [] A 12- x 18-in. sheet of drawing paper
- [] A bottle of black waterproof India ink
- [] A dip pen with a medium nib

▶ This plant makes a good subject. The leaves are broad but elegant, and there are not too many of them. The detail on the leaves is not exhaustive, but there is enough texture to make them appealing. The slender stems introduce new forms, and the flower, with its bumpy textured spike and curved hood, provides an interesting focal point.

▲ **The setup** Distance yourself so you can take in the whole of the plant at a glance but are still close enough to appreciate textures. Turn the plant around until an interesting aspect faces you—a large leaf, for example.

Because leaves are essentially curled, flat surfaces, they do not look strong in profile, so elevate the viewpoint slightly to show off their shape. This helps to capture the spirit of the plant much better. You can see this in the quick drawing (inset).

1 Lightly sketch in the shape of the plant and pot with an H pencil. Keep it simple—just indicate the various planes of the leaves and their positions, the angles of the stems, and the masses of the plant and pot in relation to one another.

The underdrawing serves as a guide for the ink drawing. Do not press too hard or you will made indents in the paper that the ink can run into, and it will make the drawing hard to erase later.

◀ **2** Hold the pen close to the nib to give a controlled, even line, and start to draw the "skeleton" of the plant. Do not merely trace over the pencil sketch, but let it guide you. Keep observing the plant, changing the sketch as you go. Look at the supporting rib that runs up the center of each leaf. Try to capture its curve and direction. Once you have drawn that correctly, it is easier to put in the leaf's outline.

As you complete more of the drawing, rest the hand that is not drawing on a piece of tracing paper so that you do not smudge the ink.

▶ **3** See how the surfaces curve and the edges are hidden. Look at the leaf on the left. Notice how the flow of the outline on the far side is interrupted because of folds. You can see the same wavy folds in profile on the leaves on the right, and these rhythms repeat throughout the plant.

Get a feel for the qualities of the ink lines. Do not worry about a blotch appearing once in a while. These often add to the effect.

4 Keep the whole drawing moving, just as you would a painting. Avoid putting in all the outlines, and then filling in detail.

Hold the pen farther back from the nib, and draw in some of the ribs in the leaves. Let the weight of the pen do the work. This gives a much freer, more fluid line that trails away as you lift the pen.

Where a leaf is seen head-on, do not ignore the folds but do as the artist has done here. Where the surface dips away behind one of the veins—on the left—make the line more emphatic. Then bring the veins closer together to comply with the rules of perspective.

5 Never lose sight of the versatility of your pen and all the qualities of line drawing. You cannot vary the tone but you can change the emphasis by pressing harder to make thicker lines and by turning the nib sideways to get fine ones. Here, a beautifully fluid line of varying thickness captures the whole outline of one side of a leaf.

6 If a leaf actually points toward you, it must look as though it is coming toward you in your drawing. Where one leaf partially obscures another, it must look as though it is on top. Create this illusion by thickening edges. You can pull a line away from detail that lies underneath by simply making the line stronger. (You can see this technique in the nearest leaf here.) Where the leaf comes out into the open again, resort to a softer line.

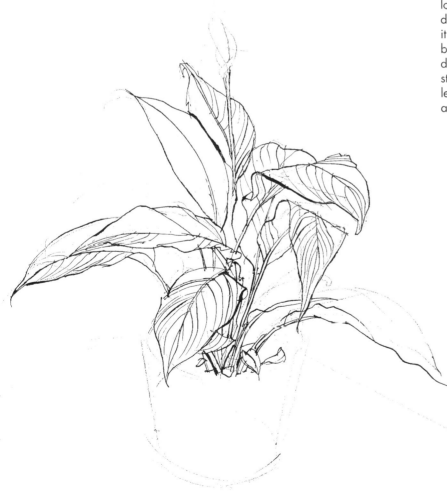

7 Try to get the ellipses at the top and bottom of the plant pot right. People instinctively know when they look wrong and misshapen ellipses create a sense of visual imbalance.

Because of perspective, the ellipse at the base of the pot should be closer to a circle than the top one. Letting your sketch guide you, draw in the top ellipse with a series of short pen marks. This allows more scope to correct the curve. Then complete the rest of the pot.

Tip

Precise ellipses

It is essential to get geometrical shapes such as ellipses just right. When doing the pencil underdrawing of the plant pot, it is easier to draw full ellipses at the top and bottom, even though you cannot actually see the far side of the pot. This allows you to keep a smooth, continuous drawing rhythm going and produce a better shape. When you do the ink drawing you can put in the near side with a stuttering line, leaving out the far side.

► **8** Leave the flower, the focal point, until last. It is like the final piece in a jigsaw puzzle, and can be given its full value only when assessed against the rest of the drawing.

Draw the hood first, keeping the same rhythms going. In fact, the texture on the flower spike consists of very small dots, spaced at regular intervals around a central core.

Two spiral lines running in opposite directions describe the form of the spike. A few dots of ink suggest texture.

► **9** To make the pot look as if it is resting on a surface and not just hanging in midair, indicate the edges of the table. You do not want to end up with what looks like a technical drawing, so it is a good idea to soften the line. Let the nib spring back at the end of the line, causing the ink to spatter.

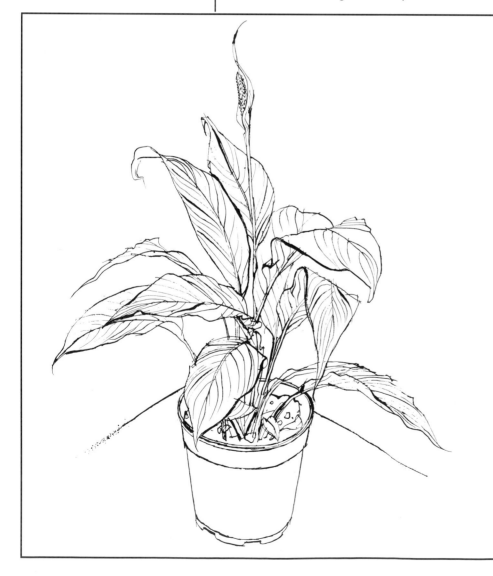

◄ **10** Just hint at detail inside the pot. Let a few simple shapes stand for stones and gravel and a thicker line indicate the level of the earth at the back. When you have finished your drawing, leave it for a couple of hours until the ink is absolutely dry.

Here, we have succeeded in capturing the energy of the plant with its "starburst" shape. The drawing's attraction is due largely to the great variety of lines and, although it stands in its own right, it would serve as a good basis for a pen and watercolor wash drawing.

Color as tone

How is it possible to work color into a black-and-white drawing? Here, our artist demonstrates how to use tone to convey a sense of color.

It is surprising how much information you can pack into a monochrome drawing. Apart from representing form, you can capture texture and even convey a sense of color. This does not mean that you can draw a red line with a graphite pencil or a yellow one with charcoal, but you can show that parts of your subject are colored and, where applicable, that these colors differ.

The secret is to use tone to represent color. Suppose you want to make a drawing of a lemon and a red pepper in pencil. The

> *Do not be deceived by the hue. The lemon might leap out at you because it is a brilliant yellow but in fact it is the lightest object.*

red of a pepper and the yellow of a lemon are both bright colors, but the yellow is a lot lighter than the red. Even the ripest, deepest-yellow lemon is still lighter than a red pepper. (You can see this in the black-and-white photograph on page 108.)

When you draw your subject, you can capture color by making the tones in the pepper darker. It might help to exaggerate this tonal difference so that it is more marked than in the photo. Once the tones are right, by association between the drawn shape of the lemon and its tone, the lemon should read as yellow. Likewise, the pepper should look as though it could well be red!

▶ **By making the overall tone of the roofs slightly darker than those on the walls, the artist conveys an instant sense of color difference.**
Vercelli by John Ruskin, 1846, pen, pencil, and wash, 10 x 6⁷⁄₁₆ in. (25 x 16.5 cm.)

Vegetable still life

◄ **The setup** The pencil drawings below show what is meant by seeing color as tone. Try it for yourself. Select objects with distinct colors, such as an eggplant, a red pepper, and a lemon. Look at the black-and-white photo (far left) and you will see that the lemon is the lightest in tone, the eggplant is the darkest, and the pepper is somewhere in between.

▲ **1** To start, draw with contour lines (see page 99). Notice here how they describe the forms of the fruit and vegetables but say nothing about their textures or colors.

▼ **2** Now try a combination of line with a limited amount of shading. The shading gives more information about form and, particularly in the case of the lemon, hints at surface texture, but there is still no indication of hue or color. For example, the eggplant could well be the same color as the lemon.

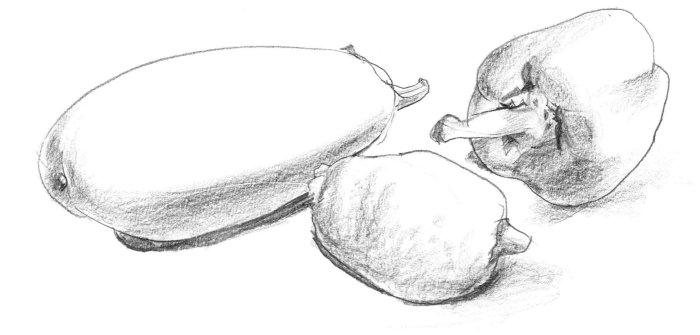

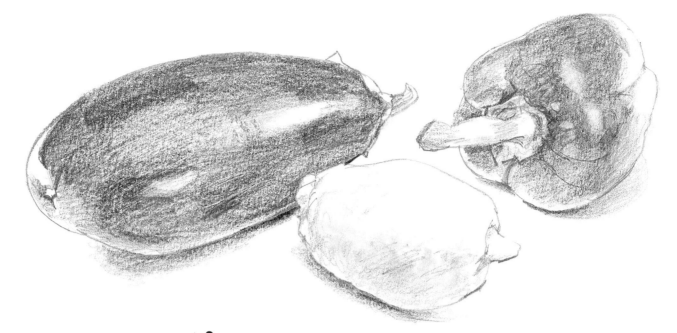

▲ **3** Now work the drawing more thoroughly, using line and shading to create form, texture, and color. See how the shading helps the contour lines describe the forms and conveys the polished surface of the pepper, the sheen on the eggplant, and the dimpled texture of the lemon. Shading also shows that the lemon is a different color from the eggplant and the eggplant is a different color than the pepper.

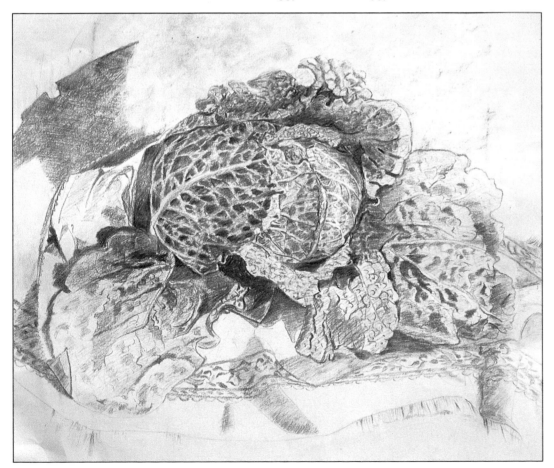

◄ When trying to show color by tone it is important that you pitch it at the right level. You can see this in the tones of the leaf to the left of the main body of the cabbage. Here they range from the light gray of the veins through to a darker, denser gray in the indentations, forming a consensus of tone—an overall tone that agrees with a dark green object in the partial shadow.

Where light strikes the solid core of the cabbage, the tones are all slightly lighter, although not as light as those of the cloth the cabbage is sitting on. This visual "logic" tells you that the cabbage is a different color than the cloth.

The cabbage *by Irene Christiana Butcher, charcoal on paper, 23 x 17½ in. (58 x 44.5 cm.), courtesy of Five Women Artists Plus*

Seeing tonal range

To get the tonal range in a colored object right, look at your subject through half-closed eyes. This helps you divorce color from tone. Try to identify the lightest and the darkest tones. The others must fall between these, but it is unlikely that they will be spread evenly between the two. Your lightest tone might be a white highlight, but the remaining tones could all be dark grays (as with the eggplant). If you have trouble analyzing your subject, make a tonal strip (see page 88).

► Color of hair and clothing are ideal candidates for tonal treatment. Here you can tell the hair, jacket, and blouse are different colors. It is easy to imagine that the girl's hair is a chestnut red and that the jacket is green, for example.
Jan by Howard James Morgan, charcoal on paper, 30 x 22 in. (76 x 56 cm.)

◄ You can also use tone to convey a sense of skin color (in this case black skin). Here tones range widely from very dark grays that are almost black (in the shirt and on the left-hand side of the face in shadow) to the lightest given by the white of the paper (in the background, highlights on the face, and on the shirtfront). However, it is really the light grays on the face that tell you the man's skin is black.
Ehyrete by Howard James Morgan, charcoal on paper, 30 x 22 in. (76 x 56 cm.)

◄ This is a fine drawing in which tone works hard to describe form, texture, and color.
 A range of dark grays suggests the boy's smooth, straight hair (which is probably brown). The sweater is clearly a woolen one (the mid grays suggest a red or perhaps a blue or a green). A range of dark grays, pushed together, give the color of the bird's breast and help to model the boy's fingers.
 Look at the houses and you will "see" brickwork, whitewashed walls, painted windowsills, and window frames.
Preliminary drawing for The Winner by David Carpanini, pencil on paper, 15 in. (38 cm.) in diameter

Rendering hard textures

Learn how to use charcoal and Conté crayon to render hard textures.

Our sense of touch reveals all kinds of qualities to us—smoothness, roughness, hardness, softness, coldness, and moistness, for example. Where they are relevant, you should try to capture tactile qualities like these in your drawings.

> 66 Let your drawing talk back
> —it might suggest ways
> of drawing you had not
> thought of. 99

Of course, unlike real objects, those in a drawing cannot be handled. You must find a purely visual way of conveying what they feel like. Although this might sound like a tall order, it is achievable. You do not need to touch a bone china cup and saucer to know they are hard and brittle. Bone china has a smooth, delicate, shiny

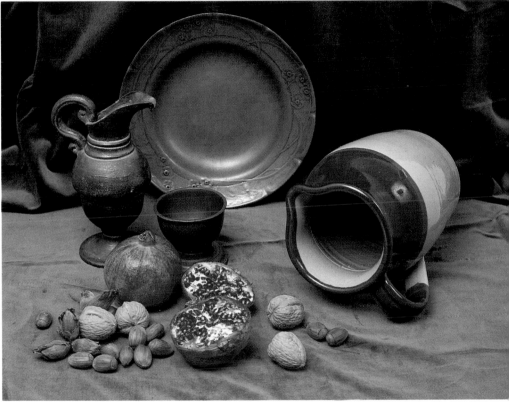

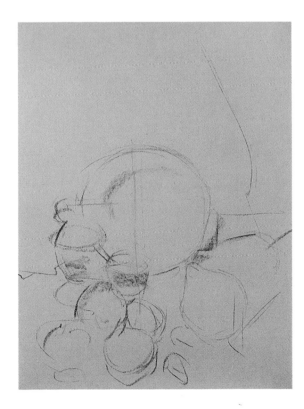

appearance that *looks* hard and brittle. Capture this in a drawing and your cup should look equally breakable!

Choice of medium is always important where texture is concerned, and here, charcoal and the hard pastel called white Conté crayon have been chosen. The charcoal will give the dark to mid tones and the gray paper the lighter ones. Finally, use Conté crayon to put in the highlights that make the hardest objects look hard!

◀ **1** Locate the basic forms, drawing from your shoulder to keep things loose. Keep in mind that everything you have learned so far about light, tone, and shadow. If you look at the setup, you can see that the light source is above and in front of the group. So the shadows fall fairly centrally under the forms.

▲ **The setup** Choose a variety of hard textures. Position your still life roughly as you want it, then step back and look at it from different angles until you find an interesting viewpoint—one from which the objects give the best account of themselves. Try repositioning them, turning things around and adjusting the gaps between them until you are satisfied.

Think of the silhouette of the overall shape and the different sizes of objects in the group. Do not make the arrangement too symmetrical. Try offsetting some items to get more interest into the composition.

YOU WILL NEED

- [] A 18- x 24-in. sheet of gray construction paper
- [] Charcoal sticks in varying thicknesses
- [] A 2B white Conté crayon
- [] Kneaded-rubber eraser; cotton cloth
- [] Fixative

► **2** Half-close your eyes and squint at the tones in your subject. In this case, the plate stands out against the dark background (see the setup). Its tone approximates the gray of the paper, so simply let the background describe the plate. Where you have broad areas of strong tone like this, turn your charcoal on its side so that you can cover the paper quickly.

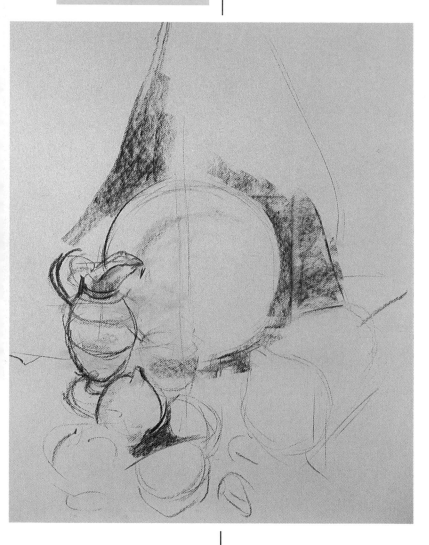

◄ **3** Look at the pewter jug. Its body is constructed from ellipses. Draw them as complete ellipses, as though the jug were transparent, even though you cannot see the far side. This helps to construct the jug accurately.

Try to capture the fluid lines of the jug's handle and spout.

► **4** Set on its side and seen head-on, the pottery jug gapes dramatically at you. Although it is actually quite heavy, the jug consists mostly of a large cavity. So describe its hollow belly with ellipses and then let the thickness of the pottery around the rim and the spout convey its weight.

◀ **5** One advantage of using charcoal is that it is easy to obliterate marks with a kneaded-rubber eraser or your finger and relocate them, thus keeping the whole of your drawing alive.

Where the groups of nuts were merely indicated, the artist has now put in some individuals. But notice that there is still no detail. The drapes in the background have been given just as much attention as the fruit and nuts in the foreground.

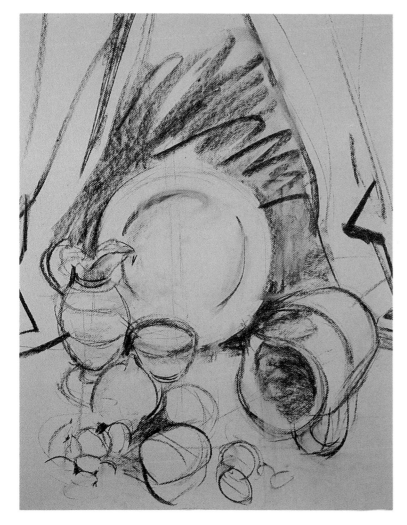

▲ **6** Keep revisiting objects, tightening your drawing as you progress. Seen head-on, the handle of the jug can be tricky to draw, but if you get it right it will make your drawing look strong.

Think of the handle as a flat piece of clay looped around like a ribbon, then check the space inside the handle on your drawing. Notice how the artist has strengthened the lines where the handle appears to touch the table so it looks like it is resting on something solid.

◀ **7** Never be afraid to use the most versatile and direct of all the drawing tools—your fingers. You can always wash them afterward!

Earlier, you used the stick on its side to lay charcoal onto the surface of the paper. Now use the tips of your fingers to rub it in. Try to capture the softness of the velvet backdrop, but also look carefully for the light and dark tones in the folds.

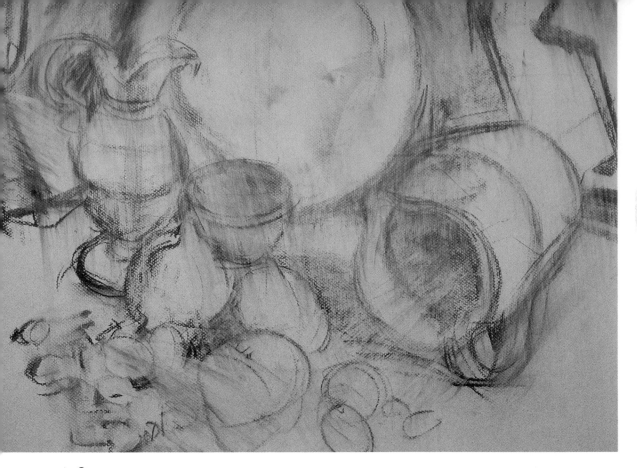

Tip

Stay clean
Charcoal is easy and fun to work with because it is so soft, but at the same time it tends to be messy. If you want to keep your hands clean, wrap all but the tip of your charcoal in a piece of aluminum foil.
And instead of rubbing your drawing with your fingers, use a cotton swab or a tortillon.
Any charcoal that you drop accidentally onto the floor should be picked up before being crushed underfoot!

▲ **8** When you have all the objects in place, flick over your drawing with a piece of clean cotton rag to leave a ghost image. Do not worry about seeing your hard work suddenly pale in significance —that's the idea! It is much easier to reassess the tones, shadows, and highlights with everything taken down to the same degree than with them all competing for attention.

▶ **9** Now look for the light tones in your group—not the brightest highlights, but ones like the gleam on the pewter plate and the shine on the cut and uncut pomegranates (see the setup).
　With your kneaded-rubber eraser, wipe out the charcoal from these areas, leaving the gray of the paper to stand for the tones.

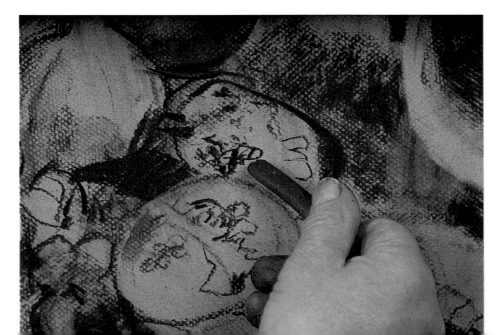

◀ **10** Put some detail on the cut surfaces of the pomegranates, but try to keep the drawing as loose as possible. By rolling the tip of the charcoal stick lightly on the paper, you can produce some dense black marks to stand as a kind of shorthand for the pomegranate pips. You can discover other ways to make new marks by experimenting. You might find another kind of shorthand that works equally well.

Although the color scheme is extremely rich—rather like that of a painting by an old Dutch master—our concern is with texture, and so far the drawing has been worked only in charcoal. The artist completed the drawing using white Conté crayon, but you could also use chalk.

When trying to render texture, it is helpful to look at the way light reflects off surfaces. Here the ceramic jug is the hardest object, and it takes the strongest highlights. Pewter, an alloy of tin and lead, is softer and looks it. The highlights on the plate and the jug on the left are more diffuse than those on the ceramic jug. But beware, you cannot always depend on shininess to tell you about hardness. The matte-surfaced walnut is clearly more unyielding than the shiny, leathery-skinned but, on the whole, much softer pomegranate. So here, allow the nut's knobbly texture to convey its hardness.

▲ **11** The light glints strongly from the highly reflective ceramic jug, but there is still some variation. Look at the setup and you will see that its rim, lip, and handle have a thin, sharp highlight that describes an edge. Use the corner of your Conté crayon to render these. On the brown part of the jug's body there is a more diffuse highlight. Here, use the crayon to scribble lightly onto the body.

► **12** Be sparing with your highlights. If you overdo them they will detract from, rather than enhance, your drawing.

Here a little carefully placed Conté not only describes texture but strengthens the forms too. Just a touch of crayon applied to the two walnuts in the foreground makes them stand out from the others.

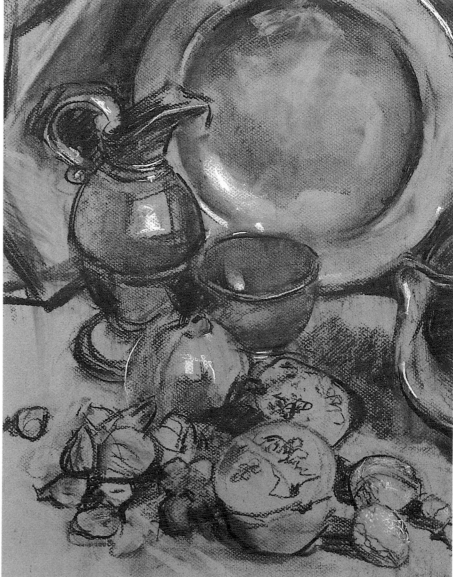

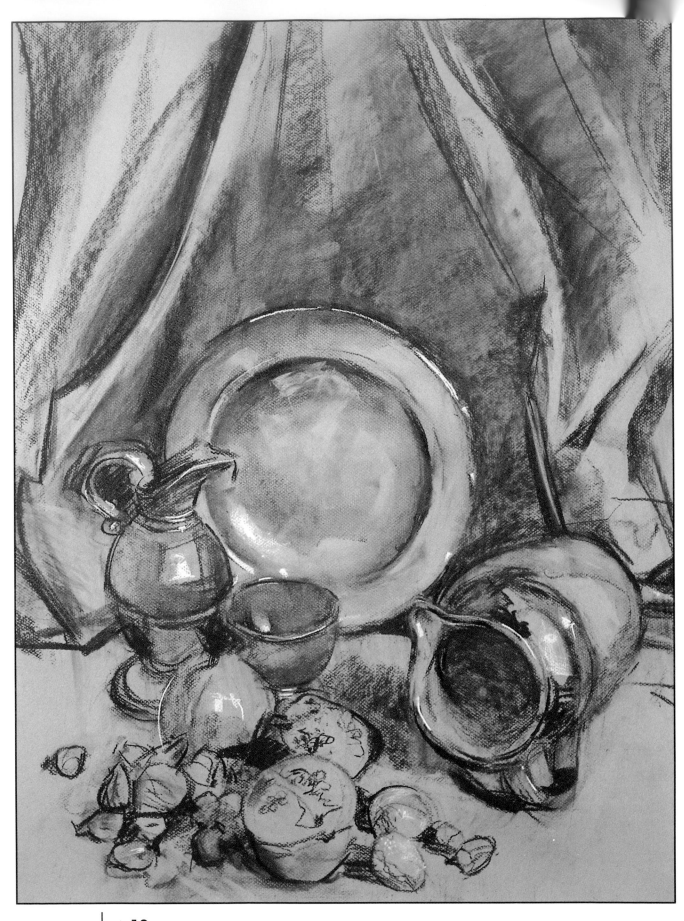

▲ **13** Build on the lessons learned so far, paying careful attention to light, tone, and shadow. Your eye should be led into and around your drawing as it is here: in from the two walnuts in the foreground, over the cut surfaces of the pomegranate, through the uncut fruit, pewter cup, and jug to the plate at the back, and then to the gaping mouth of the jug. The inside of the jug has been given the darkest tone so that it will look as if you could put your hand inside!

Charcoal and Conté crayon are disturbed by the slightest pressure, so do not forget to fix your drawing with spray fixative when it is complete.

Soft texture—rendering fur

Capture the softness of an animal's fur in this pastel drawing of a West Highland white terrier.

Of course, you will come across a great many textures, but whether they are hard, soft, rough, or smooth, you should try to give an accurate rendering in each case. The previous demonstration looked at hard textures—pewter, pottery, and nuts. Here, a different texture is tackled: the softness of an animal's furry coat.

> **" Under all that fur is a body and a skeleton with the same solidity you can see in a greyhound. "**

The subject is a West Highland white terrier called Finlay, and white pastel is used to "pull" him out from a neutral greenish gray paper. This is an acceptable way of working for any light-colored animal, whether it is a white cat, a pale gray rabbit, or a tan hamster. Use your own pet or a neighbor's as a subject, and choose pastels and paper according to the animal's color. So if, for example, you were drawing a pet mynah bird, you might find it appropriate to work on a lighter paper with dark pastels.

This exercise is not merely about drawing fur but is also about drawing an animal. Bear in mind that under all the fur of this small dog there is a body and a skeleton with the same solidity you can see in a greyhound. It is this underlying form that makes the animal what it is. This form is essential to the animal and to your drawing.

▲ Always try to capture the spirit of the animal—in this case, Finlay's alertness and defiance. Notice how the feathery wisps of hair follow the underlying form. They grow with a rhythm and direction—parting over the top of the muzzle, winding around the solid cylindrical trunks of the front legs, and then breaking over the paws.

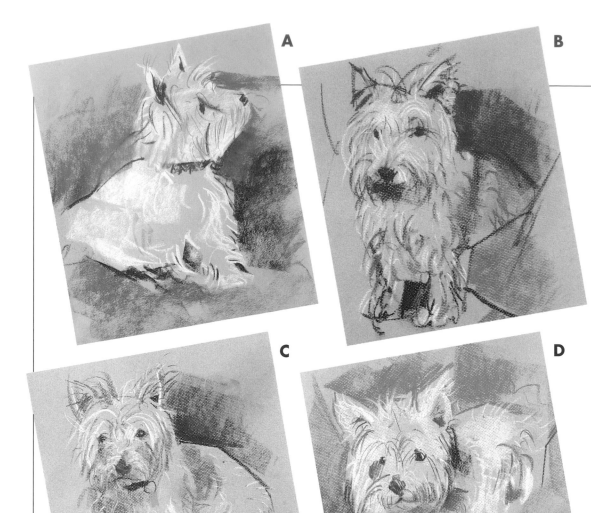

A

B

C

D

The trouble with animals is that they move! Even the best-trained pet becomes restless eventually. Finlay was a good sitter and, with a little encouragement, kept a position for up to two or three minutes. But a carefully considered drawing takes longer. So how do you manage? The answer is to make some quick sketches first.

Resist the temptation to fuss over details such as facial features. Basic proportions, such as the relationships between eyes, nose, and ears are far more important—as are the size of the head in relation to the body, the volume of the legs and their distance apart, and the overall posture.

Try to discover a repertoire of marks, treating each sketch as a rehearsal for a more elaborate drawing. This way you will be able to work more deliberately and confidently, and hence more quickly, when you come to make the finished drawing.

YOU WILL NEED

- ☐ A 22-x 30-in. sheet of dark green pastel paper
- ☐ Eight pastels: white, yellow ocher, dark gray, raw sienna, burnt sienna, ultramarine blue, black, cadmium red

Drawing Finlay the terrier

▶ **The setup** Here he is—Finlay sitting on a chair! Make your pet comfortable so that it stays in position long enough for you to make a few sketches. Use these as extra references for a finished drawing.

It is very easy to lose sight of the fact that under all that fur there is a solid body, but it is essential to recognize this. If you concentrate merely on the fur, you will end up with a formless ball of fluff.

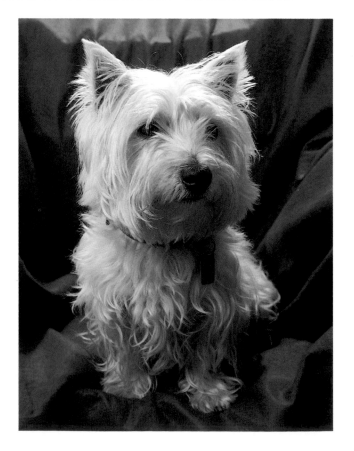

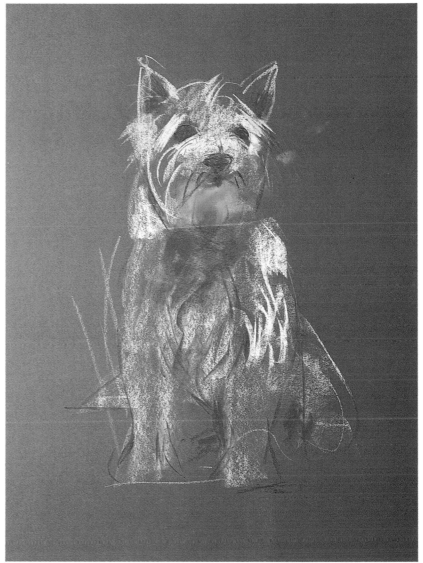

◀ **1** Use the edge of the pastel to block in broad areas and establish the basic forms and their proportions (as in the hindquarters in sketch A). It is helpful to note the geometrical forms in your subject. Here the body makes a pyramid, with the head at its apex. It is supported by the cylinders of the front legs.

At this stage, let the paper stand for ears, nose, and eyes, and work lightly —do not saturate the paper with pastel.

▲ **2** Rub in some warm colors—such as this yellow ocher under the chin. When you come to draw the fur over the top, these colors suggest a warm body underneath. A touch of raw sienna inside the ears makes them read as warm and translucent. A smudge of dark gray on the nose locates one of the darkest tones.

▲ **3** Smudge some dark gray onto the chest to visually pull the head forward. Work a few rhythmical dark gray strokes into the division between the front legs to push the hindquarters back.

Let some dark gray around the edges act as a subtle reminder of where shapes stop. Put these around the front legs and hindquarters and around the head.

4 Look at the setup and you will see that Finlay's coat is built up of feathery wisps, each comprising many hairs, all running in the same direction. In other words, his fur does not grow randomly. As a result, his coat has a rhythm to it. Try to capture this using vigorous downward strokes. Turn a short length of white pastel on its side to get the breadth of a wisp. As the wisp tapers, rotate the pastel so that you make a narrower mark.

5 Use the edge at the end of a stick of black pastel like a chisel to sculpt the fur. These dark marks lead the eye into the coat and convey an immediate sense of its thickness.

Notice that although the coat is white, it is not a cold, bluish white. So work in some warm tints, such as yellow ocher and raw sienna.

6 Put in the pupils with burnt sienna and then add the highlights using the corner of the white pastel. Place them carefully—here they go above the center of the eyeball because light strikes the eye from above.

Rather than using white or light gray for the highlights on the snout and muzzle, try a blue, such as ultramarine. This adds richness and vitality to your drawing.

To finish off, just hint at Finlay's tartan collar with a touch of red (an idea taken from sketches A and C).

Drawing different textures

Explore different ways of rendering texture and combine different textures in one drawing. Items found while hunting through the broom closet can make a surprisingly good setup.

As is so often the case, it is by no means the most beautiful subjects that make the most interesting pictures. For an exercise in rendering texture, you may well find that some rather unexpected items provide the greatest potential. Here is a demonstration of how to make a lively picture out of an assortment of quite ordinary, everyday cleaning materials. The aim is not to attempt a

> ❝ *If you copy exactly what you see in your setup, your picture is, in a sense, preordained. You will get a more interesting, personal picture if you seek to create your own interpretation of what you see.* ❞

◄ The setup The items are very carefully arranged to create a variety of shapes, curves, and angles. They form a rough triangle, the broom and mop defining two sides, the bucket the third.

On the left, a cluster of red and blue cleaning materials is the anchor pin. These will be rendered in detail, the artist taking a delight in their bold packaging. Their bright colors give an enlivening flicker against the neutral colors of the other items.

straight depiction of the setup, but to create a visual equivalent of each item. Do not make the feather duster look exactly like a bunch of feathers, for example; rather find something that conveys the idea of the duster, yet also entertains the eye in a lively and interesting way.

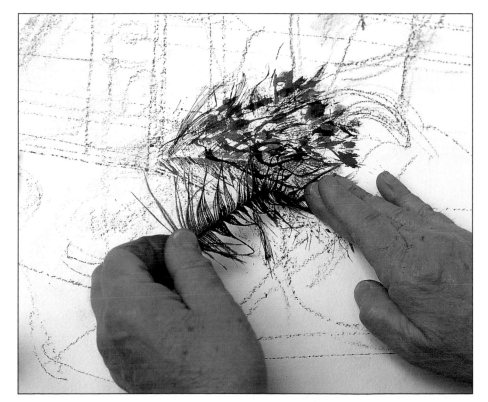

◄1 Start with a charcoal drawing, outlining each item as if it were transparent and putting in construction lines as needed. At the same time, try to get a feel for the items and think about their texture—hard, soft, smooth, bristly, or fluffy. Before continuing, dust down the drawing with a soft, clean rag to make a faint ghost image.

Start by experimenting with a printing technique, plucking a few feathers from the duster, painting them on one side with diluted ink, and then pressing the inked sides onto the paper. You may find that you achieve only one really good print from each feather, after which the ink clogs the barbs, producing a limp and indistinct print.

YOU WILL NEED

- ☐ A 22- x 30-in. sheet of 140-lb. cold-press watercolor paper
- ☐ Two watercolor brushes: a No. 2 round and a ½-in. flat
- ☐ A thin stick of charcoal
- ☐ A cartridge ink pen
- ☐ A ruler
- ☐ Two jars of water
- ☐ A soft, clean rag
- ☐ Water-soluble black drawing ink
- ☐ Six watercolors: vermilion, cadmium red, cobalt violet, Winsor blue, Prussian blue, black
- ☐ White gouache

> 66 One of the problems facing artists is how to give volume to something that is light, such as hair or, in this case, a feather duster. The item has to conform to the physical laws operating in space, yet at the same time it has its characteristic texture and feel. These systems are used: feather prints and pen to show shape and contour; and selective ink washes to show volume. As a result, you read fifty feathers, not just two. 99

► **2** Embellish the feather duster by scribbling energetically with the ink pen, taking the opportunity to organize the shape better and to convey the way it fans out. Try using the feather like a brush to achieve more texture.

Use the flat brush and some clean water to put shadows and tones into the feathers. The idea is to show that the head of the duster is a single entity, not just a collection of individual feathers. At the same time you want to give the duster more body.

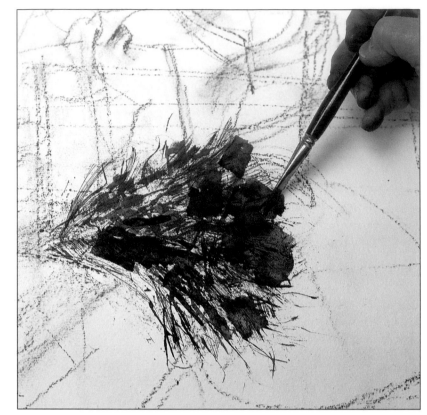

▼ **3** The artist worked on one area at a time, rather than develop all areas together. He could do this because he underpinned the picture with a solid drawing and had a good idea of how the picture would look. But do not feel bound by your initial drawing—you can adjust it at any time.

Here he is putting in the patterning on the cleaning materials, including the red stripes on the cleaning cloth, using the No. 2 brush and a mix of vermilion and cadmium red. For the blue patterning, he used mixes of Winsor blue and Prussian blue, adding cobalt violet for the can of metal polish.

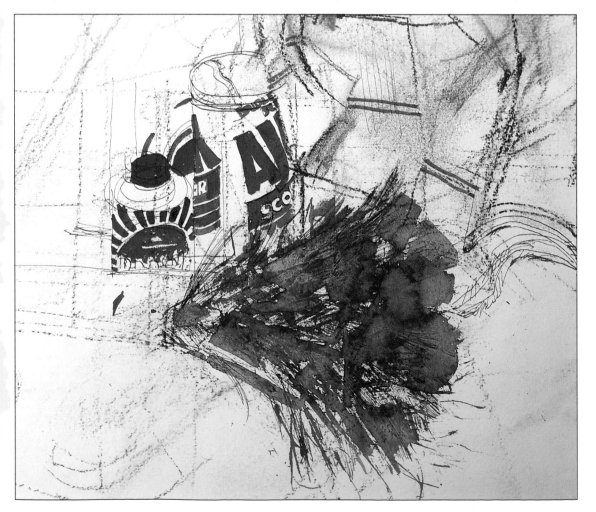

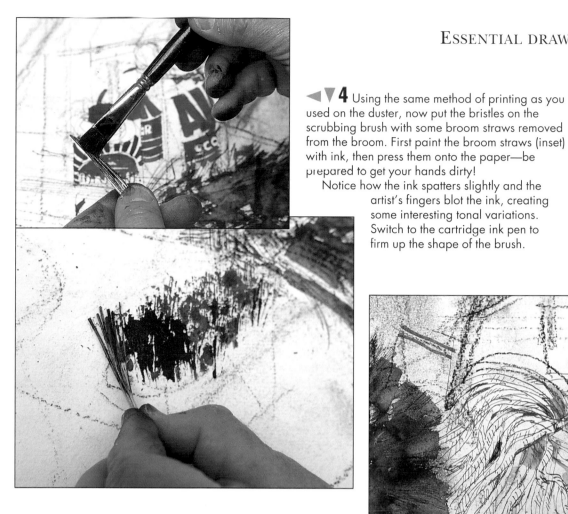

4 Using the same method of printing as you used on the duster, now put the bristles on the scrubbing brush with some broom straws removed from the broom. First paint the broom straws (inset) with ink, then press them onto the paper—be prepared to get your hands dirty!

Notice how the ink spatters slightly and the artist's fingers blot the ink, creating some interesting tonal variations. Switch to the cartridge ink pen to firm up the shape of the brush.

5 Now move on to the mop, drawing in a very linear way to pick out its decorative qualities by showing how the individual strands twist around each other in a continuous spiral. At the same time, put in a few tones and vary the thickness of the pen lines to lead the eye between the strands and then out again.

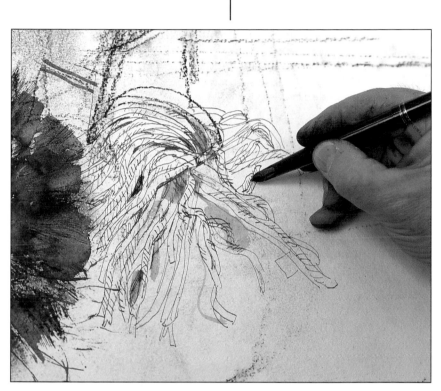

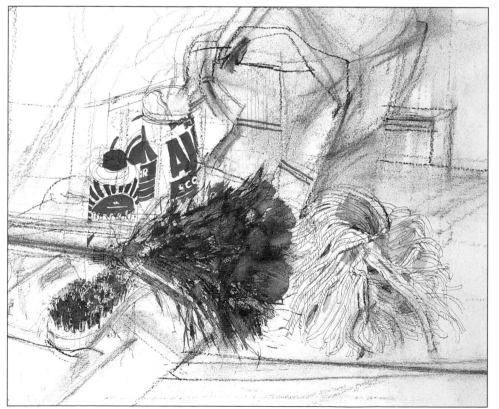

6 Make adjustments to the areas you have worked up as you go along. Using the cartridge ink pen, the artist drew in the ends of the feathers where they are bound to the pole, and used charcoal to work over the mop.

Shade the mop with a dilute black watercolor wash to give it solidity. Work up the duster with charcoal and pen, then use charcoal again to give form to the wooden part of the scrubbing brush and to shade the area behind the mop. Add some opaque water-based white gouache paint in the feather duster, as shown.

At this stage, the drawing is mainly in black and white, with a few variants added by diluting the ink. The touches of red and blue watercolor give an enlivening flicker.

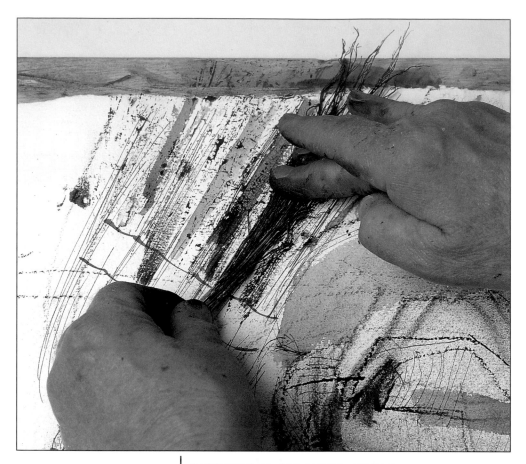

◄**7** Turning to the broom, first pick out the red lines of stitching near the handle with cadmium red watercolor and the No. 2 round brush, then define some of the broom straws with the ink pen. The printing technique works well on the scrubbing brush, so use it to enliven the broom, this time printing with longer lengths of straw. (Keep your hand from smudging the paper by slipping a small sheet of scrap paper underneath it.)

66 The addition of the white and off-white paints adds more body to the 'landscape' of the cleaning cloth so that the eye can sit on the 'mountaintops' and go down into the 'valleys.' 99

►**8** Put in the dark shadow behind the broom with a mix of black watercolor and white gouache, using the ½-in. flat brush. Then use the pen and ink to bring out the texture of the broom in the shadow.

You can see how the artist has used charcoal to describe the wrinkles and folds in the cleaning cloth, but now he is building on this with the ½-in. flat brush, using white and variants of white with black to build up the linear qualities and to give it more shape. He has also added near-vertical lines to show some of the texture of the cloth by applying ink to the side of the ruler and pressing it onto the paper.

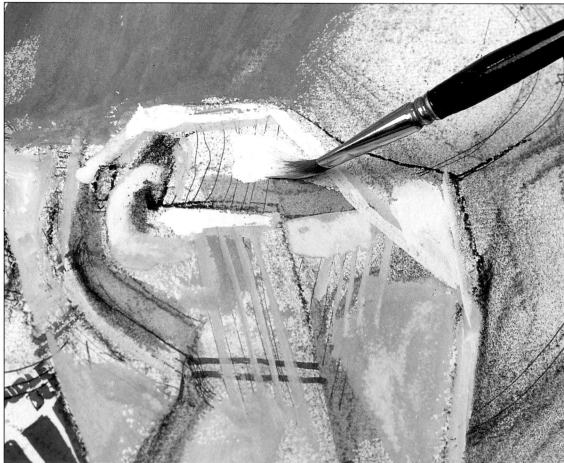

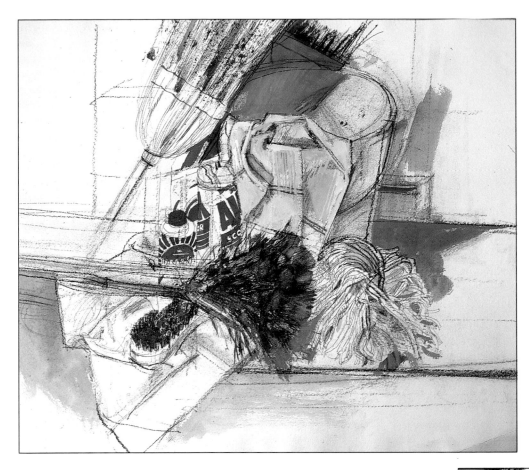

◄ **9** The artist decided not to opt for a realistic rendering of the setup, but instead to reinvent the shapes and textures to make a more interesting picture. He chose an abstract approach, giving the shapes of the items and the juxtaposition of forms greater importance. All the items are carefully arranged for a happy integration of shapes, angles, scale, and texture.

Notice how some charcoal is added to the mop to contrast with the fine pen lines, and how the same is added to the broom shadow for balance.

▼ **10** Still working with the charcoal, put in the grain of the door, dragging the stick down and across the picture, and twisting it at the same time to create a broken line. Notice how the texture of the paper gives the charcoal marks a more interesting, grainy look.

▼ **11** The pale gray on the cloth appeared to stand out too much (see step 9), so to balance it, the artist has added pale gray to the red and blue cleaning-supply containers, and added more gray to the mop head. The pale gray on the cleaning containers blocks out some of the charcoal underdrawing, making the tub of bleach appear more solid. He also elaborated the box of cleanser with his red mix and a near-black mix of black watercolor and white gouache.

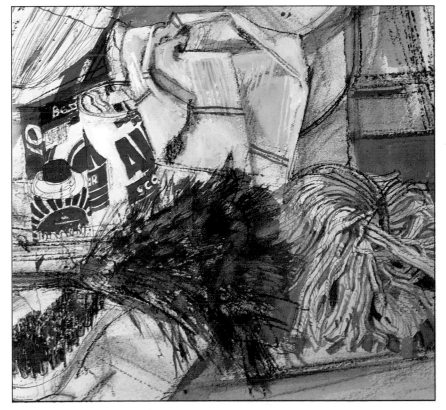

►**12** Use the No. 2 round brush to put in the blue threads on the broom with a wash of Prussian blue. Then use the same brush to work on the texture of the cloth, putting in white and off-white horizontal lines to complete the honeycomb dimples of its surface.

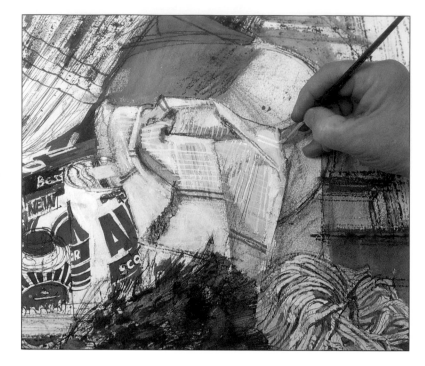

▼**13** There is a very limited range of color in the final picture. It is practically monochromatic with small color accents, but it has some strong tonal contrasts that provide a certain sense of color. More important, though, are the textures, created with pen and ink, paint, and charcoal, and even rendered by printing with part of the setup itself—the feathers of the duster printed with a feather, for example, and the straws of the broom with a few broom straws. This is not only an exciting and interesting way of working, producing good results, but it is also highly enjoyable.

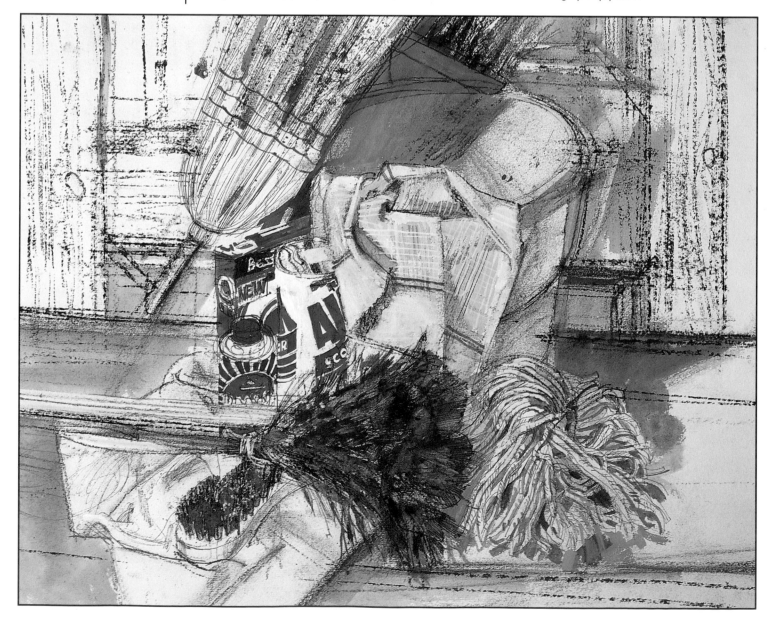

Drawing complex structures

Reconstruct a group of complex-shaped objects on paper. Tool chests yield a variety of such objects with which to practice.

The following exercise is one that could lend itself to recording a range of treasured, old possessions. For the purposes of explanation, let us assume that you have chosen tools.

Before you arrange them on the table, pick up the tools and handle them. This should to give you some insight into their character and function. You will notice that they are all made from hard, heavy materials—they have to be robust to stand up to hard use. So you might see a lot of steel, brass, wood—and plastic too, if they were made recently. However, tools have to be manageable. They are designed to yield under pressure from the hand: to be held and pushed, pulled, or twisted. The handle of a saw is shaped to fit the hand comfortably, and the shaft of a hammer has an oval cross section so it does not twist when you grip it. Typically, these surfaces are hard and smooth.

Try to get an idea of how a tool works—for example, pick up a brace and bit, and see which parts rotate in order for it to drill a hole. This helps you to appreciate the structure of the tool and so draw it better. You can apply this technique to other subjects besides tools.

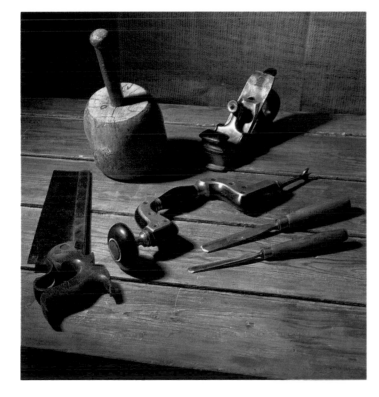

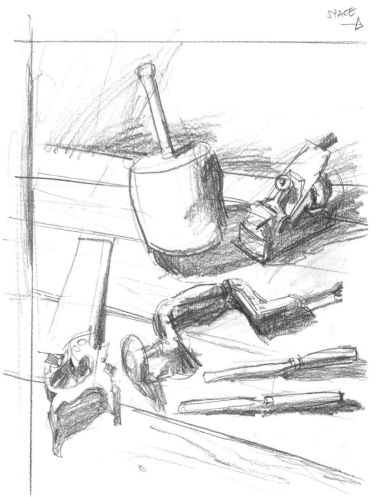

◀ **The setup** Beside encouraging you to analyze structure, a subject such as this should serve to remind you of negative shapes, hard textures, and ellipses, as well as fundamentals such as light, tone, and form.

▶ **Sketch** Spend two or three minutes making a rough sketch to help you settle on a composition. Meanwhile, try to get a feel for the lights and darks, and, particularly in this case, the angles of the tools. (The arrow at the top of the sketch is a reminder to start the drawing farther to the right in order to keep the composition centered on the page.)

►1 This subject might be interpreted in many different ways, but here the aim is to make a careful analytical study. Start by pinning down the main structures. Draw in axes and ellipses (see page 129 for guidance on construction), such as those around the handle of the brace and bit, and any useful edges or contours.

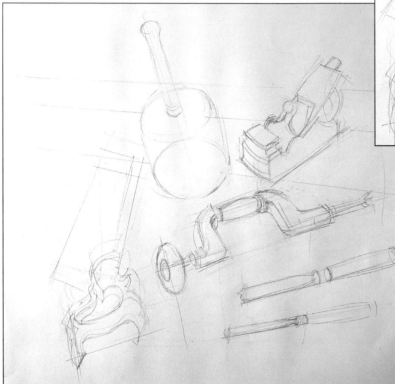

◄2 If your objects are resting on a flat surface, such as a workbench, make them look like they are on the same plane. Indicate a couple of the planks and take care to draw all the tools in the same perspective. Keep your drawing uncluttered and your pencil marks light so that you can adjust them without affecting your drawing.

YOU WILL NEED

- ☐ A 12- x 18-in. sheet of good-quality drawing paper
- ☐ Two graphite pencils: 2B and 5B. Graphite, in pencil or stick form, is a good choice. It allows you to draw precisely, and to adjust and correct. Choose a range, varying from hard and sharp for construction lines to softer and blunter for modeling tone.
- ☐ A graphite stick
- ☐ Kneaded-rubber eraser
- ☐ Tracing paper

►3 When you have the main structures in place, think about tone. You might adopt any of your favorite systems of shading, such as using the side of a 2B pencil.

Look at the setup and you will see that the subject is quite dramatically lit, but the intention here is not to use tone to capture this mood, but simply to reveal the forms. So, for example, some shadow on the inside of the wood-turning chisel reveals a curved, rather than a flat, surface.

◄4 As your drawing progresses, new mediums might suggest themselves. Here, a graphite stick seemed natural for the dense black shadow on the side of the plane. Rubbed lightly onto the paper, it leaves a rich grainy gray that is attractive. What's more, it is far more appropriate for shading on this scale than, say, an HB pencil because it produces strong, broad marks.

◄**5** After a closer look at the bit (the cutting part of the brace), the artist was surprised to find it was not symmetrical, as originally thought—it had a cutting edge on one side only. The lesson here is that you should not draw only what you expect to find. (Notice how the artist has tried to convey a sense of function by giving the tool a hard and metallic appearance.)

Construction

▲ Try to see the object in terms of simple geometric forms (here a block). Keep the edges in perspective. (See pages 79 to 86.)

▲ Look for centerlines. For the brace and bit to function, the knob must lie on the same axis, or centerline, as the bit (cutting tool).

►**6** The saw handle is a good piece of functional design—easy to hold, but elegant too. Here shadows around and inside the handle do two things. They model the form, lifting the handle away from the table—so that it looks as though you could pick it up—and they make an interesting series of shapes. Use a very soft (5B) pencil now with tracing paper to keep you from smudging the drawing.

▲ When drawing a complex shape, like the saw handle, draw it as though it were wrapped up like a package, and then put in the curves.

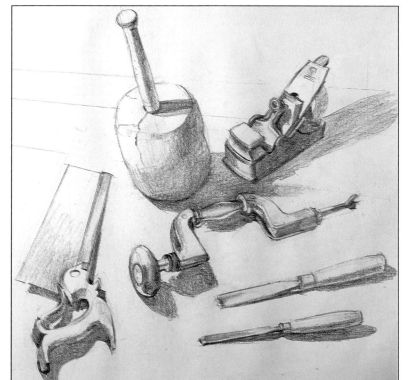

◄**7** The tones on the tools integrate with the shadows they cast. The shadows are not all of the same density. Some, such as the one cast by the chisel in the foreground, are a very dark gray and quite hard, while others, such as the one cast by the plane, are much softer. Notice, too, the little touches of reflected light—on the handles of the saw, brace and chisels, for example—and the little chinks of light just under the chisel blades.

▲ For cylindrical objects, such as the chisels, draw in the ellipses. It helps to draw them right through, as if the objects were transparent.

►**8** To complete your drawing, you can now add a few details, such as the rivets in the brace or those in the handle of the saw (all these are ellipses). Bear in mind that it is still important to count, measure, and make these details conform precisely to everything you have drawn so far. After taking all that trouble, you do not want to let things slip from your grasp, or to make the details so prominent that they jump out.

▼**9** Good drawing and painting rely on selection and emphasis. The drawing could be taken further, tackling the problem of how to render the texture of the wooden workbench, for example, but the drawing serves its purpose as it is. The solid-looking tools sit on an equally solid platform and have a substance that befits their function.

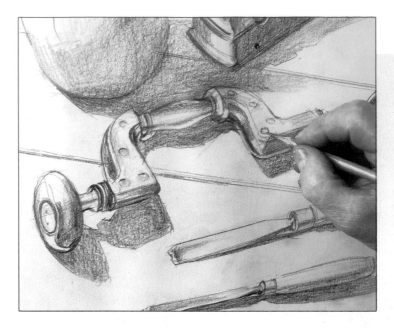

Drawing fabrics

Unless you are interested only in drawing the nude, your figure studies will inevitably include fabrics. Beware of the pitfalls.

The main reason artists concern themselves with drawing fabrics is their importance in figure drawing. If, for example, you have a model in a cotton shirt and jeans, or a tight top and velvet skirt, you cannot simply think "fabric" and draw each in the same way as it will not be convincing. You have to study their individual characteristics.

Examining the properties of different fabrics will help you know which features to expect. For example, is the fabric likely to fall into sharp creases or soft waves; will it hug the body or stand away from it? Also take the surface finish into account—whether it is smooth or textured, shiny or matte, for example.

◀ The artists of the Renaissance took the study of cloth covering forms very seriously. Leonardo da Vinci had a system of dipping a light cotton fabric into wax and draping it over a form to simulate cloth over an arm or leg. Then he could study the light, shade, and mid tones of the fabric in order to understand it better and to portray it in his drawings and paintings. His in-depth studies gave him a good understanding of the way fabric hangs. *Cartoon for* Virgin and Child with Saint Anne *by Leonardo da Vinci, charcoal and black-and-white chalk on tinted paper, 55¾ x 48 in. (141.5 x 104.6 cm.)*

▲ Draping fabric over a stable object—in this case a chair—will enable you to study its characteristics. Try drawing different fabrics so that you can make comparisons between them.

Burlap is a stiff, open-weave fabric with a rough, matte finish that falls into full, curvaceous folds, although it can be pressed into sharper creases. It is light but firm, so it stands off from the chair, revealing little about its form.

▼ Heavy fabrics, such as this wool, have a more energetic and dynamic hang than lighter ones, such as the burlap above. The weighty cloth sits firmly on the seat, and it falls in deep folds.

A common mistake that amateurs make with this sort of fabric is to darken the shadows in the folds so much that they seem to penetrate further than the form beneath. You may find it helpful to summarize the form first before rendering the fabric on top.

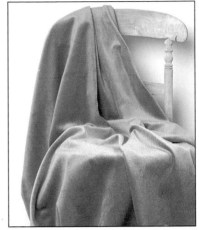

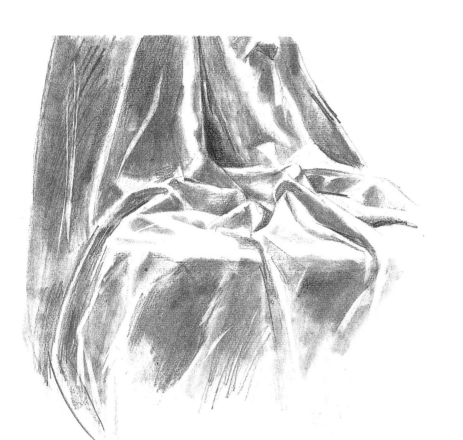

Look for associations to help you draw each fabric. The folds may form gentle rolling hills or craggy rocks and caverns, for example.

▲ Velvet is an alluring, graceful fabric. It combines a beautiful satin sheen and luxuriously deep texture with a suppleness and weight, which make it hang with great elegance. It tends to make more folds than any other material, giving it many appealing rhythms.

All these qualities can be difficult to capture on paper. In particular, watch out for the highlights. They should not look as if they were detached from the fabric but be integrated with it. Use a kneaded-rubber eraser to wipe out just enough contrast from the graphite powder to achieve this.

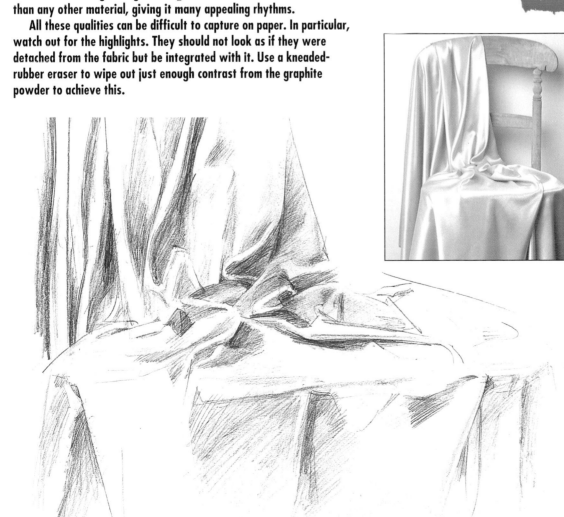

◄ Satin has a sheen similar to velvet and is equally supple, but being finer, it clings to the form underneath. Its many fine folds often have extreme angles that can be tricky to render. Soft pencil is used here, pressing hard for the dark shadows and leaving the highlights blank, but you could try other media. If you start with a toned paper, you could apply chalk highlights, for example.

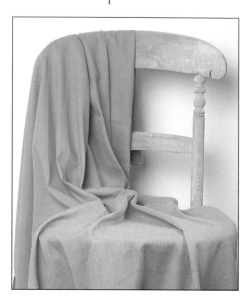

66 When you draw clothing, you will want to suggest the form of the person wearing it. It is the same when you draw hair—it is important not just to show its volume but also to show the shape of the cranium underneath. 99

▲ Cotton has something in common with satin, except that the latter clings more and has greater sheen. Cotton is crisp, with more weight than satin, and it has great fidelity— it will hold its shape perhaps better than any other cloth.

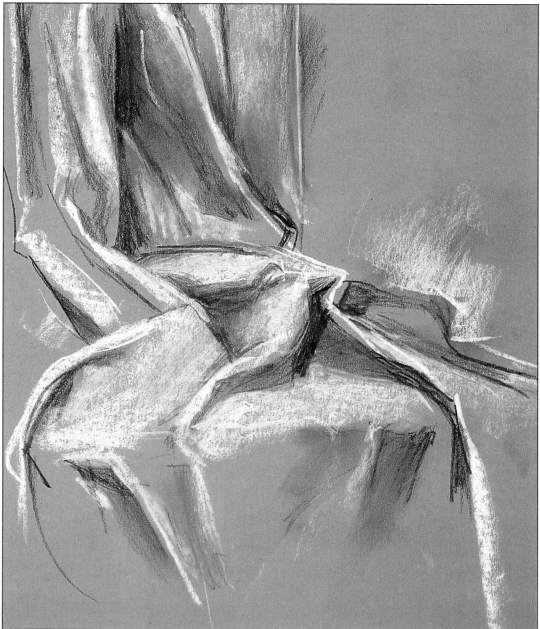

▶ Here the cotton fabric is drawn on gray paper with white chalk and black Conté crayon to produce a picture full of energy. The drawing would work equally well in soft pencil with cross-hatching for shadows. In fact, you might find it interesting to try drawing all the different fabrics with the same tools to see how you can make the differences show.

Clothed figure—three poses

Armed with pencil and paper—or whatever you feel comfortable with—you are ready to start making your own explorations into drawing the figure.

Figure drawing is enjoyable, but it can also be daunting. The figure is complicated—it moves, and it has bulk and weight, a bony skeleton, and a soft exterior. Somehow you have to cope with all this. But by underpinning your drawing using simple geometric forms, the job becomes much easier. Find someone to sit for you and give yourself no more than 10 minutes for each pose. Try to draw a well-proportioned, solid-looking figure. Sketch in the features, but do not worry about getting a likeness at this stage.

> *"Think of your drawings as inquiries into the figure—not as finished drawings."*

Look for the light source, then use tone, reflected light, and shadow to describe the forms. Remember that as a measuring guide, the length of the body is about seven and a half times the length of the head. By taking measurements with your pencil and plotting these on your drawing, you can navigate your way around a complex pose. If you meet problems such as foreshortening, try analyzing the pose using the lay figure (a jointed wooden figure).

Do not worry about the details—these drawings are meant only as inquiries into the figure When you have finished one drawing, move on quickly to the next.

▶ **We know the human form is infinitely subtle—it comprises bones, muscles, sinews, flesh, and so on. But for now it is enough to think of it as a collection of geometric forms occupying space. In the drawing at far right, a sitting pose is analyzed to solve a problem of foreshortening, or perspective. Follow this with a more elaborate drawing (right).**

Measuring up

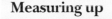

On page 87 there are instructions on how to take measurements with your pencil and transfer these to your drawing. Use this method to pinpoint various parts of the model's anatomy and make an accurate drawing. To avoid distortion (such as making the head appear too large), position yourself at least 8 feet from your model.

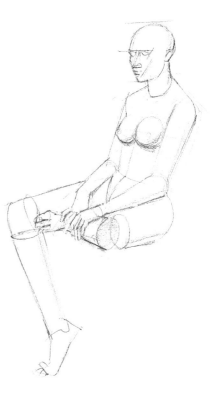

Quick standing pose

▼ The model takes most of her weight on her left leg. Her right hip is dropped and the knee is bent, so the right knee is lower than the left. The arm resting on the chair takes some weight, but really serves to steady rather than support her body.

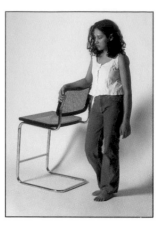

► **The setup**
Choose a simple pose that is relaxing for your model. Rather than looking first at the face, consider the model's stance—in particular, how weight is distributed.

► **1** Try to avoid a continuous outline. Concentrate and draw what you see. Here crisp, fine lines are used for the profile, and the side of the pencil is used to make thicker marks for the hair.

► **2** Make your drawing flow by working mostly in line at this stage, adding a touch of tone. Let the clothing help you. Here, creases around her left knee and over her right thigh help to describe the cylindrical forms of the legs.

◄ **3** Remember that you are making an interpretation—the illusion of a solid figure—not a photographic likeness. Quick shading with a bit of pressure applied to the lines soon reveals the forms. Draw the chair because it supports the model's arm and describes the floor.

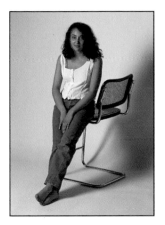

Quick leaning pose

◀ **The setup** A comfortable pose for the model, this one is slightly trickier than it looks. The model's arms and legs are arranged symmetrically but the viewpoint is not straight on, so the centerline is turned away.

▶ An analytical sketch enables you to gauge the angle at which the model leans and the angles of her limbs—something that is particularly important here.

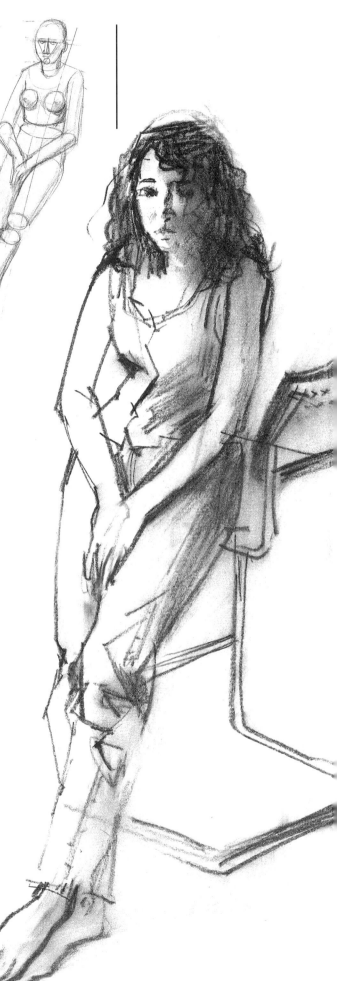

◀**1** Start drawing from the head down, as you did for the last pose. The artist has used a charcoal pencil because it makes a bold, black line that encourages him not to get caught up in detail, but use a pencil if you prefer.

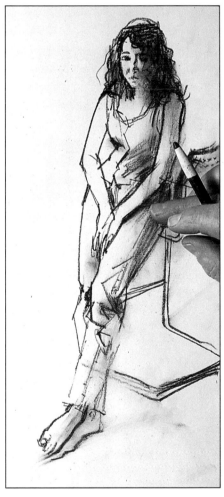

▶**2** Try shading and then blending with your finger. Notice that, as with the previous drawing, no attempt is made to render the darker color of the model's jeans. This provides a wider range of tones for capturing the form.

▶**3** Draw logically. In this case the chair supports the model. If it were not there she would topple, so it is essential to draw it! When you have finished you can continue with more quick poses or take longer to develop a more finished drawing.

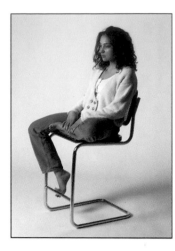

Sitting pose

◀ **The setup** This pose presents a new challenge. The model's left knee comes out toward you, thus distorting —foreshortening—the upper and lower parts of her leg. Some artists use a lay figure to analyze the pose, and you might find it helpful to do the same.

▶ **1** Adopt a soft approach at first, gradually increasing the intensity of the lines as you become more confident. Do not forget creases in the clothing—they are great for describing the forms.

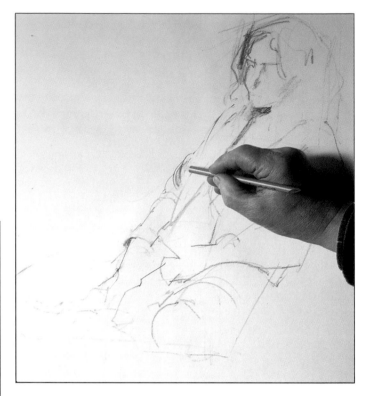

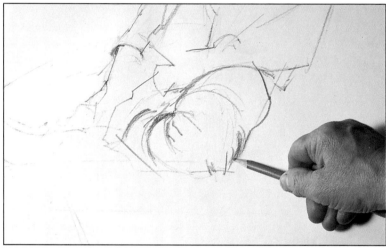

◀ **2** Think of the creases as ellipses going right around the forms. On the thigh they travel in one direction and on the lower leg they travel in a different direction, becoming smaller as they recede and approach the ankle.

◀ **3** Make hands easier to draw by looking to see what they are doing. Here they are holding the ankle, pulling the leg in (the leg holds itself in place). They are resting gently and elegantly. Count the fingers in your drawing to make sure they tally with what you can see!

Tip

Five-finger exercise
You can make quick sketches whether you are in a train, on a beach, or at a concert. They might not be very accurate at first, but all the while you are training your eye, exercising your skills at representing solid figures in space, and trying to capture character and eventually even a sense of movement.

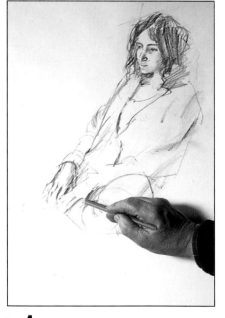

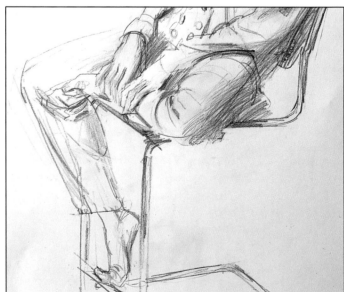

▶ **4** Take measurements to make sure the hands, feet, knees, and chair legs are positioned correctly. Where you want to emphasize a feature—such as the toe supporting the right leg and the bulge in the right calf, or the knee coming toward you—make the lines stronger.

Drawing the nude

The nude figure is one of the great themes in Western art. At first, adopt a straightforward approach to drawing a simple standing pose.

Before you can make a drawing of a nude, you need a model. The easiest solution is to join a life class, but you might have a friend who is willing to pose. Another way is for a group of like-minded artists to get together and hire a model. (Often, art students eager to learn their craft from both sides of the easel will model for a reasonable fee.)

To make a good nude drawing requires input from both artist and model. It is no use if a model is so shy that, having taken off her clothes, she

> **66** *Make sure you can fit the whole figure onto your sheet of paper—do not chop off the head at the top or lose the feet at the bottom edge.* **99**

hides behind her hair like an ostrich burying its head in the sand! On the other hand, it is your responsibility to make your model comfortable. See that the room is warm enough, and that it has a degree of privacy and somewhere to change undisturbed. Allow your model to get into position, and make sure it is a comfortable one.

Drawing for long periods without giving your model a rest is thoughtless. So, before you start drawing, mark the position of the feet on the floor or other surface with chalk. This way the model can get up from time to time, put on a dressing gown, and relax.

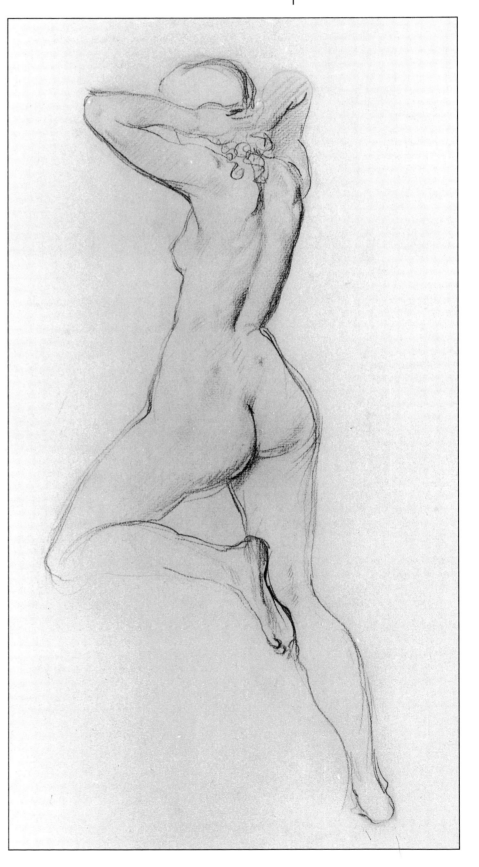

► **The nude has subtle curved forms, so avoid tracing an even outline around the figure. Vary the intensity and thickness of lines—as the artist has here—so the form appears to curve.**
Full-Length Nude from Behind *by Augustus John, pencil on paper, 15 x 9 in. (38 x 23 cm.)*

▶ **The setup** Choose a simple, classic standing pose like this. Try to avoid difficult technical problems, such as foreshortening and make sure your model is comfortable. Here the model's face and hand contribute smaller details to the larger masses of back, buttocks, and legs.

YOU WILL NEED

☐ A 12- x 18-in. sheet of good-quality drawing paper

☐ A drawing board or easel

☐ A 2B pencil

☐ Kneaded-rubber eraser

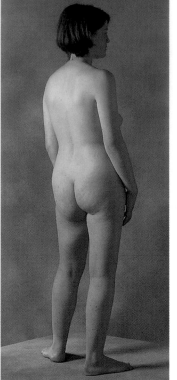

Standing pose

◀ **1** Work at an easel if you can. Distance yourself at least 8 feet away—far enough to see your subject without distortion, but not so far that you lose sight of detail. Position yourself comfortably so that you can look away from your drawing to the model by simply turning your head.

▶ **2** You do not always have to work from the head down, but with a fairly straightforward standing pose like this it seems natural. Drop a plumb line—a vertical line—through your drawing. Measure your model's head and see how many times it fits into the body. (Here it went just under seven times—her classical pose, with the weight taken on one leg, makes her look shorter than if she were standing straight, like a soldier.)

Mark off this number of heads along the plumb line and make sure the feet are going to fit on your paper!

◀ **3** Rather than losing yourself in drawing details of the model's hair, features, or hands, try to get a broader feel for the pose. Notice how the weight is distributed; notice how the shoulders are turned; look at the symmetry. Here the model's weight is mostly on her right leg. Her shoulders are turned away and as a result, the far side of her back appears narrower than the near shoulder in perspective.

◄ 4 The importance of trying to draw a solid-looking figure in space cannot be emphasized enough. This is where it helps to think of the body in terms of simple geometric forms—of the arms and legs as tapering cylinders, for example.

► 5 Think of the hair in the same way, not as individual wisps across a scalp but as a total mass. Hair may change as it is cut or as it grows or with the way it is tied or pinned, but essentially it conforms to the shape of the cranium beneath.

▼ 6 You might wonder what type of marks to make. One way is to adopt the classical system of hatching at 45 degrees. Here the tones are scribbled in many different directions—probably the simplest way and recommended at this stage.

▼ 7 As your drawing progresses, it is easy to fall into the trap of completing large portions without looking back at the model. You must keep looking from your drawing to the model, picking up new information, constantly adjusting and revisiting, and gradually coaxing the figure from the paper.

▼ 8 When you want to draw a rounded form—such as the leg here—remember to look for the light. Notice where the darkest shadow comes and where the form begins to lighten as it curves around into reflected light on the other side.

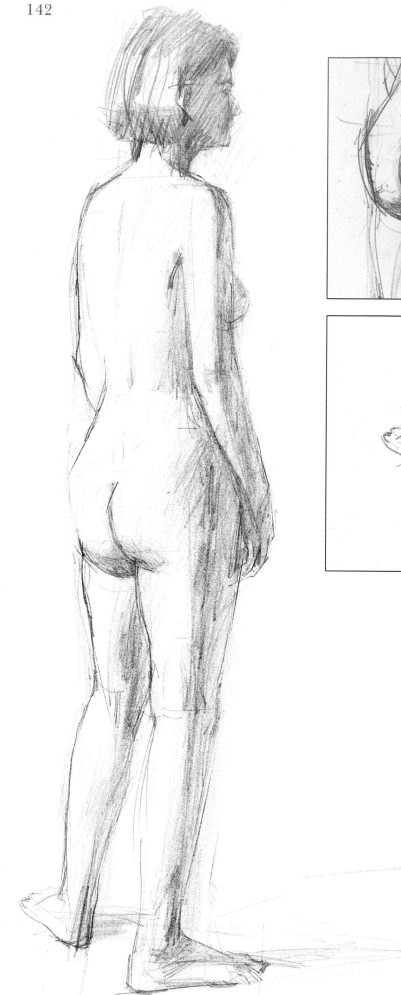

◀ **9** Let your model take a rest from time to time. When she takes up the stance again, she may adopt a slightly different stance, so you may have to go back to some areas, adding stronger shadows and strengthening lines.

▼ **10** Because the model is standing, all her weight is on her feet. They are important to the logic of the drawing. Make sure they fit on the paper and draw them carefully.

▲ **11** Think of the feet as supporting platforms, with the floor pushing up against them from beneath. Here the shadows cast by the legs and feet imply the horizontal surface on which the model is standing (a plinth), although the surface itself is not actually drawn.

◀ **12** This treatment in scribbled tones, with a little line to emphasize rhythms and outlines, is about as simple as it can get. Notice the contours drawn in around the legs at the back of the knees. No attempt has been made to render the tone of the background or the floor, or to convey the color of the model's hair—that is not the intention here.

A show of hands

Hands are not the easiest subjects to draw, but placing them in the model's pockets or behind a bouquet of flowers is not the answer. Draw them logically.

To draw hands accurately you must have an understanding of their construction—they are highly complex, mobile parts of the body. Start by examining your own hands in detail. The bones of the fingers are joined not at the knuckles but at the wrist (you can see this if you move your fingers up and down). Notice that the thumb, which has one less bone than the fingers, moves

> ❝ *Hands and fingers are capable of a vast amount of movement and expression. They can help convey mood and character.* ❞

separately. It is this independent movement that enables the hand to grasp things and pick them up.

The fingers are of unequal lengths, which gives the hands even greater versatility. Different fingers have different functions—the index finger is often combined with the thumb to pick up small items; the middle finger is the longest and is therefore useful for prodding; while the two smaller fingers provide balance and can be used to assess textures.

Notice that the joints of the fingers occur at different positions. If they were all on a level, the fingers would splay out slightly because of the extra width of the joints. Instead, the joints of one finger are usually accommodated by the curve of the next finger so that all the fingers fit snugly together. This arrangement of the joints has an additional benefit; by staggering the weak points of the fingers they become stronger when working together.

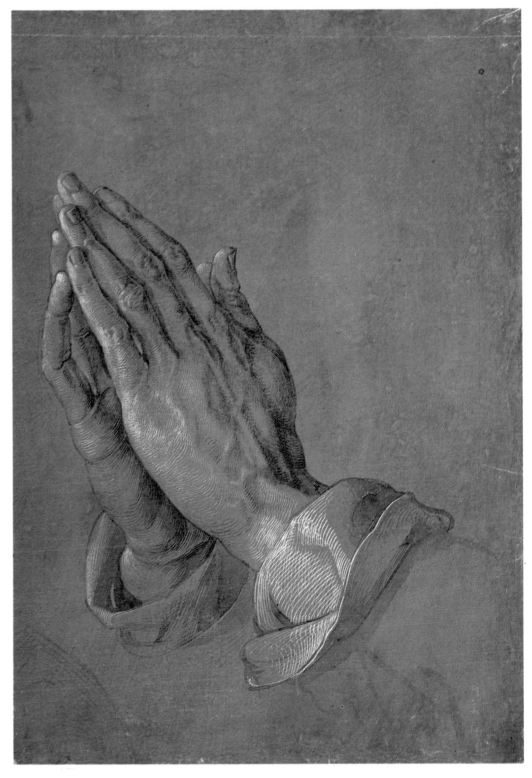

▼ This—perhaps the most famous drawing of hands—exemplifies what you should be aiming for: a combination of very careful observation and good construction.
Hands of an Apostle *by Albrecht Dürer, pen, ink, and wash with highlights on paper, 11½ x 8 in. (29 x 20 cm.)*

The bare facts

A little knowledge of the construction of the hands will help you to draw them better. Combine this with careful observation of your own hands and you should have a pretty good idea of what to illustrate.

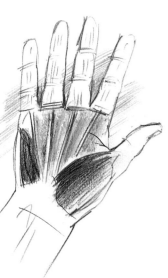

▲ The muscles pad the palms, making a series of domes. The most dominant of these, at the base of the thumb, is strong and usually well exercised.

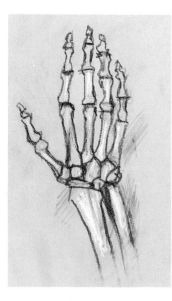

▲ The bones of the fingers are actually joined at the wrist, not the knuckles, enabling the fingers to stretch farther apart.

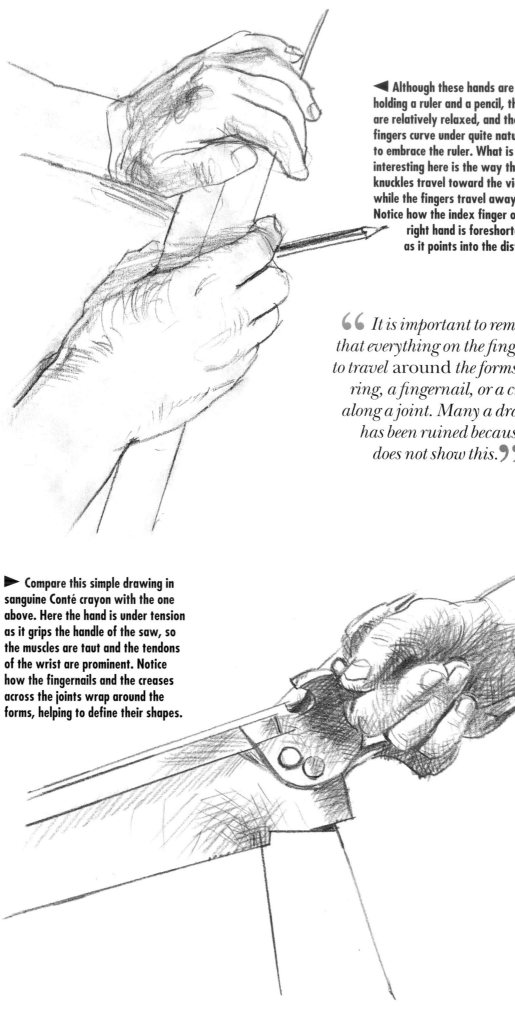

◄ Although these hands are holding a ruler and a pencil, they are relatively relaxed, and the fingers curve under quite naturally to embrace the ruler. What is interesting here is the way the knuckles travel toward the viewer while the fingers travel away. Notice how the index finger of the right hand is foreshortened as it points into the distance.

❝ *It is important to remember that everything on the fingers has to travel* around *the forms, be it a ring, a fingernail, or a crease along a joint. Many a drawing has been ruined because it does not show this.* ❞

► Compare this simple drawing in sanguine Conté crayon with the one above. Here the hand is under tension as it grips the handle of the saw, so the muscles are taut and the tendons of the wrist are prominent. Notice how the fingernails and the creases across the joints wrap around the forms, helping to define their shapes.

▲ For these hands, caught in the action of planing a piece of wood, the artist has opted for the technique of drawing in charcoal and wiping some of it off. The cuboid feeling of the man's fingers is emphasized by keeping them fairly square with a chunky, chiseled look. In contrast, a woman's fingers are usually more cylindrical, so a female hand should be drawn more delicately.

◄ Here, colored pencils are used in a pointillist fashion to create a flesh color, combining blue-red, green, blue, yellow, and so on to differentiate the warm and cool areas, the lights and darks. As little outlining as possible has been used to keep the whole drawing lively and fresh. Around the tips of the fingers, for example, there is a real economy of line.

146

> *If you get models to pose for you, it is a good idea to ask them to go through the motions—of chiseling or hammering, for example—perhaps at intervals during the pose, and certainly at the beginning before they settle down. This will give you more of a feel for the movement.*

▶ Here a classical pencil technique is employed in which the pencil is used less for linear work than for the tones. This system gives you a lot of time to reconsider. You progress from white paper, gradually building up through light and middle tones into dark tones.

Generally speaking, you should not need to use an eraser at all for a drawing such as this. Where there is adjustment, as on the palm of the left hand here, the additional lines help to give the impression of movement.

▼ Pen and ink has a good pedigree. It was used by Michelangelo (1475–1564) and other artists of that period. Generally, as here, you will notice that the cross-hatching has a double function: NOT only does it provide tone, but it also travels around the form to convey shape.

This is the sort of technique that illustrators would choose because it is very precise and specific. Here however, the hatching is not carried out to its full extent.

Drawing women's hands

As a generalization, one could say that a woman's hands are more curved and have greater fluidity, and those of a man have more muscularity and angularity. But when it comes to drawing them, the system is exactly the same for both—a little knowledge combined with concentrated looking and careful drawing.

Think about the feel of the hand. The palm is cushioned with muscles, particularly the large muscle that operates the thumb, while the back of the hand is hard, bony, and veined. If you look at your palms, you can see the fingers do not all start at the same point—the little finger starts lower than the index finger.

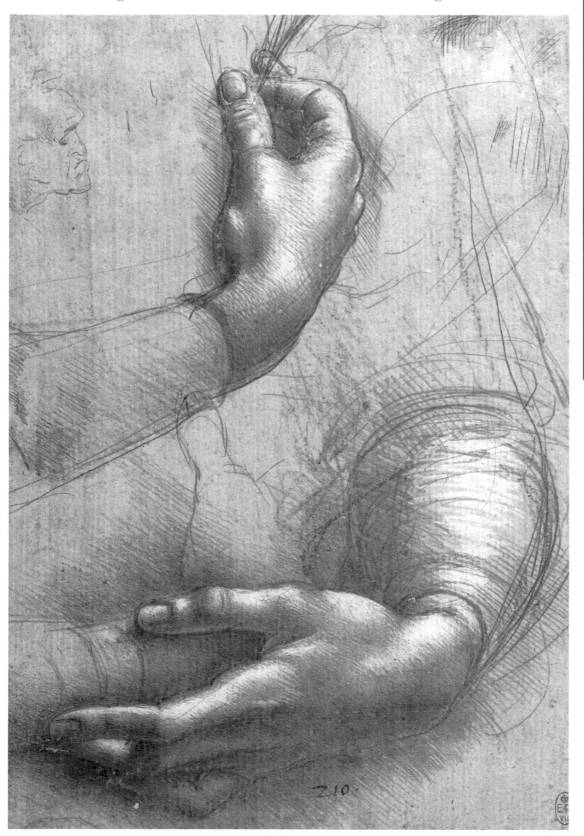

◄ It is obvious at first sight that these are the hands of a woman; ask yourself why. The artist has captured the smooth, rounded shape of the fingers and even implied the softness of the skin through judicious use of contour and hatching.

The hands have a relaxed, gentle, elegant posture—almost balletic—which reinforces their femininity. The skill shown in rendering these hands is all the more impressive when you know that in silverpoint a line cannot be removed without disturbing the surface.

Study of a Woman's Hands by Leonardo da Vinci, silverpoint and white chalk on paper, 8½ x 6 in. (21.5 x 15 cm.) courtesy of the Royal Collection, © Her Majesty Queen Elizabeth II

There is a great deal of flexibility about the materials you use to draw hands, as you can see from these drawings, but generally speaking, artists give women's hands a softer, more delicate touch than men's.

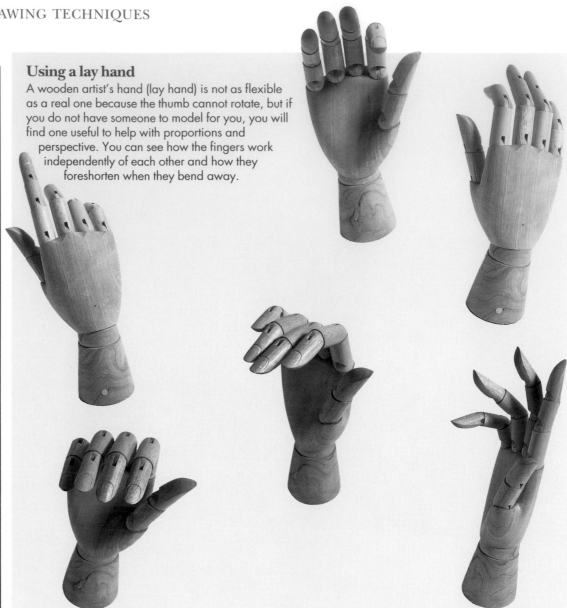

Using a lay hand

A wooden artist's hand (lay hand) is not as flexible as a real one because the thumb cannot rotate, but if you do not have someone to model for you, you will find one useful to help with proportions and perspective. You can see how the fingers work independently of each other and how they foreshorten when they bend away.

▼ This drawing of a woman's hands involved in the intricate task of sewing, shows how the fingers and thumb work together to give very precise control. A simple technique has been used, combining contour with light hatching for tone. Some of the contours are hatched over to give a sense of movement and to show the way the hands melt into shadow.

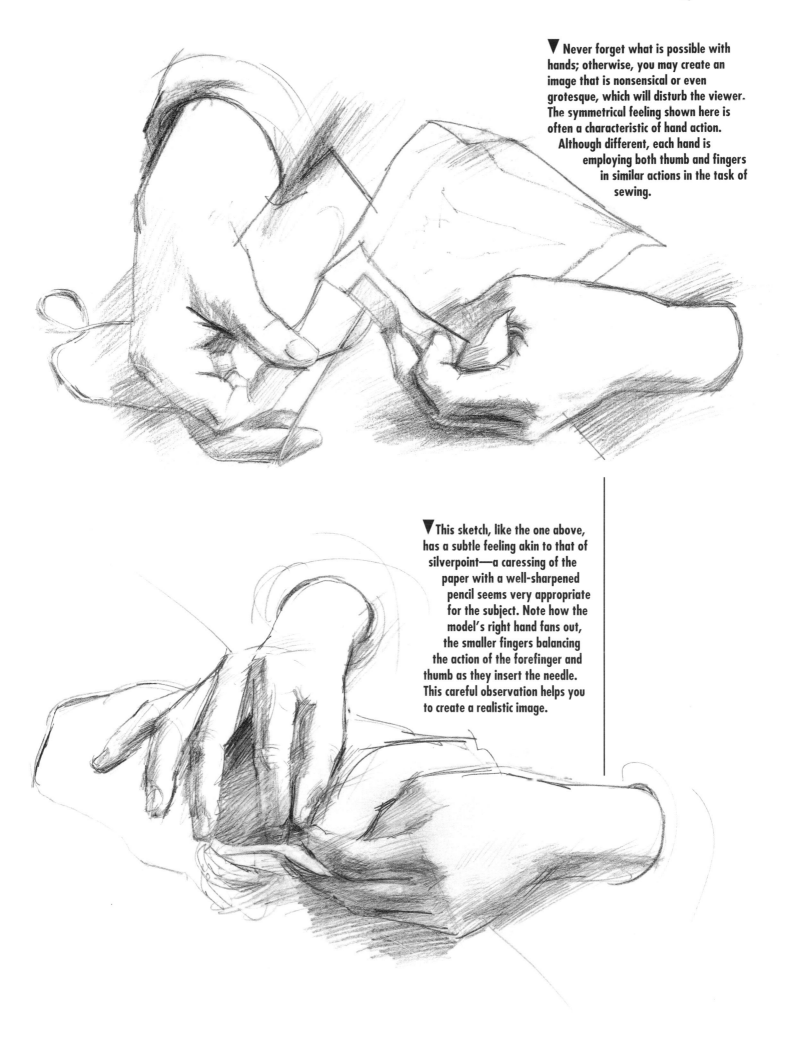

▼ Never forget what is possible with hands; otherwise, you may create an image that is nonsensical or even grotesque, which will disturb the viewer. The symmetrical feeling shown here is often a characteristic of hand action. Although different, each hand is employing both thumb and fingers in similar actions in the task of sewing.

▼ This sketch, like the one above, has a subtle feeling akin to that of silverpoint—a caressing of the paper with a well-sharpened pencil seems very appropriate for the subject. Note how the model's right hand fans out, the smaller fingers balancing the action of the forefinger and thumb as they insert the needle. This careful observation helps you to create a realistic image.

" *In the simplest drawings it is the things that travel around the fingers—the fingernails, rings, and creases over the joints—that give them their shape.* **"**

◀ Here, free strokes of colored pencil are combined to suggest the flesh tones. But although these strokes look spontaneous, they are not random. You should endeavor to put in the areas of light, reflected light, tone, and shadow accurately.

▼ In this simple Conté pencil drawing it is the contours of the fingernails, ring, and sleeves that give the hands their form, backed up with some lively shading.

▼ Compare this charcoal drawing with the one of the man's hands holding the plane on page 145 and you can see that charcoal is not limited simply to the harder angles of male hands. Charcoal comes into its own when you want to put in the really dark shadows created in bright light or when you want a different and dramatic effect.

Landmarks of the skull

If you know the anatomy of the skull, it will help you to draw a better head—and therefore a better portrait.

It is a good starting point to think of the head as a simple geometric form. However, if you have tried drawing your own head or someone else's, you will realize that refinements such as cheekbones, eye sockets, nose, and chin add a great many subtleties to this basic form.

> 66 *Try to gain access to a skull or a casting and make drawings for yourself.* 99

The drawings made from a skull on the following pages will show you some of its different aspects. You will see how this solid understructure relates to surface features as they might appear in a drawing of a head. By looking for these "landmarks" and integrating them into the larger forms, you should be able to draw a more refined version of the solid-looking head.

Always remember that however soft and yielding the flesh appears, underpinning it is a hard, bony structure. For although the skull is covered by tissues, such as muscle, cartilage, fat, and skin, these still conform to the shape of the skull. (For facial expressions and how to get a likeness, see page 155.) In the meantime, try to gain access to a skull and make drawings for yourself. The anthropological section of a museum will have specimens you can study.

▼► These drawings of a skull (see also page 152) are made in what is known as the "three-quarters front" view. This aspect of the head is often used for portraits because it gives a good account of the front of the face and the expression of the sitter, as well as the profile and, in particular, the lines of the nose, cheek, and chin (below).

Around the head

A skull is made up of not one but several bones. The large, spherical part—the cranium—comprises four large platelike bones fused together. This structure protects the brain. To appreciate the size of the cranium in relation to the rest of the skull, look at the drawing of the side view on page 154.

The face is made up of several bones that house and protect sense organs, such as the eyes. Only the lower jaw (mandible) is able to move. Various protrusions allow for muscles to attach. Apart from serving functions, such as opening and closing the mouth and eyes, the muscles afford a great variety of facial expression. Notice how, seen in profile, the front of the head curves from top to bottom.

▲ Note that the eye sockets (orbits), nasal bone, and upper and lower jaw are dispersed evenly about a centerline. In other words, viewed from the front the skull is symmetrical. Notice how the cheekbones protrude, making this the widest part of the face.

◄ Here the skull is drawn in pencil heightened with white chalk on mid-gray paper. Then, using a photograph similar to the one of the model on the previous page, half of the face is constructed as it might appear if the skull were fleshed out below).

► Although the orbit and the ball that fits into it are quite large, only a small part of the eye shows at the surface. Similarly, the lips cover a much larger structure—including the teeth. The hair fits over the cranium like a cap. A bony ridge across the brow protects the eyes.

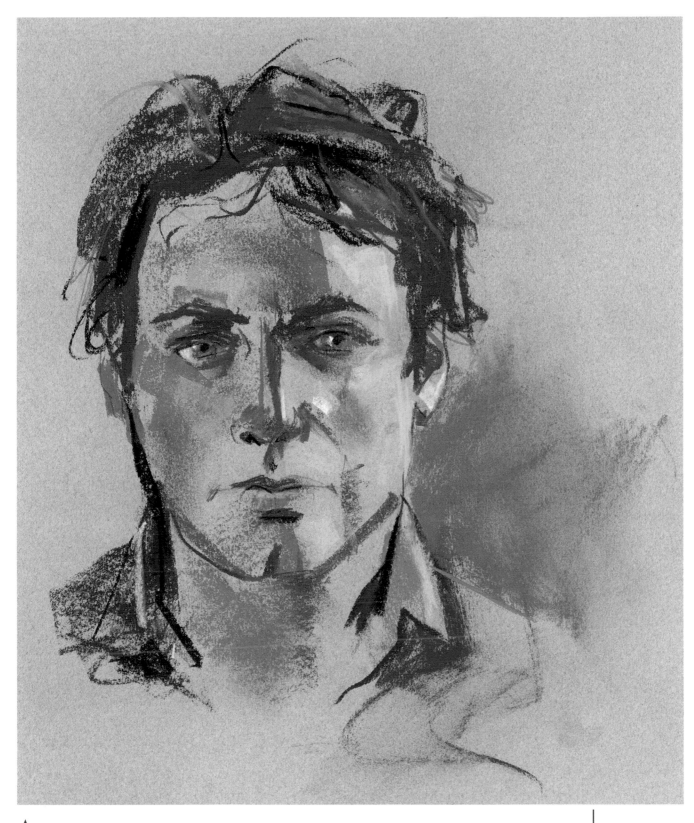

▲ Run your fingers across your own face. You can feel that some of the bones come close to the surface while others are buried quite deeply. Where bones come to the surface and change direction abruptly—such as at the cheek, side of the forehead, edge of the lower jaw, and bridge of the nose—these changes often give rise to highlights. Certainly, these are the places you would expect to find strong tonal changes, and you can see examples of them in the pastel drawing here. Being able to separate and render these tones in your drawing is the secret to modeling a head well. (You might find it helpful to refer to the exercise on page 96 in which we made a drawing of a head from a tracing of a photograph.)

DID YOU KNOW?

Three facial slopes
*Three types of slope have been recognized: steep slope (**a**), moderate slope (**b**), and the diagonal slope of the skull (**c**).*

▲ Can you see how large the cranium is in relation to the whole head? A good way of conceiving of the overall mass is as a sphere (A) interpenetrating an egg (B). The profile also reveals the facial slope. This varies between individuals and races. The nasal bone ends abruptly—not because it has been broken but because the nose consists largely of a cartilaginous extension. The ridge at the brow is very evident even when there is tissue over it.

Notice that a line drawn down the front of the face would not be straight—like one drawn down the side of a cylinder—but curved like the seam along a football.

◀ Whether you draw the head facing to the right or left depends on several factors.

Your model might prefer you to portray one side of the face rather than the other. Or, you might find it more comfortable to draw the head facing to one side, depending on whether you are right or left handed. The artist who made this drawing is right handed and preferred to draw the head facing as it is here.

Achieving a good likeness

Rendering a good pencil likeness in portraiture is all a question of where you position the features in relation to each other.

In previous demonstrations, we saw how to go about drawing the figure, making it look solid and ensuring that it is logical—the neck looking strong enough to support the head, for instance. Here, we look specifically at getting a likeness.

Much is said about capturing character, but for now, just think about what you see. As the British painter, Sir Joshua Reynolds (1723–1792) said, the painter's job is to concern him- or herself with likeness, not to "search for the soul." He asserted that a picture is only on the surface. This is not to say that a person's face, expression, and clothing will not tell us something about character, especially as people age and their laughter or frown lines assert the personality.

> ❝ *If you render a feature in detail early on, before you are sure of its exact position, you may be in danger of thinking it is too good to change. Then the whole is held ransom to the part. Perhaps the best advice in this case is to destroy the picture.* ❞

As with any art skill, portraiture requires practice. You do not need to draw lots of different people, though; you can try your hand at self-portraiture or draw a friend or relative. But no matter how many times you draw the same sitter, always try to do something different each time. Great self-portraitists such as Rembrandt and van Gogh presented something new in each picture, although each was a good likeness.

Start your picture with some serious looking and keep in mind all the rules of drawing a three-dimensional object, such as perspective, modeling with tones, and symmetry.

▲ **A picture does not have to be highly elaborate to be a good likeness. A simple pencil drawing with a few tones hatched in was all that was needed here.**
H.R.H. The Prince of Wales *by Michael Noakes, pencil on paper, 8 x 6 in. (20 x 15 cm.)*

Positioning the features

► The setup It is probably easiest to achieve a good likeness with the classic three-quarter pose because you can see something of the profile as well as the front of the face. Posture and body shape can play an important role in getting a good likeness, but for this exercise we are concerned with the face only.

►1 Consider the structure of the face. Start by drawing the inverted triangle of the mask of the face that marks the positions of the eyes and the mouth. With the face turned to one side, as here, remember that the nose does not run straight down the center of the triangle but is over to the far side of the face.

The plane of the cheek-bone is also drawn in, as well as the triangle that runs down the hollows of the cheeks to the chin. Note that this second triangle is parallel to the first.

YOU WILL NEED

- ☐ *Several sheets of good-quality paper (our artist used 18- x 24-in. drawing paper and cold-press watercolor paper)*
- ☐ *A thin stick of charcoal*
- ☐ *A 4B mechanical pencil*
- ☐ *A mirror*
- ☐ *An eraser (optional)*

One professional artist's method of portraiture is to concentrate not so much on the facial features as on the spaces between them. It is these spaces, he says, that tell us apart.

To prove his point, he has drawn two pictures of Liz below, one fairly loosely but with the features in the correct positions, the other with each feature drawn precisely but slightly misplaced. If you compare the two drawings with the photograph of Liz, you will see that the looser drawing is the better likeness.

Of course, if your model has a really dominant feature, you can achieve a likeness merely by drawing that accurately. Liz wears glasses. These count as a dominant feature, so for the purposes of this exercise she has removed them. However, she is most familiar with herself with her glasses on, so for the main drawing (opposite) she put them on again.

▲2 Using a thin stick of charcoal and smudging the tones with his finger, the artist has made a rather impressionistic drawing of Liz. Each feature is carefully positioned, but out of focus. Nevertheless, it is an excellent likeness.

◄3 For this drawing, the features are deliberately slightly out of kilter, lengthening the space between the eyes and the mouth (and therefore the length of the nose). He has drawn each feature accurately, this time using a 4B pencil to enable him to get more detail. However, because the features are misplaced it is not as good a likeness as the drawing above.

Portrait of Liz

1 Using the same setup as before, start lightly with the 4B pencil. The artist dotted in the center of each eye and the mouth, but you could draw the full inverted triangle if it helps. He noted that the glasses provided a helpful grid against which to relate the features—but do not forget that they distort the far contour of the face slightly.

> *Do not be tempted simply to pick up a pencil and start scribbling with it—this is a waste of time. Underpin your drawing with some careful assessment and measuring.*

2 Put in the overall shape of the hair and start to refine the features, adjusting them all the time as the portrait develops. Try not to use the eraser unless absolutely necessary; if you draw lightly, strengthening the lines as you find them, your first marks will pale into insignificance anyway. Start to introduce a few tones so that you are beginning to model the form.

3 Before you can define the strands of hair, you have to find the overall form. In a painting you can do this with color, but here you must do it with tone. To achieve the really dark marks our artist wanted at this stage, he tore the paper off his pad and put it on a drawing board. This harder surface enabled him to make much deeper, stronger marks with the 4B pencil.

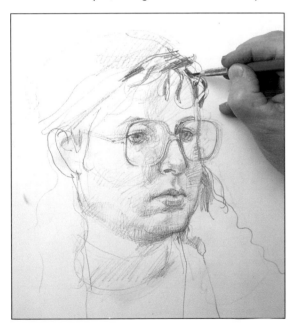

4 Develop the tones on the face and the wonderful waterfall of hair. There is already some quite subtle shading, not only bringing out the nose and pushing in the eye sockets, but inviting the eye to travel between the lips, into the nostril, and behind the head. In contrast, the hair was drawn freely to give life and vigor to the picture.

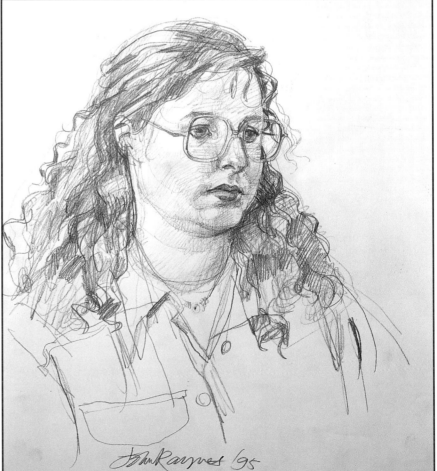

Drawings of Matthew

▼ **The setup** The artist decided to do three drawings of Matthew on the same sheet of paper. This is a real test of skill—all the drawings must look like the same person! He used heavy cold-press watercolor paper, which is agreeable to draw on because it gives the pencil marks an appealing grainy quality, but you could equally well use drawing paper.

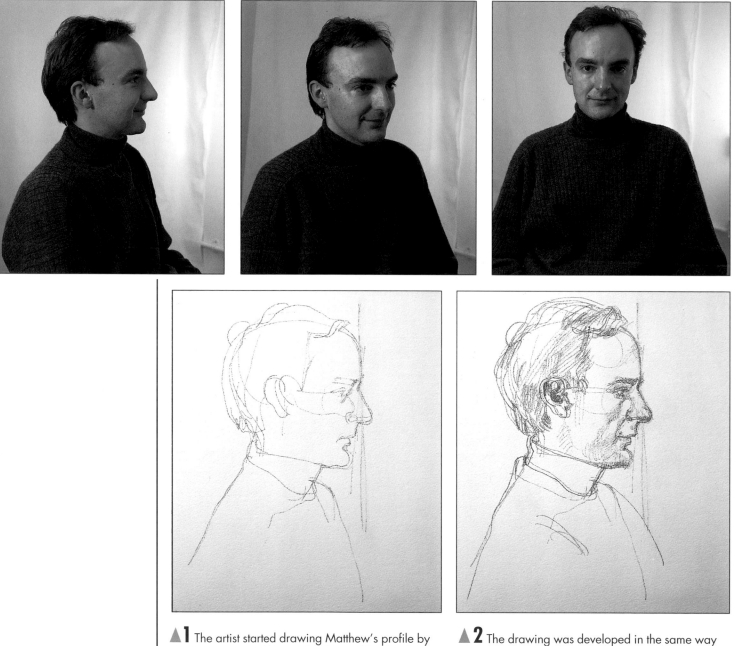

▲**1** The artist started drawing Matthew's profile by putting in a vertical line so that he could judge the facial slope. Matthew's head was tilted slightly downward, so his forehead conformed to this line while the lower part of his face pulled back from it. (Even if nothing conforms to the vertical, it is still a useful reference against which to judge angles.)

▲**2** The drawing was developed in the same way as the portrait of Liz, starting lightly and loosely, then adjusting and refining—notice the way the ear has moved. Always be ready to modify. Do not just fill in your initial drawing without question.

Notice how the artist has drawn spheres on the forehead and cheek. These represent "the top of the hills," like contours on a map.

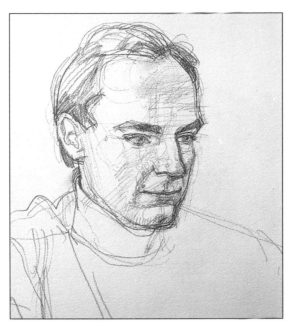

▲**3** Start the three-quarter view in the same way as before by dotting in the centers of the eyes and mouth, then working outward. Make sure you get the positions of the collar and shoulders correct. If the collar is right, you will find the set of the head comes automatically. Impose a mental grid to help you align the features (or draw one if that is easier).

▲**4** Continue to elaborate your drawing, never forgetting the relative sizes, positions, and tonal strengths of everything. The artist has placed great emphasis on Matthew's very strong forehead and has put a lot of work into the mouth, which he also thought was very significant. (A good artist will always look for features specific to the model and work most on these.)

Tip

Out of the ordinary
Study your sitter to find any deviations from the mythical norm and emphasize these, but without caricaturing. The British portrait painter, Sir Stanley Spencer (1891–1959) did just this. Here, the artist noticed the strong forehead and chin and the dashing slant of Matthew's eyebrows.

66 *Notice the collar in the three-quarter view. People nearly always underestimate how high it goes—here it curves around the back of the neck, level with the bottom of the nose.* 99

▶**5** With the full-face view you must get the symmetry right and show the protrusion of the nose without the benefit of the profile. The facets of the forehead are best seen in this view because the light is striking them, making them ripple. Notice that in spite of having done two previous drawings of Matthew, the artist does not let himself get stale, but "rediscovers" his model each time.

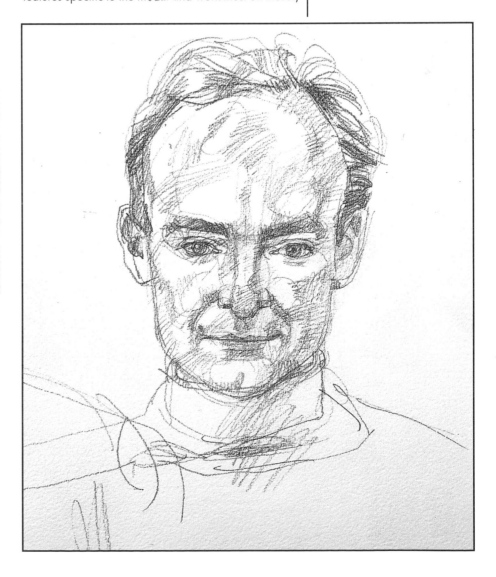

▲**6** All three drawings of Matthew are unmistakably of him, which points to very good portrait drawing. But the artist has not exaggerated or caricatured—he has relied on acute observation and discovery, combined with careful drawing.

Each new drawing reveals different things about Matthew— the profile shows the construction of the face, the three-quarter view reveals the high forehead, while the full-face view shows the construction of the mouth and the distinctive slope of the eyebrows.

66 *Practice these exercises whenever you can, using a friend or yourself as a model. Even if you are not good at it at the beginning, you will be surprised how many of the model's characteristics you can pick up. You might do a drawing that in some aspects is disappointing, even laughable, but often you will see other things in it—and my goodness, yes, it is that person.* **99**

Portraits of children

Drawing children can be very rewarding, but if you are going to be successful you need to provide some entertainment and a lot of encouragement—and be prepared to work in short spurts.

The first thing to consider when drawing a child is purely practical—children just cannot keep still for long, so do not expect them to. Make sure your model is comfortable and gets regular breaks, and try to keep things lighthearted and fun.

You will probably have to work quickly, so choose a suitable medium—pencil or charcoal, for example. For color, consider colored pencils or a few watercolor washes. If you put enough detail into your drawings, you can always use them to make an oil painting or a more detailed watercolor later.

> ❝ *It will show in your picture if your model is hating every minute of the session, so keep the atmosphere as relaxed as possible.* ❞

Drawings can be a wonderful record of a child's development to adulthood and provide an interesting record of the way a face changes as it matures. From babyhood up to the teens, the inverted triangle running through the eyes and down to the mouth changes, the mask of the face increasing in proportion to the size of the head and the features becoming more distinctive.

Remember that the proportions of a child's face are different from those of an adult. The mask within the oval of the face is smaller and so

▶ Colored pencil is often much underrated and neglected. But as this picture shows, it is possible to achieve some very creative results. Avoid the temptation to color in with a generalized pink flesh tone—instead use a combination of reds and yellows. For shadows, opt for blues, greens, purples, and browns, not deadening shades of black and gray.

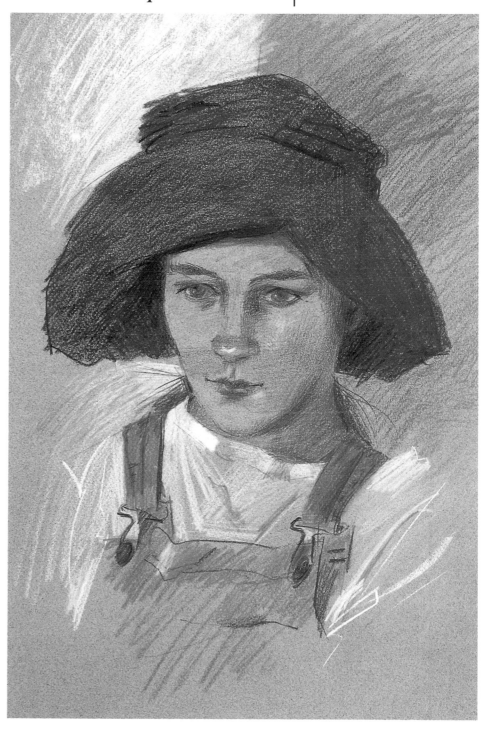

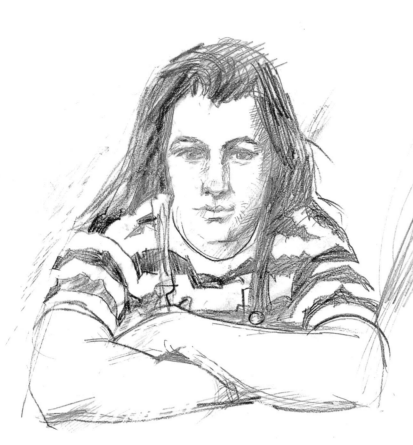

▲ Whenever you have the chance to draw a model, whatever his or her age, take the opportunity to make several sketches that examine different poses.

Try an assortment of media in your sketches to give it variety. In the drawing of Beatrice (above left), the artist has combined charcoal pencil (to suggest the color of her hair and T-shirt) with kneaded-rubber eraser and HB pencil. In the drawing (above right), only pencil is used, but the marks have been varied to keep the drawing lively—compare the subtle shading on the nose with the bold strokes in the hair, for example.

▶ Charcoal pencil, HB pencil, and colored pencils are combined for this three-quarter profile of Beatrice. Skin color is suggested with a combination of red, orange, and yellow pencils, with a little blue added for shadows. Notice how the blue in her hair not only picks up on the blue of her dungarees but also enlivens the black, which would have been much duller if rendered in black charcoal alone.

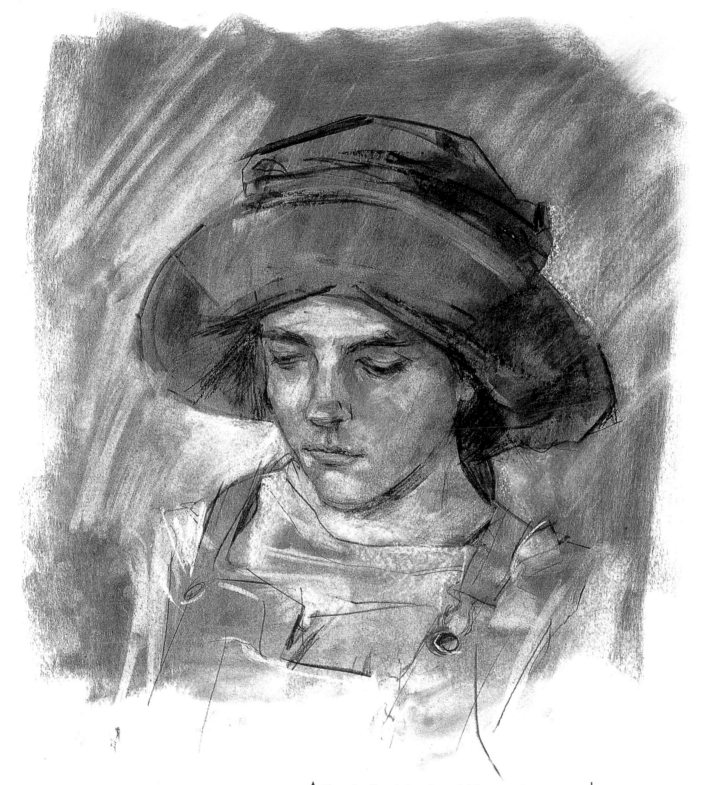

are the features themselves—the eyes, nose, and mouth. These features are generally less distinctive and defined than in adulthood. Usually the brow is high and the cheeks and chin are rounded; the skin is relatively smooth and uniform in texture and coloring. However, that is not to say that all children look alike! Even in babyhood a child has an individual look—for example, he or she may have striking eyes.

▲ The rub-off technique is useful for portraits because it is especially good at rendering the "fleshliness" of skin. Here a few touches of white pastel brighten up the shirt and show the way the light catches the edge of Beatrice's red velvet hat and her eyelids, nose, and lower lip.

Beatrice in profile

A profile can be a charming pose, and one that is worth investigating. This view of Beatrice is not quite a complete profile—you can just see her far eye. This can appeal more than a complete profile and is likely to be more popular with your model.

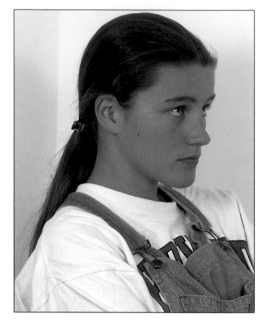

► **The setup** A pose that has a characteristic—but preferably flattering—expression and that shows off a good feature is likely to be most attractive. Of course, it can be a matter of contention which are the best features—Beatrice hates her beautiful, turned up nose.

◄**1** Bearing in mind how the portrait will fit the paper, start by drawing the mask of the face with charcoal. A few quick tones added with white pastel and the side of the charcoal stick are already giving the picture a three-dimensional feel. Add a few charcoal strokes in the hair to suggest individual strands.

►**2** Use the black and white judiciously, allowing the gray of the paper to show through for the mid tone. Create a few tones in between by smudging and softening the charcoal marks with your finger on the forehead and in the eye sockets. Notice how the head is defined by solidly blocking in the negative space around it—the white of the wall.

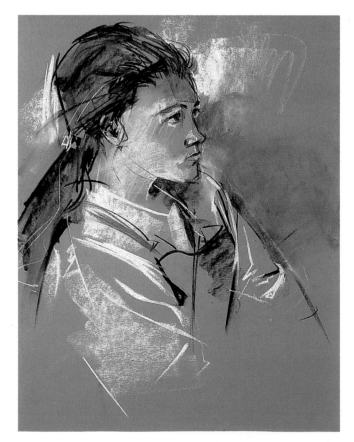

◄**3** For the finished drawing, soften the tones on the face and hair with your fingers, but differentiate the fabric of the clothes by leaving these areas unblended and sometimes using the Pierre Noire pencil. The fast and free strokes on the clothing also help to keep the drawing lively and fresh.

Child proportions

Do not try to pose children—take them as they come and it will be easier to capture their characters.

The wonderfully appealing faces and tiny bodies of children, their expectation of life, their unrestrained bouts of enthusiasm, sorrow, rage, and exhaustion, and all their misbehaving, make them marvelous subjects for the artist. But the one major problem with drawing them is that they are always on the move. They cannot be forced to stay still, and if they were, you would deny their spirit and stultify the drawing. You have to have patience, just as you do when drawing live animals.

Probably the easiest way to start is to draw children while they sleep. This is particularly true of the very young who cannot bear to stay still.

> *Drawing children is both a challenge and a joy. If they are your own, all the better, but children generally make the most marvelous subjects.*

Older children can be encouraged to sit for reasonable amounts of time, and you can mark their positions with chalk so that the pose can be taken up again after a break.

One useful tool is the video or television. If the program does not disturb you too much, it is a good way of keeping a child entertained while you jot down some quick sketches or make a more studied drawing. Alternatively, try to catch the child reading or listening to music. Ask him or her to pause every now and then so you can jot down on paper a particular slant of the body.

You have to be an opportunist when drawing children. You cannot really get children to dress up specially unless you have young models on your hands, so you will have to take them as they come. If a child is wearing something interesting, be ready to draw him or her quickly. Jasper with his face painted for a theatrical event (see page 168) is a case in point.

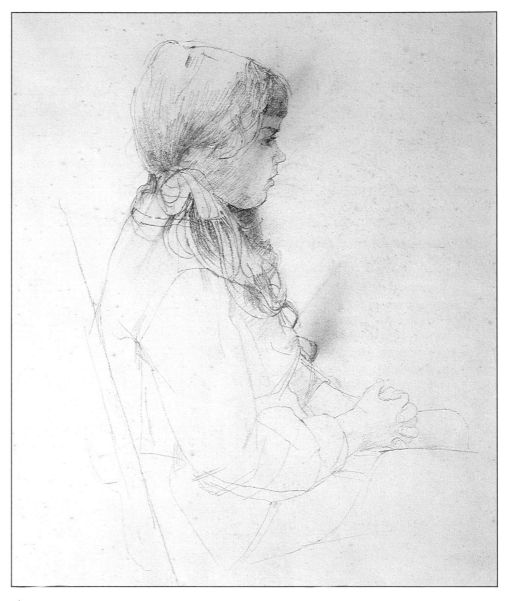

▲ This drawing is by Sally Holliday. It is a gentle appraisal of a child: a very warm and affectionate drawing that has a great deal of subtlety without being labored. Notice how it captures the diminutive, upturned mouth and nose, the relatively large eyes and plump skin that all denote the face of extreme youth.

The fact that children are so impatient and move around so much makes it very tempting to work from photographs. In their place these can be very useful and constructive, but if you work from photographs only, you are likely to end up with flat, lifeless drawings. If you do work from a photograph, the idea is to make a picture that says more, not less, than the original. So to start with, use photographs as backup if you must, but preferably not at all.

Ways of working

Different artists have different ways of working with children. You can learn a lot from a long, careful study of a child, but it is useful to start with a series of sketches in one session—perhaps 10 or 15. Sometimes they will all work; more likely some will not. Perhaps the child will move when all you have drawn is the nose or the eyes, but that is just bad luck. Learn to accept that there will be failures as well as successes.

Media can vary according to your personal preference. Charcoal is an immediate and direct medium, and one that is easily manipulated with fingers, rags, kneaded-rubber erasers, and bread, so it is a good first choice. An ordinary pencil also works well, although if you have a range you will achieve better tonal variations. For color you can use whatever you like—oil pastels and colored pencils as on the pages here, or even oils or watercolor washes.

Getting children in proportion

As with any drawing, knowing what to look for helps you avoid potential pitfalls and enables you to figure out what is wrong with the drawing if it does not seem to work. One of the most important things to study with children is the way their proportions vary according to age—a child is not simply a smaller version of an adult.

On page 161, we touched on how a child's face differs from that of an adult and how the mask of the face grows and the features become more pronounced as the child gets older. The proportions of the body also change. One of the things you will notice is that babies have longer arms in proportion to their legs, and that their heads are larger in proportion to their bodies—a baby's head fits four times into its overall height while an adult's fits seven and a half times. As the child gets older, the head stays relatively the same size while the body grows until eventually the child can look in the mirror and see the adult. This is laid out below.

▼ **It is easiest to show how the proportions of a person's body change from babyhood to the late teens in a diagram, such as this one by Albany Wiseman. We use the head as a unit of the total body height—as you can see, you get more and more heads to the total body height until the person reaches adulthood. Of course, people's proportions vary, and posture also makes a difference.**

1 year
(4 heads)

4 to 6 years
(5¼ heads)

6 to 8 years
(6¼ heads)

12 to 14 years
(7¼ heads)

18 to 20 years
(7½ heads)

► This drawing in hard charcoal, demonstrates very well how small the mask of a child's face is in the overall sphere of the head. And because the child is so young—six months old, in fact—this is particularly pronounced. You will see in these drawings that, as the child gets older, the mask of the face expands and the features become more pronounced.

Charcoal is a good medium to choose for drawing children and babies because it is so fast and is easily removed with bread or a kneaded-rubber eraser. You can even dust it down to produce a ghost image to work over.

◄ This sketchbook drawing was made with a ballpoint pen used rapidly as the elder child sat up, capturing her wide-eyed, rather startled expression. Notice how the hair of the two children differs. The baby has thin, soft hair that flops down, while the little girl has an abundance of hair that, although still very soft and silky, has much more body than her brother's.

◄ This three-year-old girl is totally exhausted. Everything is absolutely relaxed, the fingers spread so they fall into a complete rest. Notice the typical details of the child's form—her tiny nose and mouth, and her chubby hands that have dimples over the knuckles. It is these pertinent details that capture the character of childhood. If you can distill these into your drawing, you are well on your way to a successful picture.

► Here is Jasper, made up for a theatrical event. He is drawn in context on a chair, which not only anchors him but shows his small size. Notice how the different stresses of the 4B pencil create some good strong tones that lead the eye into the piece and help to create the illusion of the third dimension.

◄ This drawing by Sally Holliday is worked up in more or less the same way as the one on page 165 but with color added. Oil pastels—yellow ocher for the girl's shirt, raw umber in the hair and on the top, and a little flesh pink on the leggings and face—are combined with pencil and black Conté crayon. She has smudged the pastel with a rag that has absorbed some mineral spirits, letting the color stray beyond the contour lines so that the girl becomes part of her environment, not a lonely, isolated figure.

CHAPTER THREE

Creative approaches to drawing

Drawing from different viewpoints

Even when drawing the same subject matter and using the same drawing materials, you can achieve two very different pictures by simply choosing two different viewpoints.

An artist does not have to travel far and wide in search of inspiration. For example, in his early work, the French painter Pierre Bonnard (1867–1947) rarely went farther than his own bathroom to paint a picture. If you look closely, too, there are many pictures to be made in your home environs.

A good exercise is to try drawing the same room from the inside, looking out, and from the outside, looking in. Our artist found that his large-windowed living room provided the ideal subject for this project. Drawing from the inside, he has created a picture full of depth and bold divisions of light and dark. From the outside, the drawing is a little flatter in terms of both contrast and depth—but the artist has come up with an attractive, somewhat abstract design of shapes.

Together, the pictures make a beautiful pair. They are unified not simply by the subject matter, but also by the drawing media. In both pictures, a selection of graphite sticks was used to put in the detailed work, while large expanses of tone were blocked in with graphite powder.

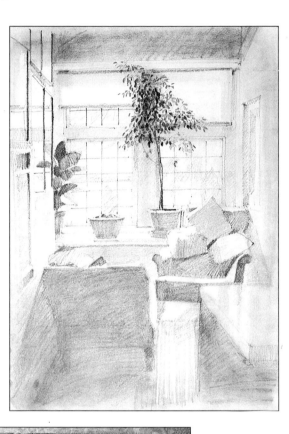

◄ Abrupt divisions of light and dark in this interior scene create a lively picture surface and help to give a strong sense of depth to the picture.

Note how the eye is led up the shaft of light in the foreground and pulled through the furniture toward the bright light outside the window. The effect is reinforced by the use of graphite powder around the edges of the picture, creating a dark surround that directs the viewer's attention to the center.

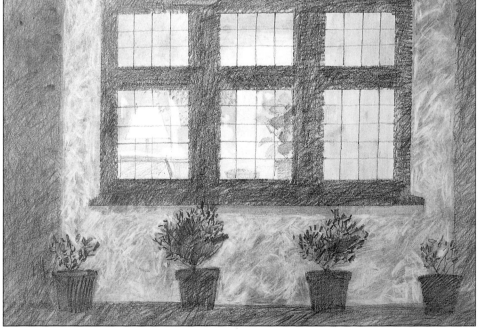

◄ For the outside view, our artist decided to draw at night so that the lights inside the window could draw the eye. The graphite powder—used across the wall—is ideal for simulating night scenes, but there is a danger that it could produce a rather dull, uniform mid gray. Our artist therefore scribbled across this graphite powder with an eraser to enliven and lighten the tone.

Inside, looking out

YOU WILL NEED

- [] Two 18- x 24-in. sheets of drawing paper
- [] Three graphite sticks: HB, 4B, and 6B
- [] Graphite powder
- [] Cotton balls
- [] Spray fixative
- [] Kneaded-rubber eraser

For the interior scene, our artist chose a view looking straight at the window, creating bold silhouettes and exciting reflections. Much detail is eliminated because the surfaces are either brightly illuminated, and therefore left as white paper, or in deep shadow.

The artist worked in three basic stages. First he used the graphite sticks for the initial drawing and to hatch in the tones. Then he applied graphite powder to give a more general impression of the dark recesses of the room. Finally, he rubbed out the powder in the foreground to put in the shaft of light.

►**1** Start by lightly mapping out all the objects in the room with the HB graphite stick. Then begin hatching in some of the darker tones with the 4B graphite stick.

▼**2** Continue working on the dark tones throughout the picture. Look carefully at the fall of light on the cushions. Achieving lifelike modeling is not always easy when you are working with bold blacks and whites rather than with many subtle gradations of gray.

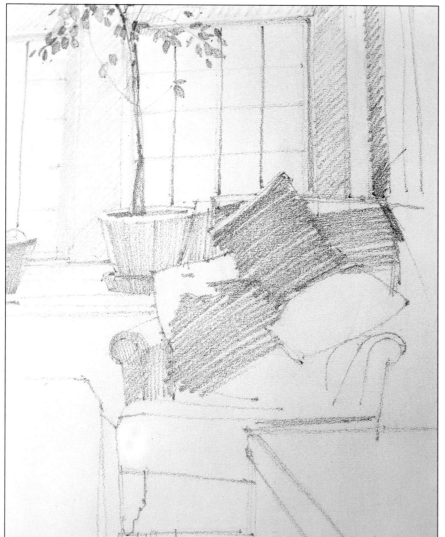

▼**3** Work your way around the picture with the 4B graphite stick, varying the direction of your hatching strokes to help create a lively picture surface. Use very dense marks for the leaves against the window.

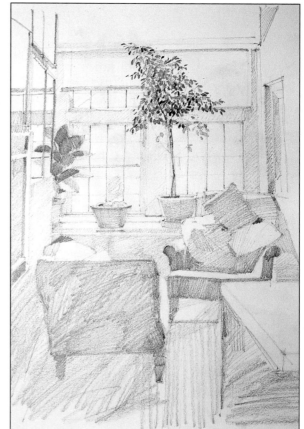

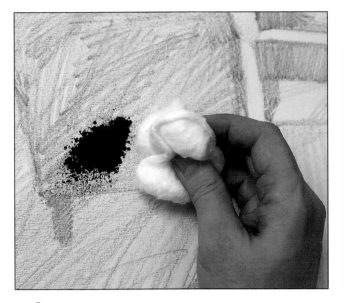

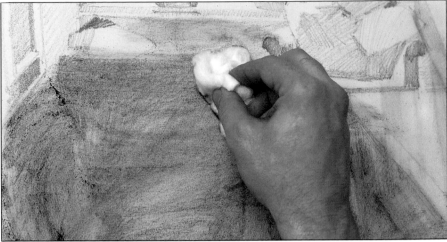

▲**4** Now use the graphite powder to put in the darkest tones, starting with those nearest the viewer. Simply pour a little powder onto the back of the armchair in the picture and begin to rub it in with a cotton ball.

▲**5** Spread the powder over all the shadow areas with broad, sweeping motions. The idea is to lay in large areas of tone quickly, rather than attempting to draw with the powder. (The powder, no matter how thickly you apply it, will not obliterate your initial drawing.) Blow any excess powder off the surface paper—this can be very messy, so take the drawing outside to do it.

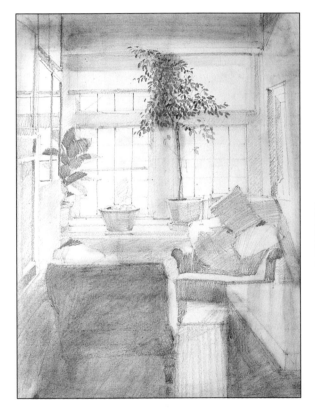

◄**6** Rub the powder into the shadows in the bottom right corner and around the edges of the picture. This darkens the tones, providing a deep surround that directs the viewer's attention to the center of the image.

►**7** Brighten the shaft of light passing between the armchair and the table by taking back the powder with definite, linear strokes of the eraser. Clean up the other light areas in the same way.

Spray the drawing with fixative at this stage to hold the powder on the paper.

◀ **8** Use the 6B stick to darken any small areas of tone, such as the leaves of the potted plant. Note how the leaves set against the wall are solid black, while the leaves against the windows have been put in more tentatively to give the impression of light passing through them. Try not to define the outlines of this plant too sharply, otherwise it will appear to loom forward incongruously.

▶ **9** In the final drawing, note the startling use of the white paper. With graphite powder, there is often an inclination to smear it liberally over the whole picture. This drawing, however, gains much of its impact from leaving areas of the paper showing through.

Note, in particular, the way in which the tops of the plant pots, cushions, chairs, and table have been left white to give the impression of skimming light.

Outside, looking in

Viewed from the outside, the window and the potted plants produce a pleasing symmetrical arrangement. Indeed, so perfect is the symmetry that the drawing was in danger of becoming static and unexciting.

To introduce a sense of verve, our artist used a variety of texture effects, including removing some of the graphite powder with an eraser, and scribbling in the window frame and the dark border with a range of graphite sticks. As a result, what attracts the eye in the final drawing is the vitality of the picture surface every bit as much as the three-dimensional representation of the subject matter itself.

▶ **1** Sketch the outlines of the window frames, the plants, and some of the objects inside the window with the HB stick. Then lightly hatch in the objects inside the window with the 4B stick. Next, scribble with the 6B stick over the window frames to achieve a dark tone. Use a ruler so that you do not stray beyond the outlines.

◀ **2** Now draw in the potted plants outside the window with the 4B stick. Use closely hatched lines to put in the tone of the pot, and dense marks with the tip of your stick for the foliage. Do not "draw" the leaves on the plants, but find a mark that is a rough equivalent, otherwise the plants will become too important and the picture will not hang together.

▶ **3** The basic composition is now established and the main elements of the subject have been indicated. It is time to turn your attention to livening up the picture by adding different texture effects.

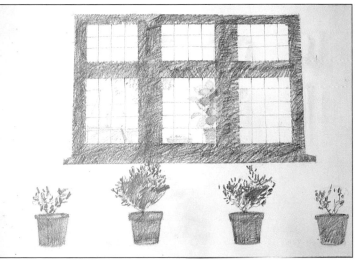

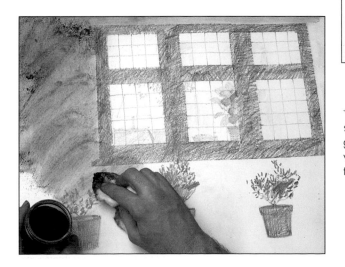

◀ **4** Smear graphite powder over the walls, using sweeping motions with a cotton ball. Do not worry about going over the potted plants, but avoid intruding into the window. Note how the graphite powder immediately gives the impression of a night scene.

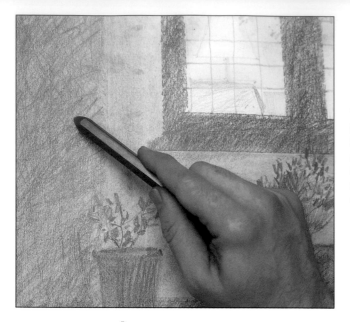

◀ **5** Now add the dark tone of the ground and the recesses on each side of the house wall. Do this by vigorously scribbling with the side of the 4B stick. This dark tone provides a neat internal frame, directing the eye toward the focus at the center of the picture.

▶ **6** Break up the smooth graphite tones on the lighter area of the wall by scribbling the eraser over the graphite powder. This adds interesting and lively textures, and helps simulate the pebbled wall texture.

▼ **7** The final picture works well as a two-dimensional design because the wall and the window are parallel to the picture plane, and the picture space is very shallow. There is no depth, but the pattern-making, abstract aspects of the image are emphasized. It has an elegant symmetry, yet the irregular placement of the objects inside the window prevents the picture from appearing too static.

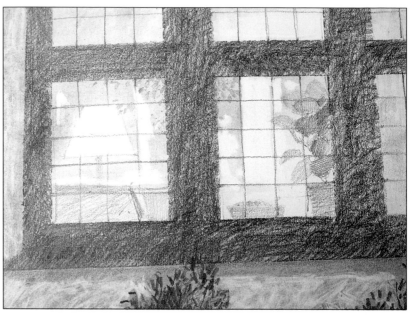

Atmosphere versus accuracy

With man-made structures, it is important to achieve accuracy in your drawing, but it is even more important to capture something extra—the atmosphere enveloping the building.

An architect's impression of West Pier in Brighton, England, would contrast dramatically with the version demonstrated here. The architect's drawing, naturally, would be highly accurate, but our artist was more interested in capturing the mood of the day and the general feeling of the place, which technical rendering does not attempt to achieve.

This drawing is as much about atmosphere as it is about a literal description of the structure of the pier. The artist has not ignored the important considerations for drawing structures, such as the rules of perspective, but in her drawing you really feel the swirling of the wind and the rolling of the sea. Into this evocation of wind and weather she

has incorporated the extraordinary structure of the pier, its detachment from the land giving it a surreal quality that complements the atmosphere of the drawing.

For sea, sky, and shore, the marks are flowing and undulating, but for the pier itself they are straighter, tighter, and more geometric, to match the nature of the subject. The artist favors charcoal for its expressive qualities and the fluidity of line she can achieve. Fine details with charcoal are only possible on a large scale (especially with the chunky charcoal stick she used), so she worked on a very large sheet of paper. This also allowed her to make huge, gestural movements using the whole of her arm.

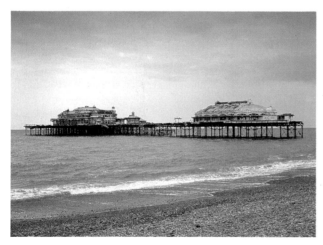

◀ **The setup** On a cold, windy day on Brighton beach our artist settled down on the gravel to tackle her subject. The weather added to the gloomy atmosphere of the pier—somewhat forbidding because it is cut off from the land and in ruins as a result of fire.

At first sight, our artist likened the pier to an animal skeleton surrounded by water. She decided to start her drawing by attacking the supporting struts.

▶ **1** For this artist, drawing is a puzzle, so she began her picture by feeling her way around the subject in order to understand it. First of all, she indicated the struts, stroking them in quickly and loosely with the charcoal pencil. The aim is not to achieve precise accuracy at this stage—these are just vague suggestions to guide her, so she does not care where her marks begin and end. She also indicated a little of the sky to the left with the side of the thick stick of charcoal.

Then, still with the charcoal pencil, she found the horizontal line marking the base of the pier.

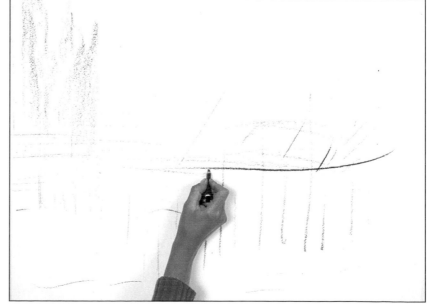

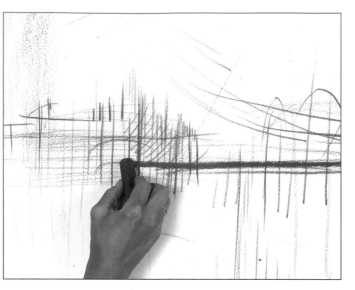

◄**2** Our artist began to bring out the vertical lines of the window bars and railings, hatching in diagonal marks over them to deepen the tone. Notice how, on the building to the right, she indicated the shape of the roof, plotting the far side that is not visible from her viewpoint. This strengthened her understanding of the structure.

This work obscured the strong base, so she reinforced it with a thick stick of charcoal, carving her way through the picture with definite, positive marks.

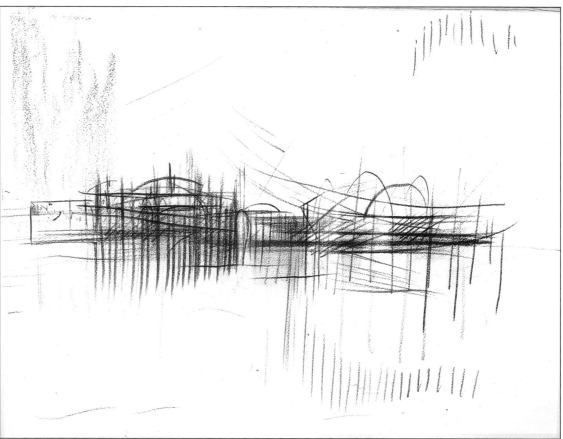

▲**3** The artist continued making horizontal and vertical lines to capture the intricate architecture—not so much for accuracy, but more in spirit at this stage. She worked outward in both directions from the baseline to create a geometric rhythm that would act as a structural skeleton for the picture. With the supporting struts, it is important to suggest the moving water around the static verticals.

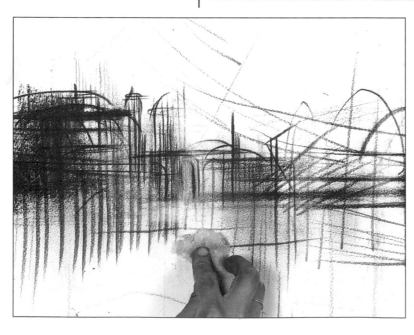

◄**4** The structure continued to emerge as the artist found more definite marks, such as the strong outline of the roof to the left, made with the edge of the thick charcoal stick.

If you are working in this way, you may lose details as you build up deep tones, and therefore you may need to rub back into the charcoal. Soft, white bread makes a good malleable alternative to a kneaded-rubber eraser. Our artist prefers its gentler effect. Here, she reduces a few marks to a soft, quiet echo of their former selves.

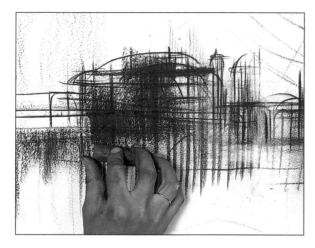

◄5 Half-closing her eyes in order to see the most basic tonal areas, the artist blocked in a deep tone on the building to the left with the side of the thick charcoal stick. This is not just for the sake of tone—having found the architectural details, she promptly loses them, wishing to block out of her mind the intricate, lacelike ironwork—and so discourage herself from being too detailed in her drawing. This helped her to keep her approach fresh and exploratory.

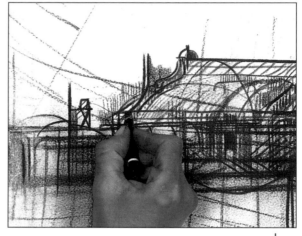

►6 Having temporarily edited the building to the left out of her mind, the artist now turned to the building to the right. Here, she developed the decorative scrollwork of the architectural elements. Instead of aiming for a replica, she was much more interested in relating the marks she made here to others around the drawing—perhaps the rhythm of some marks in the sky or sea. She used a variety of tools—the charcoal pencil for the flowing lines; the thick stick for the chunky, strong marks; and a sketching pencil for the straight lines of the railings.

◄7 Leaving the sky until last is often a mistake. If you do not develop it with the rest of the picture, it can look as if it is pasted on. Our artist intended to give great emphasis to the sky in this drawing, so now she concentrated on it, giving it a wild nature with sweeping strokes of the side of the thick stick of charcoal. She also defined more sharply the outlines of the structure to the left by scrubbing in some dark marks right up to the edges.

►8 With such a strong skeleton to work from, the progress of this drawing is an organic process, unfolding bit by bit. You can see this in the way the artist continued to elaborate the buildings here.

　　She saw the sky and water as a continuation of the pier itself, and therefore swept them in expressively, rather than literally. Because of the steely day, the sky had a gray quality that has been captured with charcoal marks overlaid with white chalk. This harder medium brings another interesting quality to the drawing.

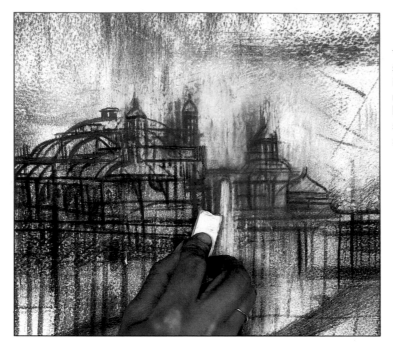

◄9 This piece of chalk comes in the shape of a small rectangular wedge—a perfect shape for putting in the pale tones between the railings and helping to redefine the buildings. Here, the artist worked in between the railing and down into the struts, using the sketching pencil positively and the chalk negatively to sharpen their shapes.

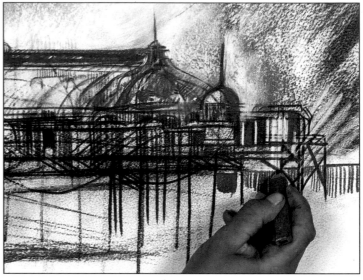

►10 Working the chalk into the sky created a mysterious blanket of mist, which lightened the sky and complemented the subject. On the sea, it hinted at the color of the water. At this point, it does matter where the marks start and finish, so our artist spent some time redefining details, becoming more accurate in her mark making.

▼11 After defining the shadows under the pier with the medium charcoal stick, our artist swept in the shoreline with the thick charcoal stick. Notice how the sea and sky provide a free environment within which the tight, detailed structure can exist. A good impression of the pier has been created that leaves you responding to the mood and atmosphere as well as to the ornate structure of the building.

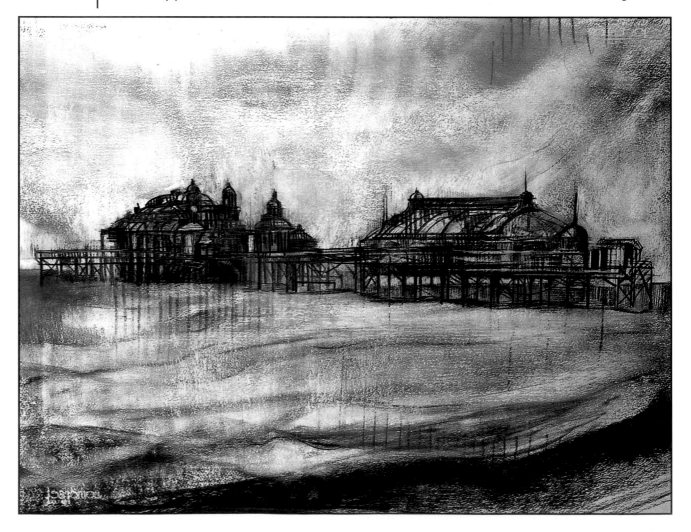

Drawing by inspiration

When your personal response to nature leads you beyond a literal representation, the results will be as fascinating and unique to you and your viewers as individual snowflakes.

Besides being superbly transportable, charcoal, with its rich and velvety marks, has great potential for expressiveness—a quality that can be used to spin artistic magic when working on location. With the subject right in front of you, take the opportunity to respond to it emotionally and intellectually—to the atmosphere of the scene itself and to the feelings it inspires in you—and record your individual perceptions and feelings in your drawing. The artist here did just this for her drawing of the Sussex Downs. Her reaction to the mood of the day, and her own way of seeing the view, are just as much the subjects of the drawing as the view itself. Charcoal, in its varying guises as pencils and thin or thick sticks of willow, gave her the tools to sculpt the forms as she saw and felt them. The dramatic result does much to enhance the interest of the scene itself.

◄ **The setup** Before starting, our artist took a long, quiet moment to look at the landscape as a whole, "internalizing" the scene and its rhythms. The scene itself is simply a motif—the source of inspiration.

With your drawing, remember that each mark you make relates to the last one, leading back to your first stroke, so consider carefully how and where you want to start.

YOU WILL NEED

- A 26- x 40-in. sheet of etching paper or cold-press watercolor paper
- Masking tape
- A drawing board or easel
- A utility knife for sharpening
- Conté B and 2B charcoal pencils
- Conté 3B Pierre Noire drawing pencil
- Thin and very thick sticks of willow charcoal

◄**1** Our artist began by sweeping in the curve of the hill to the left with the B charcoal pencil. Looking more at her subject than at the paper, she put down a range of marks— strong marks, curly lines, and gentle strokes—to explain the undulating planes of the hill, the cloud edges, and the outlines of the big trees in the bottom right of the composition.

Note the slightly tentative hatched marks across the paper, made as the artist "felt out" her subject. Compare these to the definite curves of the hills. Each line has its own essence, and this variety of line creates much interest.

▶**2** Here, our artist concentrates on the top left of the picture area, hatching in marks to emphasize the clouds. She responds more to their shapes and rhythms, the mood of the moment, and the changes in mood in herself and in her reactions than to their fluffy lightness, consequently creating a very dramatic impact.

Again, she keeps her marks varied, using both grades of charcoal pencil and applying the sharpened and flattened tips and the sides. Here, she finds the curving outline of the trees on the hilltops with the B–2B charcoal pencils.

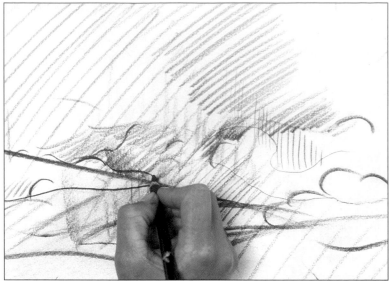

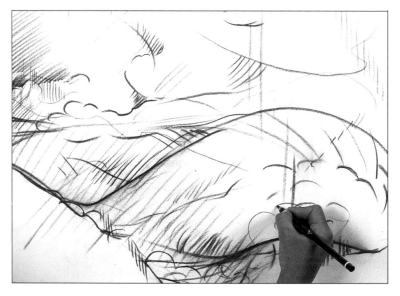

◀**3** Note the sweeping strokes in the sky, which indicate cloud edges, and how the gestural hatched lines fan out from them. Moving down the page and farther to the right, our artist now sculpts the contours of the landscape, indicating foliage with a lively mix of strong lines, brisk shading, smudges, and energetic rhythms. She does not work on any area for too long, but puts down a few marks, developing the area a little, then moving on.

▶**4** As the drawing develops, the artist's growing involvement becomes evident in her marks—they are stronger, and more decisive and pronounced. By now, she has a strong skeleton to work from, and continues working in much the same way, developing the drawing bit by bit and keeping most of her marks quite loose.

She uses the side of a large charcoal stick, smudging the broad marks to indicate clumps of trees in some areas; for slightly finer details, she picks out trees individually. Instead of trying to depict the exact tree and shrub shapes, she creates her own symbols for them—semicircular shapes, for example, which are in keeping with the general rhythm of the overall drawing.

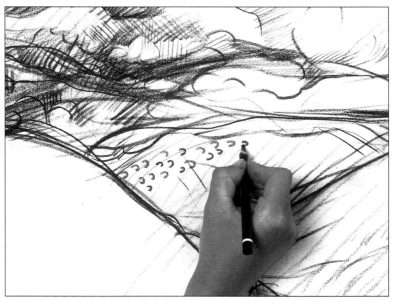

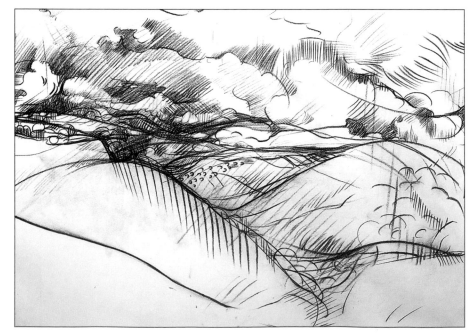

◀**5** Even at this stage, the different patterns in the drawing read together as a whole. The sky and landscape roll into each other fluidly, but you can still tell them apart. Although you get a good sense of light hitting the tops of the clouds, light is not what interests our artist. The clouds were not this dark in reality, but the added darkness gives them a solidity you would normally associate with land, not sky.

Our artist responded to the dynamism of the sky, the blanket of constantly moving clouds and the strong wind, by working it as solidly as she does the hills. She respects the ethereal quality of air and clouds, yet she responds positively to their strong presence.

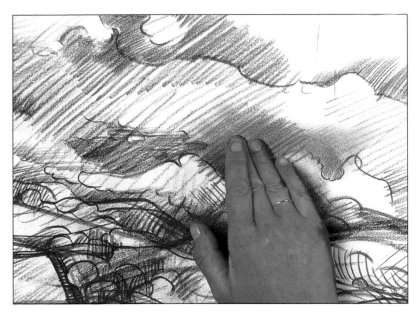

◄6 The artist continues to sculpt her subject, finding outlines and hatching in solid tone. She carves out the valley between the hills, then starts to smooth out some of the hatching around the drawing (here, in the sky) by rubbing with her fingers to make the effect less linear. In some areas she hatches back into these softened areas for a varied effect.

►7 Having developed the sky, our artist found herself drawn to the middleground to bring out the many trees and bushes there. Again, she does not try to render the foliage in too literal a way. She tries to link the shapes to other patterns and shapes around the drawing—in the clouds, for example. By placing the foliage across the hills, she is able to feel out the curves of the hill mounds.

Here, she darkens this area of the hillside with the side of a thin stick of willow charcoal to prevent it from jumping out of the picture, and to make it relate better to the tree area tonally.

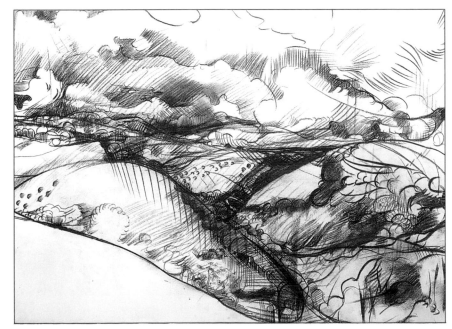

◄8 Once she puts a mark down, our artist tries not to go over it, change it, or erase it; she feels that each mark is a decision made, with an energy of its own that would be killed with overworking. Because of this, she has kept the picture rolling up to this stage, where the general scene is established.

By now, she is totally involved in the drawing and knows exactly what she needs to do to complete it.

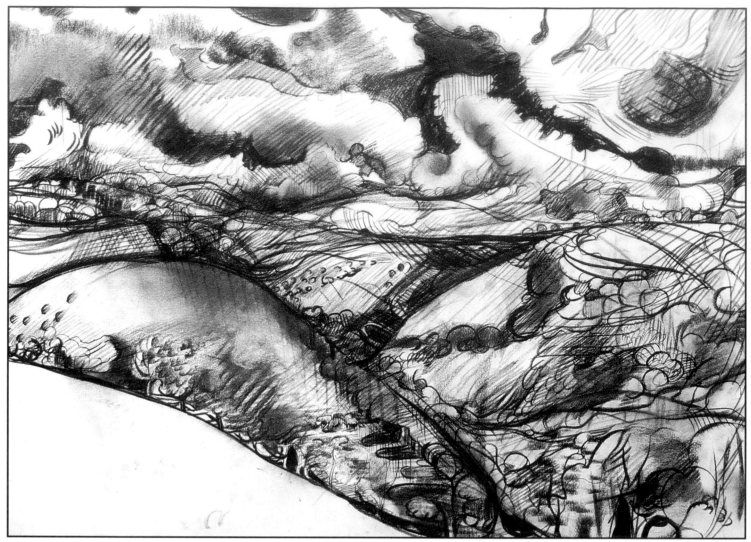

▲**9a** For the final ten to fifteen minutes, our artist worked freely and rapidly around the drawing, not calculating her marks but responding purely to what she saw and felt in the scene, taking the drawing to its final conclusion.

She created a highly atmospheric, somewhat brooding, romantic effect with the ponderous clouds and the rhythmical, animated landscape. Instead of recreating the light as it was at the time, she preferred to darken the scene considerably, working much more with form, texture, and gravity than with light.

◄**9b** Many of the rhythms that you find in the sky are also evident in the folds and contours of the land. Here, you get a wonderful sense of the bulk of the land— the rounded form of this hill, for example, and the rhythms of the contours that lead your eye across the mound backward and forward, and from side to side. In fact, our artist deviated from the landscape she saw, creating forms that do not actually exist, in order to capture the essence of her response to the view.

▶**9c** Many people make the mistake of not incorporating the fabric of the sky into the weave of their picture, leaving the sky until the end of the drawing, then knocking it in quickly as a backdrop to the landscape. But here the sky is as important as the land itself, and the artist has created a sense of a high, wild wind moving the rain-laden, billowing clouds.

Creating depth and contrast

With just a single stick of willow charcoal you can create an impressive range of tones and textures—as in this landscape with its intense afternoon shadows and soft, undulating, distant hills.

Charcoal is an extremely versatile medium, responding well to the surface of most papers and even picking up very fine textures. The way you apply it allows you to create drawings that are bold and expressive, or subtly blended to give a whole series of delicate tones.

If you use the gritty surface of sandpaper to sharpen the charcoal stick to a chisel tip, you will find that the range of tones and marks possible from a single stick expands greatly. The sharpened tip produces fine, almost pencil-like lines, while the blunt, flat end of the chisel gives bold, dense, expressive marks. You can use the side of the stick to block in large areas. Lighter tones are made by blending the charcoal on the paper with your fingers. Gently blocking in areas on a white textured paper leaves some of the paper showing through for a broken-color effect, which provides sparkle and keeps the picture lively.

As in a black-and-white photograph, a strong contrast of tones in a picture makes for a very interesting image. Your eye travels over the surface and is drawn to areas of contrast. Using all of the techniques described above helps you to express the different tones and textures in your subject and keeps your drawing fresh.

▼ **You can create a great sense of depth using charcoal only.** Here, the dark trees in the distance have been blocked in heavily, while the trees in the foreground are scribbled on for a light, airy effect. More texture comes from the broken lines of the tiled roofs, adding liveliness to the foreground.
Rooftops, Southern France by John Raynes, charcoal on paper, 11½ x 16½ in. (29 x 42 cm.)

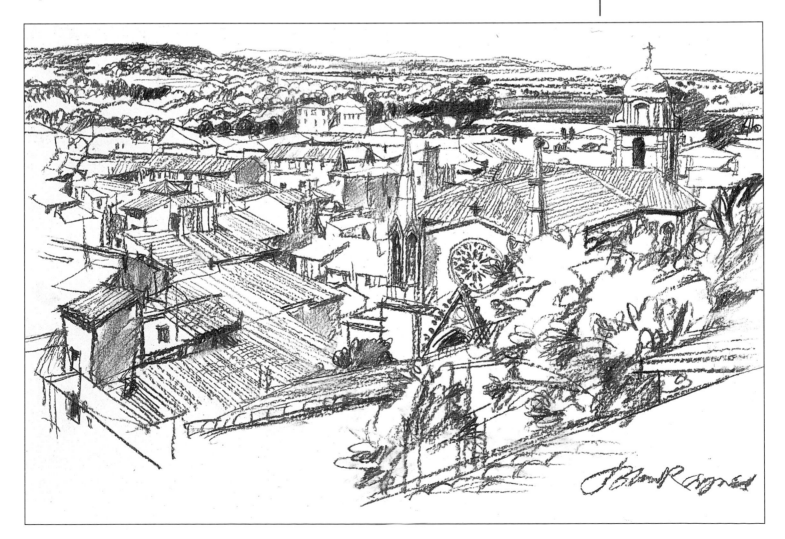

Afternoon sunshine in the country

◄**1** Begin by putting in the skyline with the tip of a sharpened stick of willow charcoal, then gently describe the outlines of the trees, hedge, and lane. Do not worry about being too precise at this stage.

Our artist likes to draw a border around his work since he finds this helps him focus on the composition.

►**2** Start to put in some of the different tones, switching between the flat end and the tip of the charcoal, keeping your marks loose and spontaneous. Draw in the shadows on the hedge, using the flat chisel end of your sharpened stick. Use the bold, hard mark made by pressing hard with the tip of the stick to describe the edge of the lane. The flat end gives a broader area of solid tone for the middle of the lane.

Before you go any farther, carefully spray the drawing with fixative so that these layers of charcoal are not disturbed by subsequent layers.

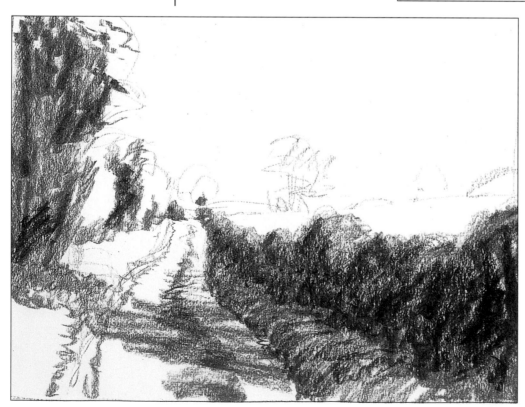

◄**3** When the drawing is dry, begin to deepen the initial tones by overdrawing with the charcoal stick. Use the flat end of the stick to put in the broad shadow cutting across the lane. Suggest the tangles of foliage in the bushes on the right by scribbling with the very tip of the stick.

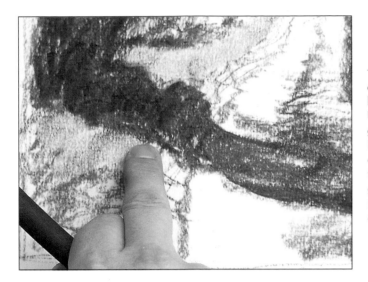

◄4 To take down or soften any areas that look too harsh, you can blend the charcoal on the paper. Use this technique to describe the grassy bank on the left of the lane. Lightly crosshatch a loose tone over the area. To convey the wispy feel of the long grass, rub over it gently with your finger (or a soft rag if you prefer) to blend the charcoal on the paper.

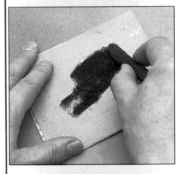
►5 Now indicate some of the trees on the horizon. Mark out the darker area of vegetation on the crest of the distant low-lying hill and the hedge at the far end of the field on the right. The chisel end of the charcoal stick is ideal for laying in these darker areas that you will soften later.

▼6 Sharpen the charcoal stick at intervals. Pull the broad edge of the sharpened end of the stick lightly across the grassy bank and up to the horizon, giving a light, broken area of tone that picks up the texture of the paper. To give the bank a distant look, blend the charcoal with your finger.

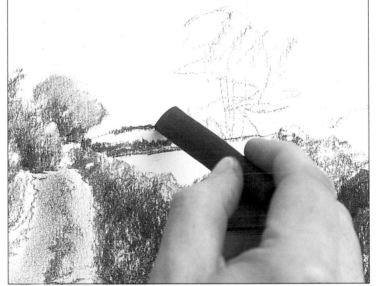

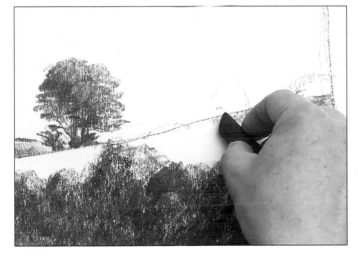

►7 Put in the remaining trees and bushes on the horizon. For the small bushes, use the blunt end of the charcoal stick to lay a fairly solid, but small, block of deep tone. Slowly build up the foliage of the trees with the tip of your stick, sharpening it for the finer branches.

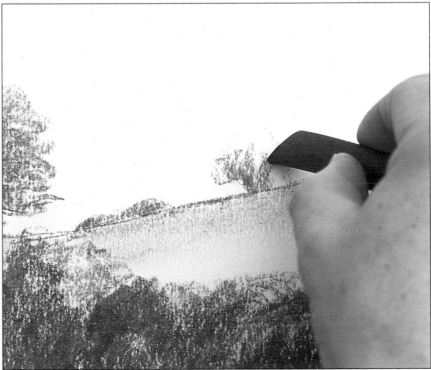

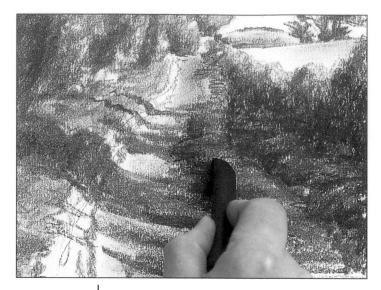

◄ 8 Lay a light tone over the surface of the lane, again blending it with the tip of your finger and following the bend in the lane. With all the light tones blocked in, you can now work up some richer, darker areas.

Throw the dark shadows across the road with the blunt chisel tip of your charcoal stick. Darken the hedge on the right, using the flat side of the chisel to give a broad mark. Now go over the entire hedge, changing the direction of the marks you make for a rich, intense tone. Allow a few white patches of paper to show through to add some dappled light among the deep shadows. Loosely scribble the rough grass growing in the middle of the lane using the blunt tip of the stick.

► 9 Draw a fine line along the horizon with the very tip of the freshly sharpened charcoal stick. Break the line in places to soften it by lightly blending with the tip of your little finger.

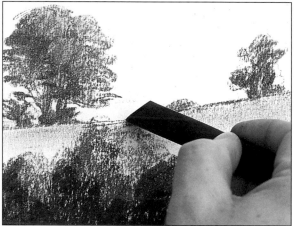

▼ 10 For the finishing touches, put in some wispy patches of grass along the left shoulder of the lane, using the tip of the charcoal stick. Develop further or soften areas to give your drawing the greatest range of tones. But do not overdo it since you want to retain the immediacy of working with charcoal—in particular, the full intensity of the late-afternoon shadows and the play of light on the leafy country lane. Do not forget to spray the finished drawing with fixative.

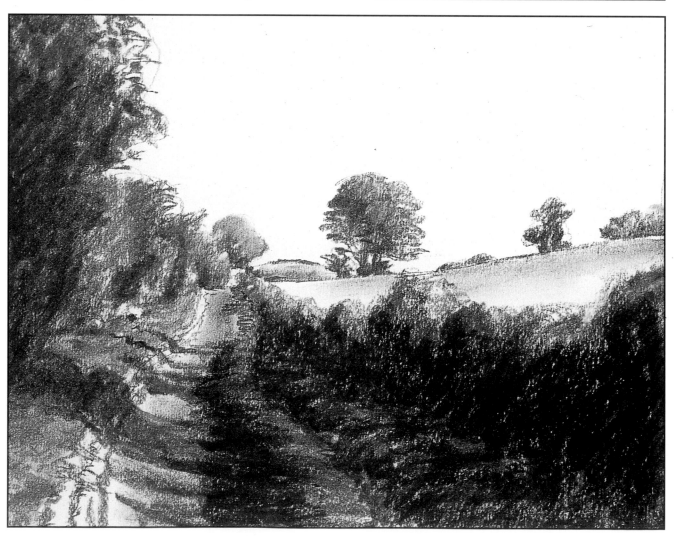

Using shading for a tranquil effect

One grade of pencil is enough to make the many different marks and to shade in the subtle tones you need to illustrate the structures and contours of this Greek village and terraced hillside.

Learning how to get the most from a pencil is part of the process of learning to draw. Regular practice makes you familiar with the different marks you can produce and improves your drawing skills at the same time.

Here our artist used a 3B pencil only, coaxing the tip into various shapes with a utility knife. She sharpened the tip to a fine point for fine lines and details, but used the side of the lead to shade large areas. For smaller areas of shading she used a fairly blunt point, making light parallel strokes. As the drawing progressed, she developed some of these to create richer, denser tones.

For the loose, light, generous strokes that establish the composition, the artist held the pencil quite near the top. But for the control needed to build up dark tones, she held it closer to the point, applying more pressure on the pencil at the same time.

To start this drawing, loosely block in all the elements of the composition. Work freely and lightly so that you can rub out any mistakes easily. Do not start to shade until you are happy with the proportions. When you come to shade, do not work up any one area until it is finished —instead, build up the drawing as a whole, moving freely all over the paper. This allows you to check one area against another to make sure your tones and proportions are correct.

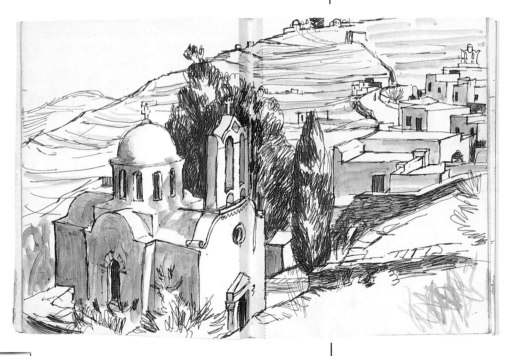

► **The setup** The artist made this felt-tip and ink sketch while on vacation on the Greek island of Syphnos. She was fascinated by the soft shadows on the buildings and the sweeping rhythm of the hillside terracing, and by their contrast with the strong geometric structure of the church.

◄ **1** Lightly draw in the horizon line to use as a guide to help you establish the proportions and general scale of your picture. Now loosely block in the church in the foreground, using the side of the lead to make light marks. Hold the pencil a little way down the shaft to help you keep your lines loose and light, so you can rub out any errors without undoing too much work.

YOU WILL NEED

- [] An 18- x 24-in. sheet of 100-lb. drawing paper
- [] A 3B drawing pencil
- [] Kneaded-rubber eraser
- [] A utility knife

▶ **2** When you are happy with the main structure of the church, start to draw in the window recesses and the tree in front. Put a little more pressure on the pencil to emphasize lines that stand out against the background.

Keep referring to the sketch to make sure the proportions are right, correcting any mistakes as you go along.

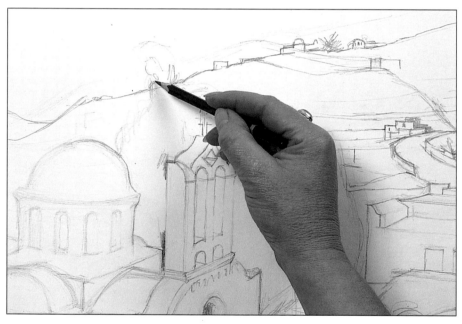

▲ **3** Draw the basic outlines of the buildings in the middleground on the right. This mass of houses looks quite daunting but is really just a series of boxes and blocks. Complicated areas can often be simplified by reducing objects to geometric shapes. Once you feel you have established these, draw in the other features, such as the distant buildings on top of the hill.

Remember you are just mapping out the composition at this stage, so keep your lines light enough to rub out easily.

◀ **4** Draw the general shape of the tree behind the church. This is an important element in the composition—it reaches up behind the church to break the skyline, uniting foreground, middleground, and background and pulling the whole drawing together. By breaking the skyline in this way, you establish distance between the church and the hills in the background, giving your drawing depth.

At this stage keep working in line only, without any shading, until you feel you have established the correct proportions and everything is in the right place. Continue working in this way, making adjustments as you go.

▶ **5** When you are happy with the proportions, begin shading. Start by gently touching in the shadows on the church dome, using parallel pencil marks and following the curve of the structure. Remember that this is a light tone. If you make it too strong it will destroy the rounded form of the dome and be confused with the window recesses, which need to be quite dark. Shade in the windows with more pressure on the pencil.

Emphasize any lines that need to be stronger; around the edges of the church, for example. These stronger lines stand out against the background, giving the illusion of distance. Put in heavier shading inside the window recesses.

Start shading the tree behind the church. Be careful not to shade it too heavily, though. You can always go darker but it is not as easy to make the tone lighter.

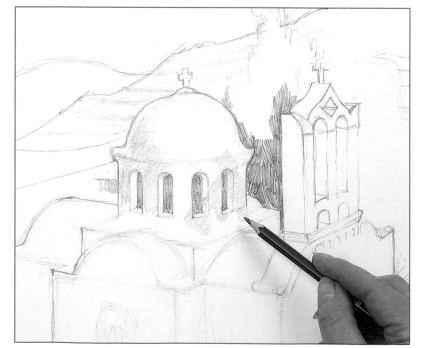

▶ **6** Continue shading the church, keeping your marks quite light and using your pencil to follow the shape of the building. Touch in some of the darker tones by building more parallel lines over the ones you already have, putting them in at roughly the same angle. Shade the tree further, and loosely put in some of the shrubbery around the church.

Sharpen some of the architectural details—the bricks above the door on the left, for instance. Leave as white paper the right facing wall of the church. This is the lightest tone, where the wall catches the direct sunlight. Continue working around the whole drawing in this way, refining areas here and there and strengthening any lines you feel need to be darker.

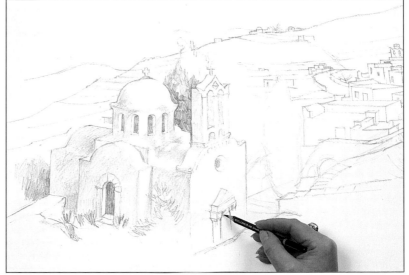

▶ **7** Continue shading the middleground trees behind the church. Use your pencil to suggest the upward growth of foliage on the trees. Cross the pencil marks over each other slightly, but keep them working in roughly the same direction. These energetic upward strokes contrast strongly with the softer shadows on the church and the sunlit wall, forming an important element in the composition.

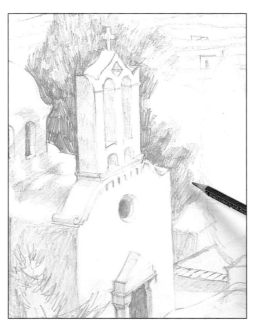

▲ **8** Use the side of your pencil to indicate the terracing on the hillside. Keep the pressure quite light—too much pressure would darken the detail and make the hills seem closer to you. These details need to be vague and soft to make them appear farther away. Work on the buildings in the middleground right, too, assessing how dark they should be by comparing them with the shading on the rest of the buildings. Shade them as you did the church, using parallel pencil marks.

At this point, start tightening up details, such as the windows, the trees, and the stone walls in the right foreground.

◀ **9** Intensify any tones that need to be darker; for example, the church window recesses. This pushes them back, making the building look more solid. It is the contrast between tones that pushes areas forward or backward. In this case, darkening the arched windows of the dome makes them appear more realistic. Once you have shaded a few areas, it is easier to compare them to work out your other tonal values.

If you find that your hand smudges the pencil marks as you work, rest it on a clean piece of paper, sliding your hand over that rather than over your drawing.

◄10 Strengthen the tones of the trees to create a more dramatic effect against the white church building. But do not overwork the drawing. Although you want your marks to appear richer and darker, you do not want to obliterate the energetic upward movement of the pencil strokes.

Keep comparing your tones and be prepared to change things if you feel they are wrong, even at this late stage.

►11 Shade the tip of the tree that breaks the skyline. Grip the pencil away from the point to make looser, less controlled strokes that contrast well with the more static feel of the church. Make any adjustments you feel are necessary. Our artist chose to strengthen the defining line between the hills to suggest the distance between them.

▼12 See how the finished drawing brings out the contrast between the solid structures of the buildings, the soft, blurred shadows, and the vigorous feeling of the foliage—all achieved by using only one pencil.

Using strong, dark tones for drama

Bold charcoal on a white ground can create the most vibrant of pictures—the abrupt juxtapositions of light and dark lead the eye through the composition like a series of visual stepping-stones.

An artist in search of inspiration could be forgiven for overlooking a bleak inner city landscape under a lowering sky. However, it is often the most unlikely subjects, such as this, that provide the most interesting pictures. Indeed, for many artists, a seemingly mundane scene is more of a challenge than tried-and-true "picturesque" subject matter.

Our artist found a viewpoint high over the center of an industrial city that creates an ideal composition (see pages 194 through 198). The overpass provides a dramatic diagonal that propels us into the picture, while the curve of the road below echoes its striking sweep. And the variety of flat and sloping roofs in the distance creates a strong and energetic geometric pattern.

Charcoal is ideal for such a picture. The lack of color helps convey the melancholy feel of the subject matter and the harshness of the urban scene. At the same time, the tension between the white areas (which jump out at the viewer) and the dark charcoal makes an exciting, hard-hitting picture.

In addition to charcoal, our artist used a cloth to soften tones and an eraser to draw out of the charcoal. He also used a black charcoal pencil to put in fine detail and a white Conté crayon to add bright highlights.

▼ **Charcoal is perfect for evoking a bleak wintry landscape. Note how skillfully the artist has used an eraser to suggest both the snow-covered roofs and roads in the foreground and the swirling winds in the background.**
The Winder *by David Carpanini, charcoal on paper, 22 x 30 in. (56 x 76 cm.)*

Urban landscape

▶ **The setup** Our artist took a series of photos from a single viewpoint on the fifth floor of a high-rise overlooking the beltway area of the city. He then joined these photos together to make a wide view of the city for use as a reference for his drawing. (Note that he waited for the sun to come out before he took the photos in order to capture the hard, dramatic shadows falling across the city.)

◀**1** With the tip of the medium charcoal stick, plot the main elements of the composition, including the curving lines of the overpass and the road beneath, and the main building on the left. Draw with confident, sweeping strokes, but keep the marks quite light so that you can easily rub out mistakes with the cloth or the eraser.

▼**2** Block in the whole of the sky, using rough, expansive strokes with the side of the charcoal stick. You should pick up the texture of the paper as you do this.

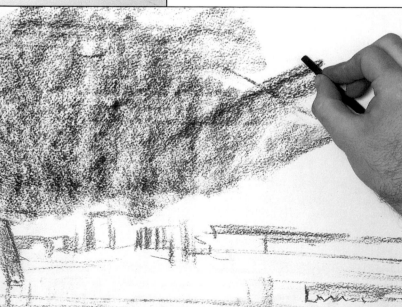

▶**3** Gently rub over these marks with the cloth, softening the charcoal to create a misty gray. Do not overblend the tones—they should retain some liveliness and movement.

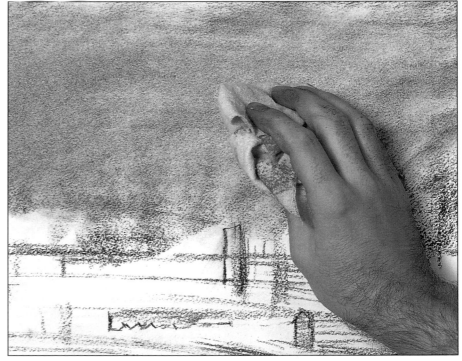

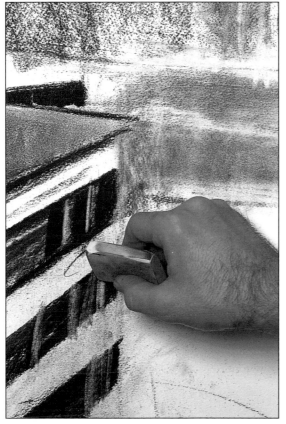

◀**4** Now concentrate on the office building on the left, pressing heavily with the tip of the stick to fill in the windows. Then work back into the charcoal with the eraser to "draw" the vertical window bars.

▼**5** Use a clean corner of the eraser to work into the sky tone. Lift out the tones in diagonal and scribbled strokes to indicate the position of some of the lighter clouds.

YOU WILL NEED

- ☐ A 22- x 30-in. sheet of 90-lb. cold-press watercolor paper
- ☐ A drawing board
- ☐ A medium and a thick willow charcoal stick
- ☐ A cotton cloth
- ☐ An eraser
- ☐ Spray fixative
- ☐ A black charcoal pencil
- ☐ Piece of white chalk

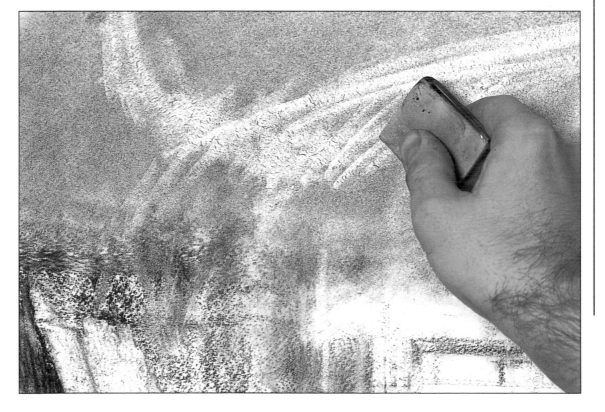

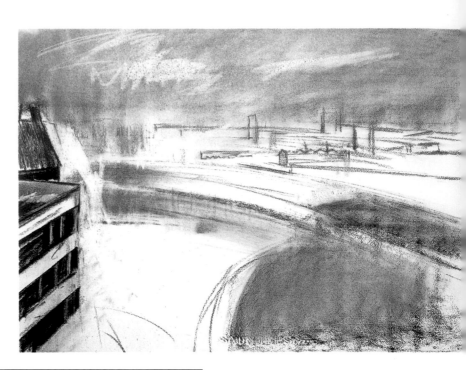

Tip

Mid tones

Although much of the impact of a charcoal drawing relies on the contrast between blacks and whites, also try to include mid tones—like the ones in the sky here. To create a subtle array of tones, use a cloth to lighten broad areas of charcoal and blend white chalk or pastel into the darker marks.

▶ **6** Return to the cloth to blend in some of the more obvious eraser strokes in the sky. Then indicate the shadows on and beneath the overpass by using the side of the charcoal stick and smudging these marks with the cloth.

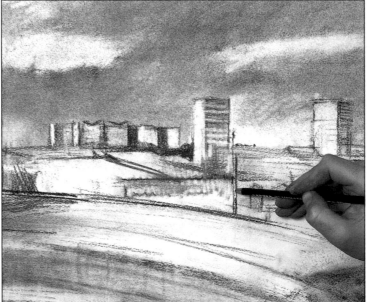

◀ **7** Work over the sky with more charcoal to suggest dark and stormy clouds. Use the cloth to lift out pale, soft-edged clouds. Then lift out the geometric forms of the tall buildings on the horizon line with the corner of the eraser. Work over these forms with the black charcoal pencil to add detail and shadow. Smudge these marks lightly with your fingertip to indicate distance.

Now start on the foreground details. Draw in the lampposts and define the overpass and the roads more precisely.

▶ **8** You have now established the composition and the arrangements of lights and darks, and already the drama of the image is beginning to emerge. Now is the time to take stock and decide exactly how much more detail you want to include. It is all too easy to get carried away with unnecessary details that only clutter the picture.

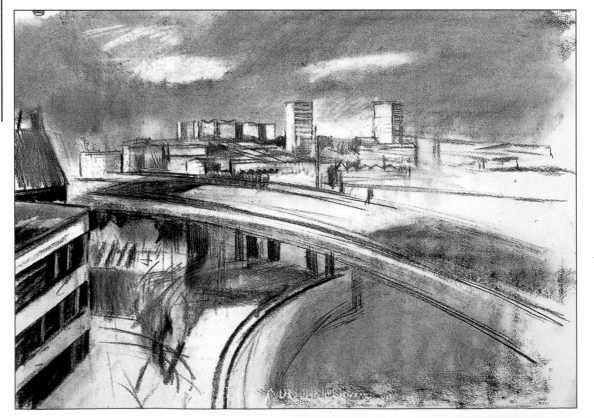

►**9** Concentrate on the overpass, blocking in the cast shadows on and beneath it with the thick charcoal stick. Blend the charcoal into the paper with your fingers to create dense, rich darks. Try to suggest shapes and forms, rather than to define them precisely.

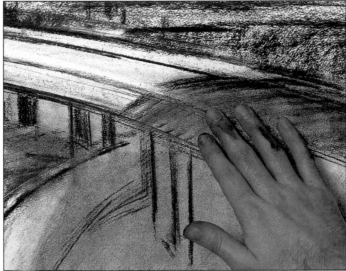

▲**10** Fill some of the deep shadows under the overpass with the tip of the thick charcoal stick. Pick out lighter areas with your fingertip or the corner of the eraser.

▲**11** Suggest human presence by using the medium charcoal stick to jot in one or two cars on the overpass and a lonely figure in the shadow on the street directly below. Keep these details very sketchy —they should not command too much attention.

To draw the tall lamppost, use the black charcoal pencil, which gives greater control. However, you may need to soften the lines slightly with your fingertip so they blend naturally into the surroundings. Then spray the drawing with fixative.

◄**12** Work over the drawing with the piece of white chalk to brighten up the picture. Define the light-struck areas on the overpass, the buildings, and the lampposts.

In some areas our artist applied white chalk over charcoal to create a silvery gray. In others, he laid it over the white support to create a very bright white.

▲**13** Use the white chalk more freely on the buildings toward the horizon. The white marks blend with the charcoal beneath to create a soft, silvery gray that perfectly suggests distant, hazy light.

▲**14** Smudge the side of the white chalk over the buildings and draw in crisscross patterns on the high-rise buildings in the distance with the tip of the chalk. Also put a few dashes in the sky.

▼**15** The final picture is composed of stark, graphic shapes that evoke the bleakness of the surroundings. Note how carefully the areas of black and white have been handled. The center of the picture has been left largely in white to pull the viewer's eye into the picture. The deep shadows that apparently encroach on the center add to the ominous mood.

Developing a style

An exuberant drawing style with a whimsical sense of humor is the perfect combination for a playful and offbeat colored pencil drawing.

When you think of colored pencils, you usually think of children's pictures. To counter this assumption, artists often go out of their way to create complex and highly finished drawings when working in colored pencils. Indeed, you can achieve surprisingly intricate works with subtle gradations of tone and wonderful sporadic color—see, for example, the drawing of garlic bulbs on page 59.

It is also possible to celebrate the immediate qualities of colored pencils and create instead a charming and playful picture. Certainly, this was the inspiration for our artist. His drawing is full of bold primary colors, loose lines, and rather crude, almost cartoonlike characters. This exuberant style is complemented by a whimsical sense of humor. Look, for example, at the motorbike rider who seems to be toppling off and

the four men who sit in similarly slouched poses, apparently sharing one cup of coffee.

This is not to say that the picture has been made in a frivolous or slapdash fashion. Although it appears unstudied, its underlying structure has been carefully worked out. The composition is based on a dynamic triangle, with the chairs, the traffic island, and the flags at the corners. This triangle leads the eye from the figures to the traffic island and down the road. In another touch of whimsy, this last movement of the eye is pointed out for us by the arrow of the road sign.

◀ **The setup** The artist made his initial linear sketch while enjoying a cappuccino at a café in Umbria in Italy. Using only one colored pencil, the sketch took no longer to finish than the cappuccino. For his studio version, he took a little more time, because he included a range of colors and added blocks of tones. He was careful, though, not to overwork the picture, by leaving a lot of white paper showing for a light and airy feel.

◀ **1** Make a preliminary linear sketch in red. Then begin shading with the dark blue. Note that the dense blue on the beret serves chiefly as descriptive color, while the primary purpose of the scribbled blue on the trousers is to put in the beginnings of a shadow tone.

◀ 2 Begin with the skin tones, using the side of the pink pencil. Overlay orange on the pink for a better rendition of tanned Mediterranean skin. Also use the orange to put in the window frames in the background. Apply light blue on top of the dark blue of the trousers to build up the color here.

YOU WILL NEED

- ☐ A 12- x 18-in. sheet of drawing paper
- ☐ A drawing board
- ☐ An eraser
- ☐ A set of colored pencils, including yellow, orange, pink, red, light blue, dark blue, purple, light green, dark green, brown, gray, black

▶ 3 Scribble in yellow and orange on the trousers of the man resting on the café table. From a distance, these colors mix optically, creating a warm brown. Also use these two colors for the hat of the man in the center and the window frames in the background.

　　Already the picture is taking shape. Note how, as the picture is worked up, the artist uses much larger and bolder areas of dark tone in the foreground to give an impression of depth.

▶ 4 Block in the body of the motorbike with red. This hot color, together with the jaunty angle of the bike and the bodybuilder's pose of the rider, makes for an eye-catching— and comic—element in the composition.

　　Use purple to build up the color of the trousers of the man facing out of the picture and also for the glass in the window frames in the background.

◄ 5 Fill in the man's shirt with yellow. This provides another hot color to attract the eye to the picture's center, and it makes a bold contrast with the red of the motorbike nearby. Also use yellow, this time in a scribbled motion, to enliven the color of the man's trousers.

▼ 6 Use the dark blue pencil, sharpened to a fine point, to draw in details and redefine lines. Note how the red outlines of the chair, the men's trousers, the newspaper, and the table have all been emphasized with blue. Leave the objects in the distance much looser to help give the impression of depth.

◄ 7 Add weight to the trousers of the man in the foreground with brown. The darkening of the tone here helps to "plant" the man's legs, enhancing his slouched appearance.

► 8 Draw the traffic island on the far left of the picture in dark green with touches of blue. Also put in the large-leaved plant with light green. Scribble in the sky with light and dark blue, then gently rub the eraser over patches of this color to give the impression of wispy clouds. Put in the flags and the ice-cream sign in red, yellow, and blue (which pick up the colors of the motorbike and the shirt).

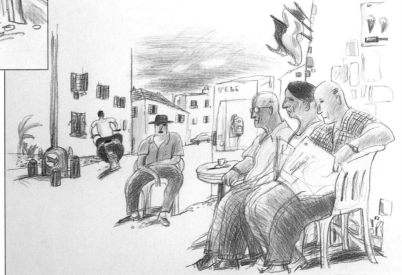

▶**9** Now develop the men's clothing and put in any other finishing touches. Add more dark blue to the sky near the horizon. Make sure you have established all the cast shadows, so everything seems to sit properly. Vary the colors of these shadows, using black, gray, purple, and dark blue.

▼**10** Although many artists would be tempted to continue filling white paper with color, the picture is now complete. The sea of white space gives a good impression of the glaring noon Mediterranean light. It also encourages the eye to flit around the picture from color to color—almost as if you were experiencing the street itself.

Capturing distinctive character

When your subject is as brilliant and bustling as New York's Chinatown, a colorful mix of different media helps to capture its distinctive character.

Our artist made many sketches in Chinatown, preparing for the drawing shown here. He drew architecture, people, and the general activity of a Monday morning. As he sat immersed in the noise and color, making sketch after sketch, ideas began to spring up in his mind about how to put the information together.

Back in the studio, he set about the task of amalgamating his references and creating a picture that captured the flavor of the place. His chosen media of colored pencils, soft pastels, and oil pastels were as vibrant and colorful as the scene itself, and the mixture added excitement and interest. His finished drawing is a good characterization of Chinatown, with the figures expressing the dignity of the Chinese community and the vibrant colors creating a visual "sound" as lively as the place itself.

▲► **The setup** Although the artist made many sketches on-site, in the end he chose these two as a base for his drawing because they both depict a glorious Chinese gateway (these gateways are characteristic of Chinatown). He liked the composition of the lower sketch, with the dramatic diagonal line of the rooftops sweeping up to the gateway and the foreground figures expressing the hustle and bustle of the area. The low viewpoint, looking up to the buildings, adds another note of drama.

◄1 There was little our artist wanted to change in the composition from his sketch, so he taped it to a window with a clean sheet of paper over it and traced the image through with a Prussian blue colored pencil, editing the image as he went. If you are working from your own sketches, remember that the most important ingredient is atmosphere. Concentrate on pulling out the details that capture character, letting others fall back. For instance, our artist emphasized the Chinese lettering.

YOU WILL NEED

- ☐ A 12- x 18-in. sheet of hot-press watercolor paper
- ☐ Scrap paper
- ☐ A 2B Conté Pierre Noire drawing pencil
- ☐ 10 Derwent watercolor pencils (or their equivalents in a different make): gold, deep cadmium yellow, flesh tint, rose pink, geranium lake, pale vermilion, indigo, Prussian blue, golden brown, gunmetal gray
- ☐ Two soft pastels: Naples yellow and pale cobalt blue
- ☐ 10 Guitar oil pastels (or their equivalents): orange-yellow, light orange, pale orange, vermilion, pale blue, ultramarine, gray rose, green, emerald green, pale brown

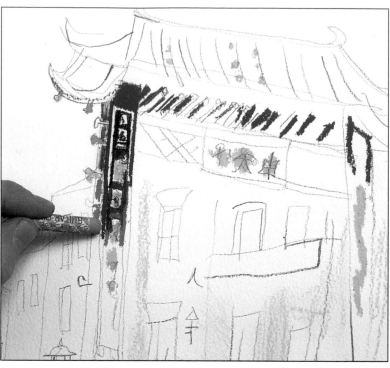

◀**2** Rub a little preliminary color on the buildings around the gateway with some Naples yellow soft pastel. Then start working with oil pastels—use vermilion to touch in the main body of the gateway and orange-yellow for the Chinese lettering. Fill in the panel around the lettering and the side of the gatepost with pale blue and ultramarine. For the decorative lights, apply green and orange-yellow. Use the Pierre Noire pencil for the black areas on the gatepost.

This bold, brilliant start instantly establishes the energetic atmosphere. With oil pastels you apply vibrant color directly to the paper, without mixing. This gives the drawing a feeling of freshness and immediacy.

▶**3** Now move down to the foreground to concentrate on the face of the figure to the right. Start her off in general pinkish flesh tones, using pale brown for dark tones and pale orange for mid tones. Leave the paper blank for the lightest tones.

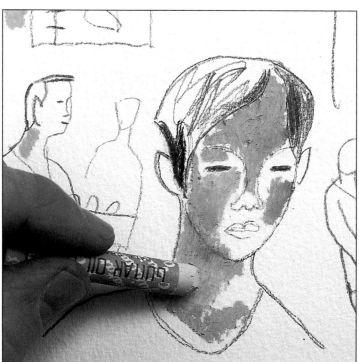

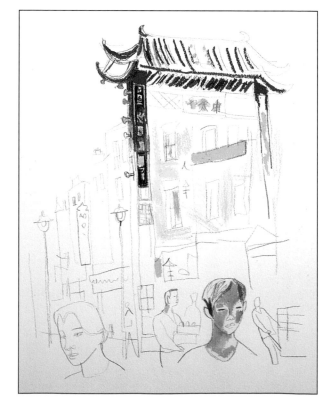

◀**4** Indicate the sign on the building seen through the gateway with orange-yellow oil pastel (you will add the lettering in red later). Then scrub emerald green oil pastel on some windows. Continue to work up the bright gateway with the same colors as before. Do not overcomplicate the drawing by slavishly recreating the intricate detailing of the gateway roof. Aim for an impression, selecting a few fine details and keeping the drawing fresh and simple.

Notice how the rather neutral colors on the figure contrast with the energy and razzle-dazzle of the gateway.

▶**5** Work around the drawing, bringing out details with the colored pencils. Then use the edge of the orange-yellow oil pastel to bring out the crisscross latticework at the top. Outline these with gunmetal gray colored pencil, and use the same pencil to put in the lights on the gateway roof. Now fill in the panel around the letters at the base of the roof with the indigo pencil. Cut around the shapes of the lettering, defining them as you go.

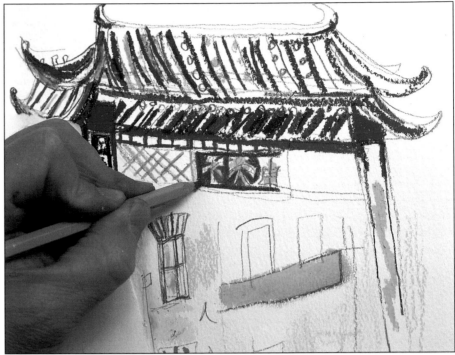

◀**6** Work on the face of the figure to the right— add some warm rosiness with flesh tint and geranium lake colored pencils. This makes the head more three-dimensional. Start on the sign behind this figure, putting in the musical note with light orange oil pastel.

When working over oil pastel in pencil, you will find that the pencil picks up some of the waxy oil, so keep a sheet of scrap paper handy, scribbling on it to wipe off the residue.

◀▼**7** Now work around the drawing, adding different colors here and there to keep the whole picture dancing. Bring out details, such as the windows and chimneys, lamppost, and awning (see detail below). Notice how the blue outlines of the initial drawing stand out clearly from the bold, bright colors. Continue to build up the colors on the gateway.

▶**8** Continue to develop the details around the picture, such as the red post in the middleground. Now turn your attention to the other figures. Start with a mid tone, working into this for darker tones and leaving the paper blank for paler tones to give a sense of solidity.

Work on the shop signs around the drawing. Do you have the shapes of the letters right? Although you do not need every tiny part of each character to be accurate, try to make them clear enough to be readable in Chinese.

▼**9** Spend time on the foreground figures. If you place them well in the foreground, you will create a good sense of depth, with the rest of the drawing receding into the distance. Notice how the widow's peak on the foreground figure to the left mirrors in reverse the hairline of the figure to the right. Our artist creates good visual entertainment by playing with shapes in this way.

▶**10** The foreground figures need more work to bring them well forward. Add the glasses and collar on the figure to the left, and the earrings on the one to the right, darkening the sweater with stronger colors as well. Fill in middleground details, such as the food hanging in the window of the restaurant and the boxes stacked outside. Although the sky is only lightly touched in, it adds to the perspective of the picture by suggesting a plane behind the buildings.

In the final drawing each tiny area seems to tell its own fascinating story, and the brilliance and vigor of the media together, along with the visual liveliness, suggest the noise and bustle of the scene.

Conveying energy with originality

Distressing your support brings an extra dimension to your work before pencil touches paper. This "invisible underdrawing" is a springboard for inventiveness, creating wonderful surface patterns.

Many of us have seen spy movies where someone writes down a message on a pad, then tears off the page and leaves the room. The spy comes in and lightly rubs the surface with a pencil and, as if by magic, the message appears! Drawing on a distressed surface works on exactly the same principle. You make indentations on the surface of your support—a dried-up ballpoint pen makes the perfect tool for this. These "marks" appear only when you work over the surface with your colored pencils. The pigment does not reach the depressions, leaving them white against the newly colored surface—a very appealing effect.

The challenge with this technique lies in integrating your drawn marks with your scored ones. As an experimental exercise, try distressing your surface randomly; faced with your subject, attempt to marry the two harmoniously. You could take a more considered approach, as the artist did here, and draw your subject with scored marks. If you like to work with textures, you will enjoy making the most of the tactile quality of a distressed surface. For instance, you could score the foreground grasses and flowers in a landscape. This highly textured foreground will advance, increasing the sense of dimension.

▼ **The variety of distressed lines—hatched, curved, and scribbled—adds to the drama of this energetic drawing. It is almost as if the artist used the indented lines to draw the wind blowing through the trees.**
Kenwood House *by Phil Wildman, colored pencils on paper, 24 x 18 in. (46 x 61 cm.)*

YOU WILL NEED

- [] A 9- x 12-in. sheet of 140-lb. hot-press watercolor paper

- [] A dried-up ballpoint pen to score the paper (try a paintbrush handle or a knitting needle for different marks)

- [] 10 colored pencils: yellow, yellow ocher, terra-cotta, brown-orange, light green, dark green, lilac, purple, brown, blue-gray

Sunset over the heath

The setup For this drawing of a public park, our artist worked from a photograph in his studio. Before embarking on the finished work, he made a rough sketch in colored pencil, establishing the composition and the variety of shapes in the landscape.

▶ **1** Lightly draw the scene with terra-cotta so you have some idea where to make your score marks. Then score a vigorous semicircular pattern in the sky using the unsharpened end of one of your pencils.

Continue scoring with a dried-up ballpoint, which gives a sharper line. Use long, curved strokes over the trees and more random lines in the foreground. (These scoring marks are not visible in this picture—look at the final step to see them clearly.)

Next apply yellow over the top of the paper for the sunset—note how the scoring breaks up the yellow, giving the sky a powerful luminosity.

◀ **2** Block in the wood with vertical strokes of terra-cotta, brown, and purple; the terra-cotta and the brown establish the local colors of the trees, while the purple suggests the cool, shadowy light. You want the trees to be a fairly solid, dark tone as they are almost silhouetted against the sunlight. Also introduce some patches of terra-cotta onto the hillside in the middle distance.

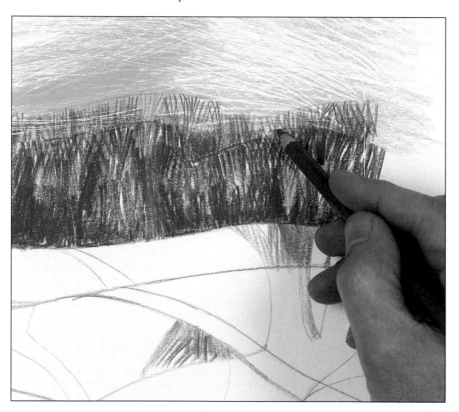

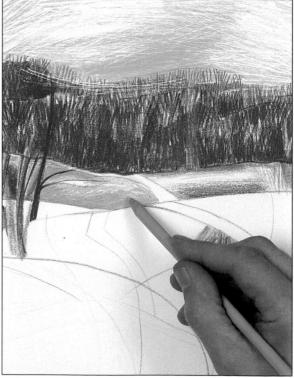

▶ **3** Continue using terra-cotta, brown, and purple to put in the tree trunks on the left. Then begin laying in the grass with light and dark green. Vary the texture here. At times, use the point of the pencil to obtain dense color, but also run the side of the pencil across the paper to achieve gentle "rubbings" of color.

►**4** Begin overlaying color by using yellow on top of the greens. Use pure color in places but, for the most part, build up the muted autumn shades with broken color. Work lightly when applying the first color, so you can overlay a second and maybe a third color. (Check how the colors blend on a scrap of paper or on the edge of your sheet.)

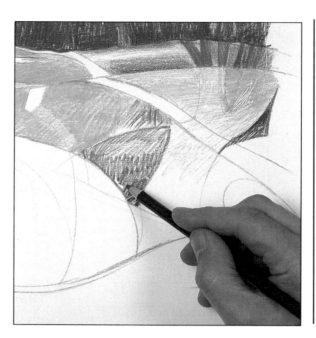

▼**5** Use yellow ocher lightly to color the path. Note how the path emphasizes the perspective, pulling your eye into the scene. This creates a tension with the blocks of color, which encourages the viewer to see the picture as a two-dimensional, almost abstract, design.

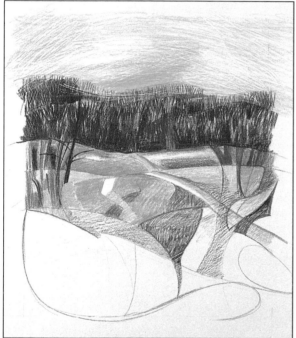

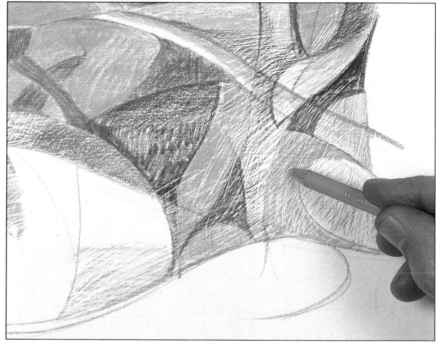

▲**6** Add a strip of lilac on the left to echo the line of the path. Note how this color, like the path, follows the undulations of the land, again underlining the depth of the picture. As you reach the bottom, the scoring marks are more frequent. Press the pencil harder to make the scored white lines more obvious.

Continue building up the grass with light and dark greens, working toward the foreground.

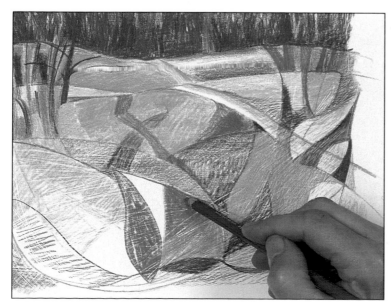

◄**7** Fill in the leaflike shapes at the bottom with warm autumnal colors—terra-cotta, yellow, yellow ocher, brown, and brown-orange. Note how frequently terra-cotta has been used as a single color—giving the picture a pleasing harmony.

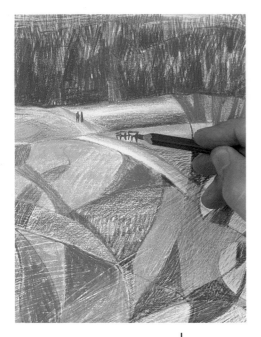

8 As a final touch, use the blue-gray to add two lovers and a couple of empty park benches. In the shadow of the ominously dark wood, the couple lends a rather melancholic aspect to the picture.

9 Note how in the final picture two very different styles of drawing have been used. The top two-thirds of the picture is rather representational. The path, which pulls your eye across the heathland toward the woods, gives a strong illusion of depth. And the scoring here has a logic: strokes have been used to emphasize the tree line and describe the setting sun.

In the bottom third of the picture, though, the artist is more concerned with two-dimensional design, playing with the leaf motif and a variety of autumn colors. Appropriately, the scoring here is much more random, used for decorative and textural effects rather than description.

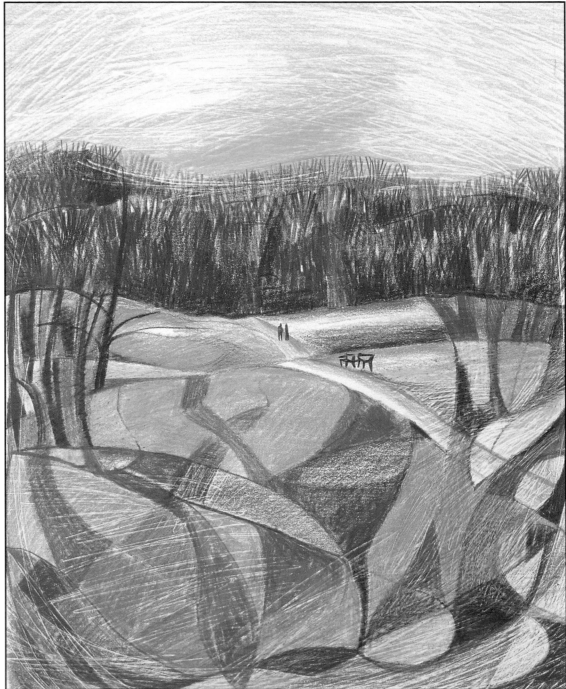

Embracing the semiabstract

Geometry and design take precedence over perspective and tone in semiabstract drawing, giving you greater freedom to interpret what you see.

British artist David Hockney's use of colored pencils in his portraits and still lifes is classical and restrained—precise lines contain subtle passages of color shading—as perhaps befits his naturalistic approach. However, colored pencil is also an excellent medium for semiabstract or design-dominated work. Here any worries about the pencil colors (they can seem candylike) need not apply, and the medium can be used with great freedom. If architecture is ostensibly the subject, as in the demonstration here, the pencil point is perfect for picking out major geometries, and the flat of the pencil is good for block shading.

For his demonstration, our artist has selected a fairly ordinary view—a bridge in the heart of an industrial city (Turin, Italy)—and transformed it into an interesting play of shapes and colors. Look at the finished drawing on page 214 and you will see that although not completely ignored, the scene's space, perspective, light, and shadow have taken second place to geometry and design. There are many deliberate distortions and improvisations, and the reflections in the canal appear as solid as the buildings casting them. The result is a fascinating and colorful jigsaw-puzzle effect.

YOU WILL NEED

- [] A 9- x 12-in. sheet of drawing paper
- [] A B pencil
- [] Scrap paper
- [] Pencil holder (for pencil stubs)
- [] 13 colored pencils: light red, light blue, cobalt blue, ultramarine, jade green, emerald green, violet, mauve, raw sienna, Vandyke brown, light gray, Payne's gray, black

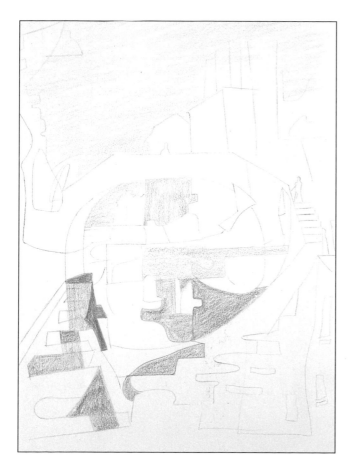

◀ **1** Use the B pencil to tick in the composition, placing the bridge a little above the halfway level. Start to add color. Our artist began with raw sienna to tint the industrial sky and plot one or two reflections in the water, using the color more strongly in some areas. Notice how he has abstracted the reflections to make them more decorative.

▼ **2** Color a number of the reflections with light gray, shading lightly with the side of the pencil. Overlay some of the areas of raw sienna to create a greater range of tones. Remember: for the color mixing to work, the first base color must be allowed to show through the color overlaid.

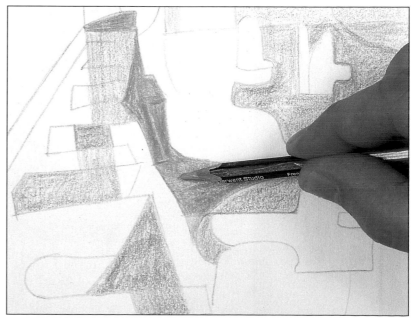

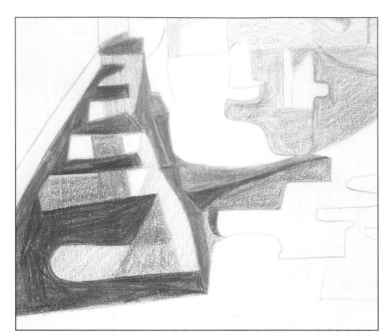

◄3 Fill in the "toothed" reflection running along the left side of the canal with Payne's gray, pressing heavily on the point of the pencil to produce strong, dark lines. Overlay portions of this with Vandyke brown to create an even more solid impression and to make the darkest tones so far.

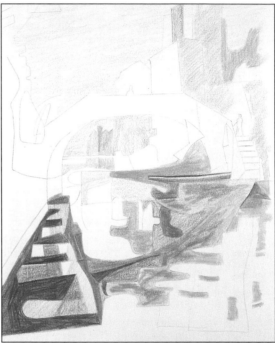

▶4 Work more freely over the middle and right of the composition, using light gray to fill in more reflections on the canal surface and some sections of the buildings on the right. Do the same with raw sienna, shading over the gray areas here and there. Vary your shading methods as much as possible for greater interest.

Already you can see our artist is building up a pleasing pattern of shapes and colors.

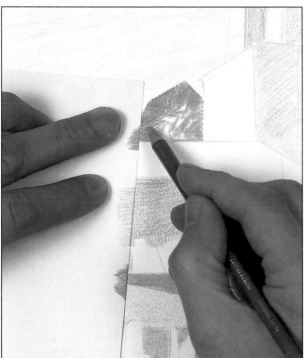

▲5 Concentrate now on the roof of the warehouse in the center back of the composition, working with first the jade green pencil. Our artist protected the surrounding areas with scrap paper to make sure that he achieved crisp edges. Work around the roof, varying the angle of the hatching. (The artist left a space where he intended to add a figure.)

▶6 Move down to the lower portion of the far warehouse using black. Then switch to light blue for the building in front and for a few reflections under the bridge. Use black on the left of the composition, going over it in places with light gray, smudged with a finger.

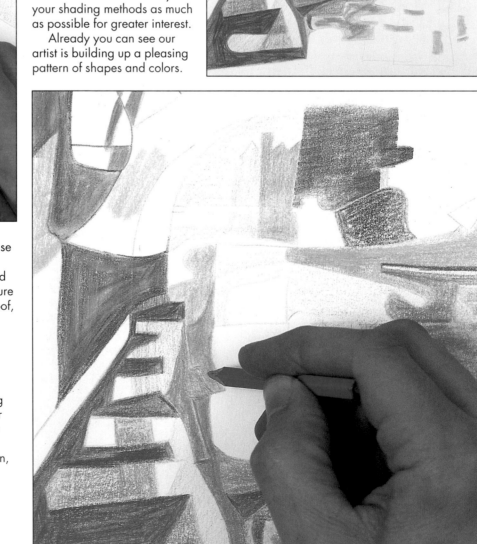

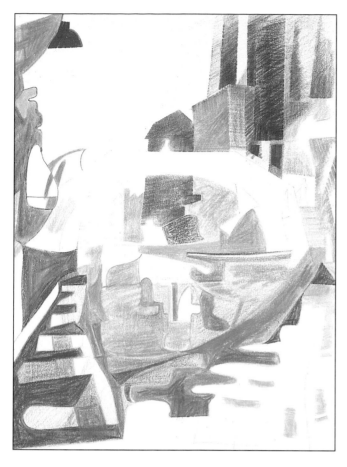

◄7 Use cobalt blue, strongly applied, on the reflection of the bridge—a curve on the lower right of the picture space. Work Vandyke brown, raw sienna, and light red over the overlapping planes of the buildings on the top right, again using scrap paper to protect surrounding areas. Color the steps on the right of the bridge with light blue and the windows on the right with ultramarine.

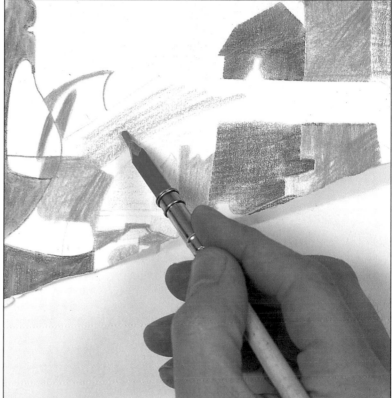

►8 Begin to work on the bridge itself now. Resting your hand on a clean piece of paper to prevent smudging, fill in the bridge loosely with light blue. This is a base color that will be overlaid with several more pencils.

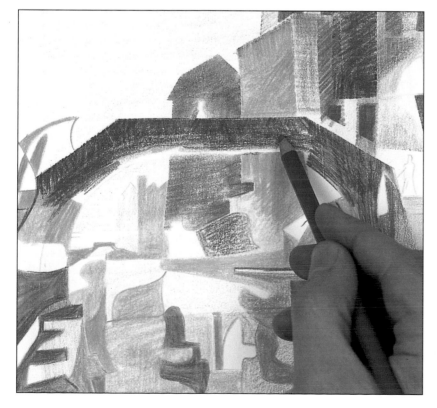

◄9 Block in some sections on the right of the bridge with ultramarine. Now go over the central span of the bridge with violet, using vertical hatching near the top edge to suggest the solidity of the structure. (For clean outlines, use the scrap-paper edge once more.)

Tip

Not child's play
To avoid the colored-in look often associated with children's pictures, keep your pencil marks loose and varied, and steer clear of making too many outlines. Our artist's technique of shading up to scrap paper enables him to scribble up to the edges of a shape, creating softer outlines such as that on the roof of the jade green factory in the distance. Contrast this with hard outlines elsewhere.

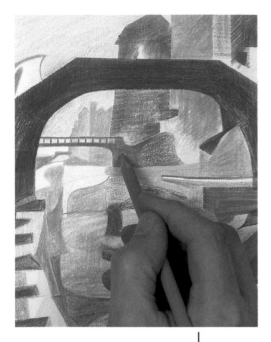

◄**10** Add a little black to the underside of the bridge to suggest the dark shadows here, and balance it with black elsewhere in the picture.

Now use mauve to draw in the small bridge in the background and parts of its reflection in the canal. Again, balance this by applying the color in other areas. Our artist applied it over areas of the front bridge and its shadows. Overlay some of the light blue reflections with light gray, smudging and smoothing the color with a fingertip.

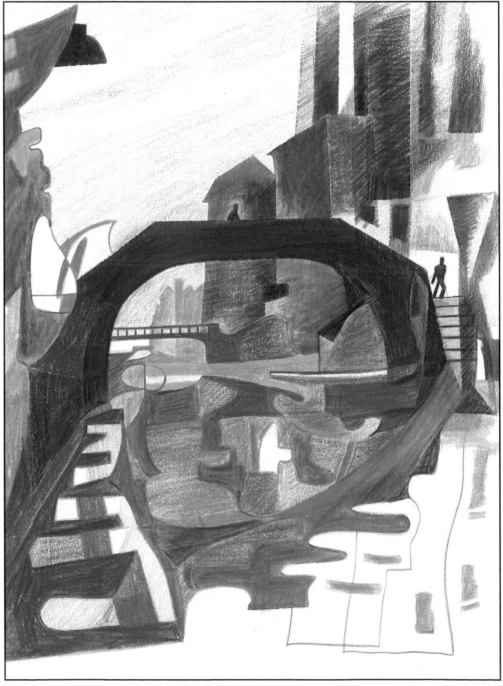

►**11** Add a little emerald green to the factory roof and its reflection in the water. Delineate the steps to the right of the bridge using black lines, then add a couple of moving figures with the same color.

As a final touch, trace in the outlines of the reflections in the lower right of the composition using light blue, adding isolated gray and blue patches to suggest window reflections. Add any other finishing touches on areas that have been left out.

The picture is now finished. It is useful to learn this system of working because you can make such colored pencil drawings on-site, and you will find that they not only look good in their own right, but also make excellent references for paintings.

Working on a large scale

Colored pencils are not just for small, detailed drawings. They can be used loosely to achieve stunning effects on larger drawings.

Drawing with colored pencils usually means you work on a small scale, perhaps not much bigger than a sheet of 9- x 12-in. paper.

Making a lively, large-size colored pencil drawing—working on an 18- x 24-in. scale or larger—calls for a very different approach in the handling of the pencils and the way you make marks. The planning is essentially the same as for a smaller drawing: you need to consider the color range in your subject and look for the areas you want to emphasize before you begin drawing. If you are not used to drawing on a large scale, it is a good idea to make a small compositional sketch before starting. A large-size drawing gives you

scope for a variety of pencil marks. Drawing with broad, sweeping movements, using the whole of your arm, results in more generous, expressive lines. (Holding the pencil higher up the shaft gives controlled, tighter, smaller marks from the wrist, and the lines become more scribbly.)

Since you cover the paper fairly slowly with a fine pencil (think, in contrast, about how swiftly you cover the paper with a fat oil stick), a large-scale drawing takes time to complete. This demonstration of a basket of vegetables took our artist two days. It is important to allow yourself time to take a few breaks, so you can stop and assess your drawing, rather than doggedly continuing, possibly becoming tired (and bored) long before the drawing is finished.

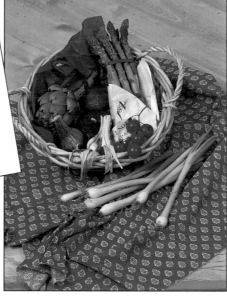

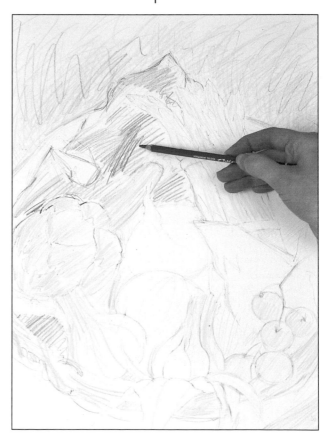

▲▶ **The setup** Our artist arranged her still life on the floor to give herself a high viewpoint. This emphasized the strong, circular shape of the vegetable basket, an important part of the composition.

The large sheet of poster board she used for her drawing has a smooth, hard surface to withstand heavy working without the danger of tearing. She sketched the positions of everything first to ensure that she was completely satisfied with the arrangement.

▶ **1** Begin with the tissue paper and scribble loose marks in different shades of blue. Start with the palest colors you can see, and vary the shades. Use orange, carmine, and lemon yellow at the top and carry the lemon through as a base for the onions, artichoke, tomatoes, and asparagus. Add some jade onto the tissue paper, and on the artichoke, onions, and asparagus in this initial underdrawing.

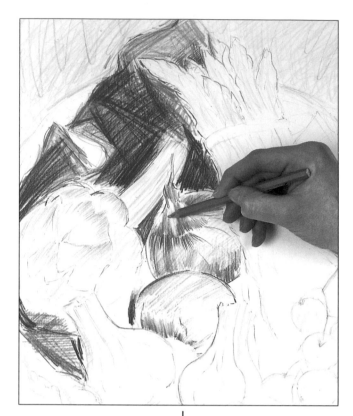

◄ **2** Using both pink and carmine pencils, draw over the onion with a fair amount of pressure, tailing off as you follow the forms and the veins in the onion skins. Continue using these colors on the artichoke, garlic, and tomatoes, maintaining continuity across the paper. Treat the tissue paper as simply as you can, working the pencils in different directions to model the creases and folds. Try not to use a single blue here where two or three will do the job more effectively and sensitively—really look for other colors.

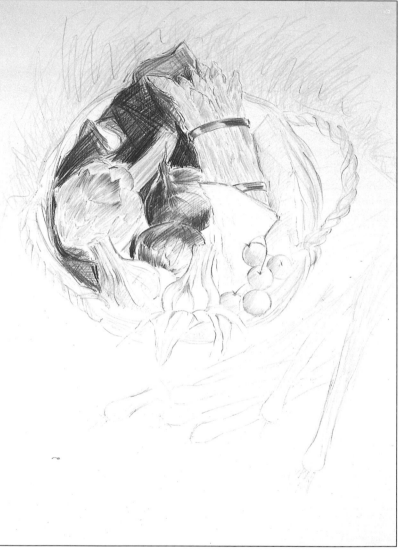

YOU WILL NEED

- ☐ *A 20- x 30-in. sheet of mat board or poster board with a smooth surface*
- ☐ *Drawing board*
- ☐ *Masking tape*
- ☐ *An HB graphite pencil*
- ☐ *A soft white eraser*
- ☐ *17 colored pencils: pink, ocher, orange, carmine, vermilion, emerald green, sky blue, light blue, yellow-green, jade, gray, Prussian blue, purple-violet, russet, scarlet, dark green, lemon yellow. (This is a minimum list to which you can add other colors. Our artist used Caran d'Ache pencils, but use the pencils you have.)*

► **3** Concentrate on drawing the outlines of the shapes and shading in the underdrawing. Use light strokes with generous sweeps, loosely scribbling over the surface. At this early stage, keep continuity and harmony across the drawing by using the same colors in different places. You can enrich specific colors and work on individual forms later.

Lightly draw over the asparagus and the artichoke with yellow-green.

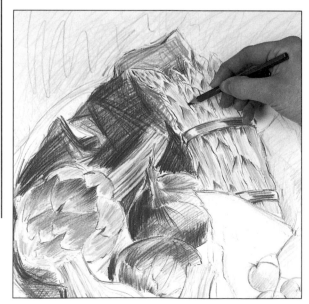

◄ **4** Begin to sharpen up some of the colors so that the drawing does not become too soft and blurred. Work blues and blue-greens into the asparagus and artichoke, and some blues and purple-violet into the onion skins. Draw the tips of the asparagus with purple-violet and define the edges with Prussian blue.

Varying the pressure and the speed of working creates different marks. Twist the pencil occasionally on the edge of the asparagus for a sharper line.

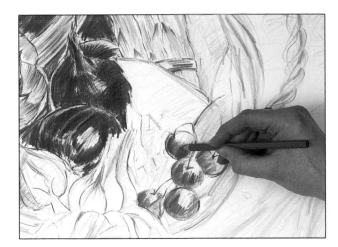

◀**5** Fill in the tomatoes with vermilion, using carmine over the top to make the color richer, but leaving white paper for the highlights.

Lightly add some very loose scribbles of pink to the basket. Then begin some more linear work, drawing with confident, flowing strokes of orange pencil over the pink and yellow underdrawing of the basket.

Tip

Assessing color
The colors you use as a base have an important effect on the final drawing. Try out your colors on a spare sheet to assess their shades before you use them. Start drawing with lighter colors and judge whether they are warm or cool. Generally, the last color to be drawn is the dominant one, but this varies according to how heavily you have shaded the previous color.

▶**6** The floor behind the basket is literally scribbled in with loose strokes of yellow and orange. Add more colors to maintain color harmony within the drawing, letting your strokes radiate from the edge of the basket. Add some stronger russet strokes to the basket.

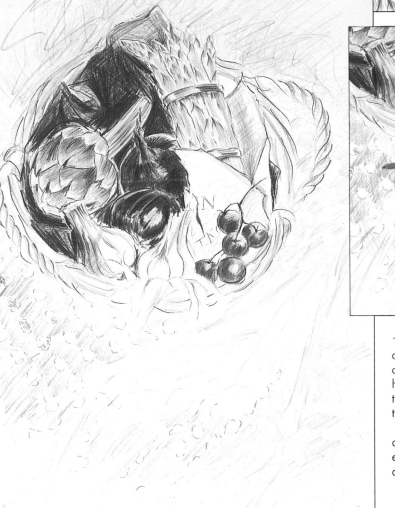

◀**7** Outline the patterned cloth with light blue, then fill in the background. Make the strokes looser and broader at the edge of the paper for a vignetted effect. Loosely scribble with orange and emerald green for a suggestion of the pattern, but do not try to reproduce it exactly.

◀**8** This is a good time to sit back and look at your drawing objectively. Keep an overall balance and think about what needs working up. With this in mind, our artist has brought coherence to the background by introducing touches of blue to the top area and scribbles of yellow on the cloth. (You can see this more clearly in step 9.)

Now ask yourself a few pertinent questions. Does the drawing have enough continuity of color overall? Are there enough colors, types of marks, and tonal values? Do any areas need tightening?

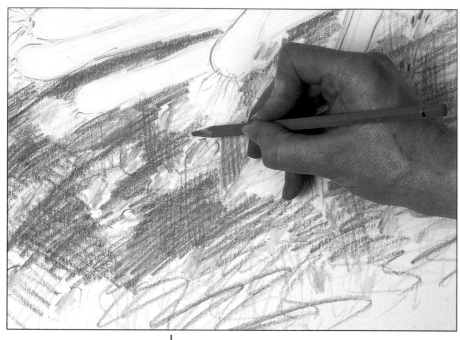

◀ **9** Again working on the blue cloth, build up the surface with a mixture of sky blue, light blue, and Prussian blue. There is quite a lot of ground to cover here, so use the broad side of the pencil, which makes a wider mark. Remember, though, that this is a large drawing; you do not have to finish it in one day, or even in a week.

▼ **10** Work on the detailing of the spring onions, using yellow-green, emerald green, and dark green over the yellow underdrawing. Use light pressure for the final lines that define the edges. Draw the roots with purple-violet and emerald green.

Warm up the shadow under the basket by shading in pink and adding a touch of darker blue over the top.

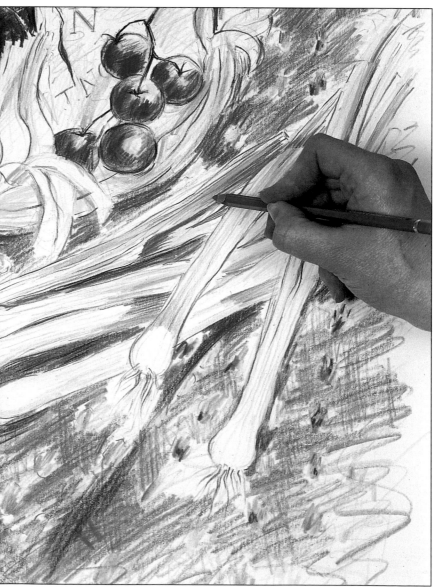

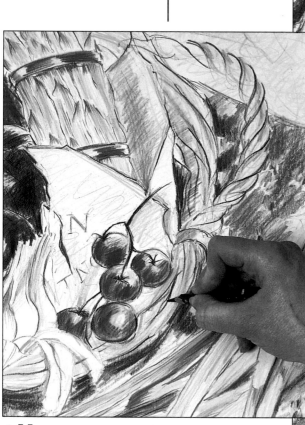

▲ **11** To add strength and enhance the contrast with the blue background, define the edges of the basket with Prussian blue, going over some of the previously drawn lines. By starting with the paler colors you will feel your way into the structure of the basket. This experience will give you the confidence you now need for these bolder, stronger strokes.

 12 Work over the top of the tomatoes with scarlet to make an even richer color. Add some lemon yellow around the highlights to make them stand out. To give extra dimension to the spring onion roots, add a little ocher. Deepen the shadow under the basket with the same dark blue you used earlier.

▼ **13** Take a look at the composition as a whole. Even at this stage there are very few solid blocks of one color or continuous lines of color encircling a shape. All the edges either melt into the white paper or into another color. Avoid using any color for too long in one area, because this makes the surface look flat and dense.

Erase some of the blue cloth in places to diffuse the material slightly and to push it back a little so it does not become too dominant. Apply scarlet, pink, yellow, and orange to make the scribble technique work for you around the top edge of the basket, keeping the circular rhythm of the still life going (see Tip on page 220).

Tip

Using an eraser
You can create an interesting surface by rubbing out a densely scribbled area of pencil in places with a

clean, soft white eraser. It is also a useful device for varying tone and softening any areas that have become too dominant.

▲ **14** Use a rich variety of color to bring out the globe artichoke—lemon yellow, jade, yellow-green, pink, carmine, emerald green, and dark green.

Define the edges with Prussian blue and purple-violet. Here you can define the tips of one leaf with the base of another. Use fine strokes for the artichoke to contrast with the thicker, softer strokes on the onion.

◄15 Add a little more definition to the pattern of the cloth with touches of orange and yellow to contrast with the blue, but do not make it too regular, and allow the color to diminish toward the edge of the drawing. Use some gray to darken the shadow under the basket.

Tip

Lively scribbles
An area worked over with lots of loose scribbles, one color over another, has energy and liveliness. Varying the direction of the strokes adds to this

effect and helps describe forms. In this demonstration, the direction of the final color scribbled on the background at the top emphasizes the rounded form of the basket and the circular rhythm of the still life.

►16 The finished drawing vibrates with color and life. The technique of loose scribbling in the background conveys a sense of energy and defines the drawing. Use the eraser to soften any edges if they appear too hard.

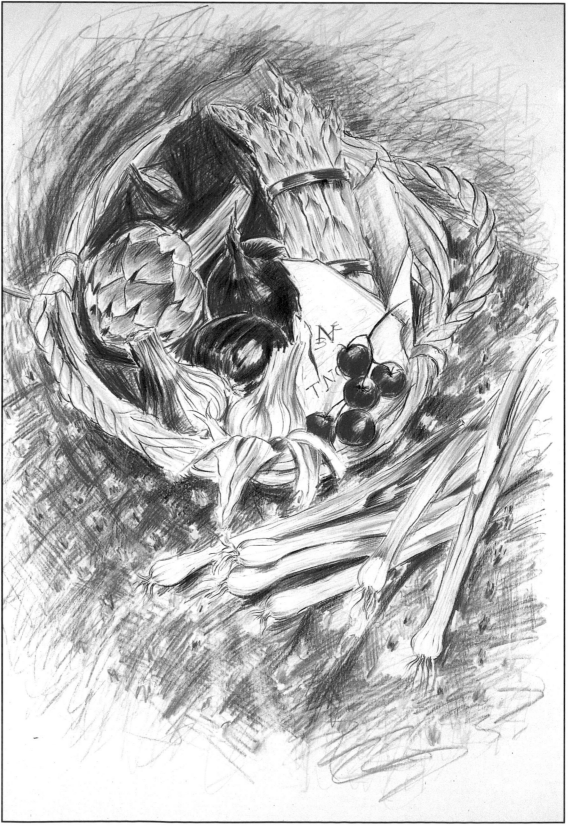

Index

Credits

Artists

All artwork by Stan Smith except the following:

5 Anne Wright, 6 Ian Sidaway, 8(t) Ian Sidaway, (b) Sarah Cawkwell, 11(b) Ian Sidaway, 15–18 Ian Sidaway, 19 Albany Wiseman, 22–24 Tig Sutton, 25 Anne Wright, 26–27 Tig Sutton, 28 Chris Vollans, 29–32 Ian Sidaway, 33–36 Ian Sidaway, 37–40 Albany Wiseman, 41–46 Melvyn Peterson, 47(b) Dennis Gilbert, 51(t) Ian Sidaway, 52 Sarah Donaldson, 53–56 Humphrey Bangham, 57 Anne Wood, 58–60 Joe Ferenczy, 61–66 Lynette Hemmant, 67 Ian Sidaway, 68–70 Pippa Howes, 71 John Crawford-Fraser, 73 Albany Wiseman, 75 Ian Sidaway, 79–86 Tricia Sheldon-Lochore, 88 Ian Sidaway, 89(c) Kate Simunek, 91 Courtauld Institute of Art, 94(tl,cr) Imperial War Museum, 99–102 John Crawford-Fraser, 103 John Ward RA, 107 V&A Museum, London, 109(b) Irene Christiana Butcher, 110(t,c) Howard James Morgan, (b) David Carpanini, 121–126 John Raynes, 131 et archive, 139 Courtauld Institute of Art, 143 Bridgeman Art Library/Giraudon, 147 The Royal Collection, 155 Michael Noakes, 156–160 John Raynes, 165 Sally Holliday, 166 Albany Wiseman, 168(bl) Sally Holliday, 169 Ken Cox, 170 Anne Wright, 171–176 Ian Sidaway, 177–184 Tessana Hoare, 185 John Raynes, 186–188 Roy Ellsworth, 189–192 Anne Wright, 193 David Carpanini, 194–198 John Devane, 199–206 Ken Cox, 207–214 Phil Wildman, 215–220 Anna Wood.

Photographers

Julian Busselle, Mike Busselle, Mark Gatehouse, Ian Howes, Patrick Llewellyn-Davis, Graham Rae, Martin Riedl, Nigel Robertson, Steve Tanner, Mark Wood.